BONINGTON

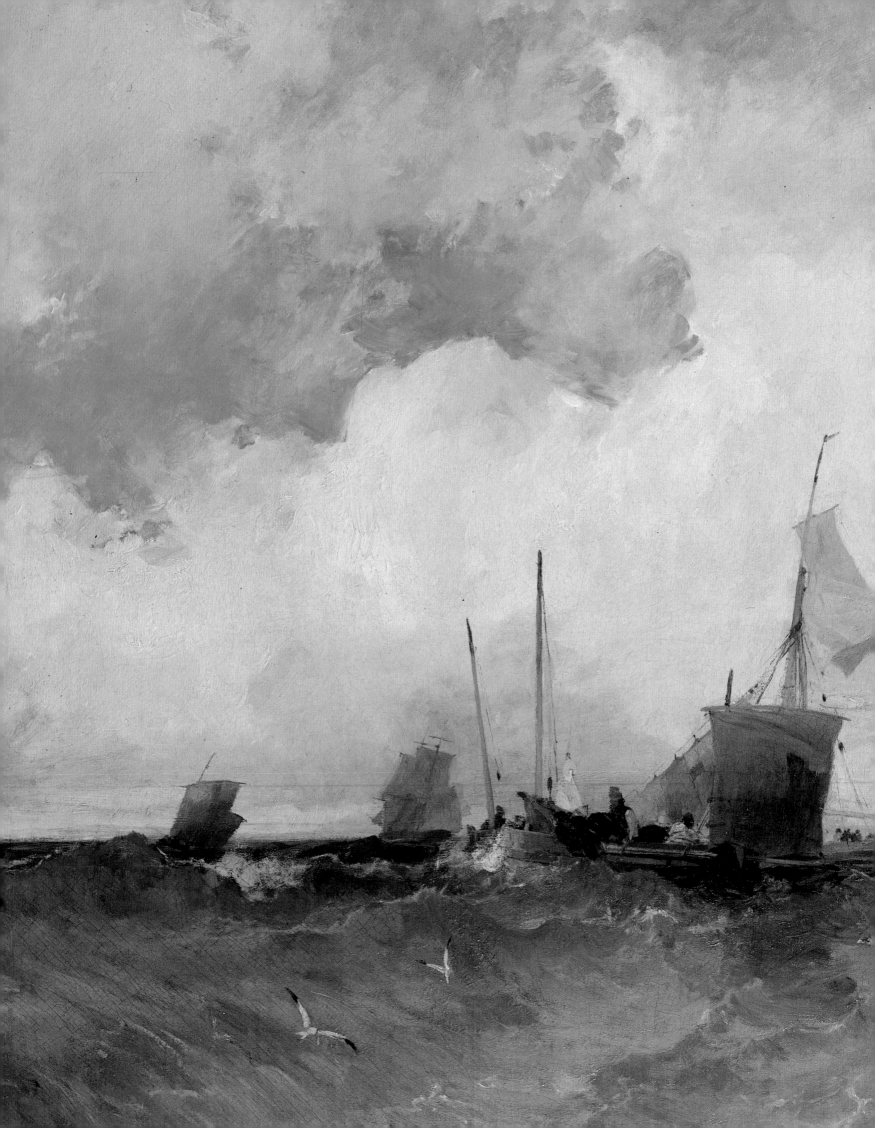

BONINGTON

Malcolm Cormack
Yale Center for British Art

The right of the
University of Cambridge
to print and sell
all manner of books
was granted by
Henry VIII in 1534.
The University has printed
and published continuously
since 1584.

CAMBRIDGE UNIVERSITY PRESS

CAMBRIDGE
NEW YORK · PORT CHESTER
MELBOURNE · SYDNEY

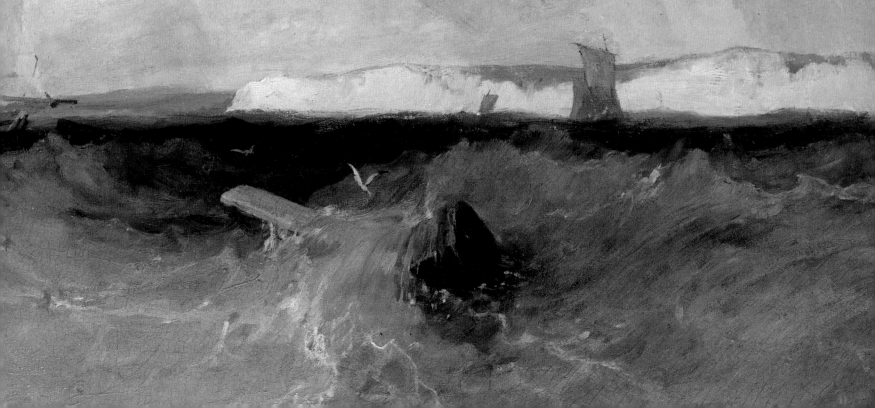

Published in North America by the Press Syndicate of the
University of Cambridge
32 East 57th Street, New York, New York 10022

First published 1989
© Phaidon Press Limited, Oxford, 1989

Printed in Great Britain

Library of Congress Cataloging-in-Publication Data

Cormack, Malcolm.
 Bonington/Malcolm Cormack.
 p. cm.
 ISBN 0-521-37299-2
 1. Bonington, Richard Parkes. 1801–1828—Criticism and
 interpretation. I. Title.
ND497.B63C67 1989
759.2—dc19
 88–38622
 CIP

Endpapers: *Studies for Shylock. c.* 1826–8. Pen and sepia ink,
$8\frac{3}{4} \times 13\frac{4}{5}$ in. (22.3x35.2 cm.) New Haven, CT., Yale Center
for British Art

Half-title: *Honfleur. c.* 1823–4. Black chalk, heightened with
white, $10\frac{3}{4} \times 9\frac{3}{4}$ in. (27.3 × 24.7 cm.) Cambridge,
Massachussetts; Fogg Art Museum

Frontispiece: *A Sea Piece. c.* 1824. Oil on canvas,
$21\frac{2}{3} \times 33\frac{1}{4}$ in. (54.9x84.5 cm.) London, Wallace Collection

CONTENTS

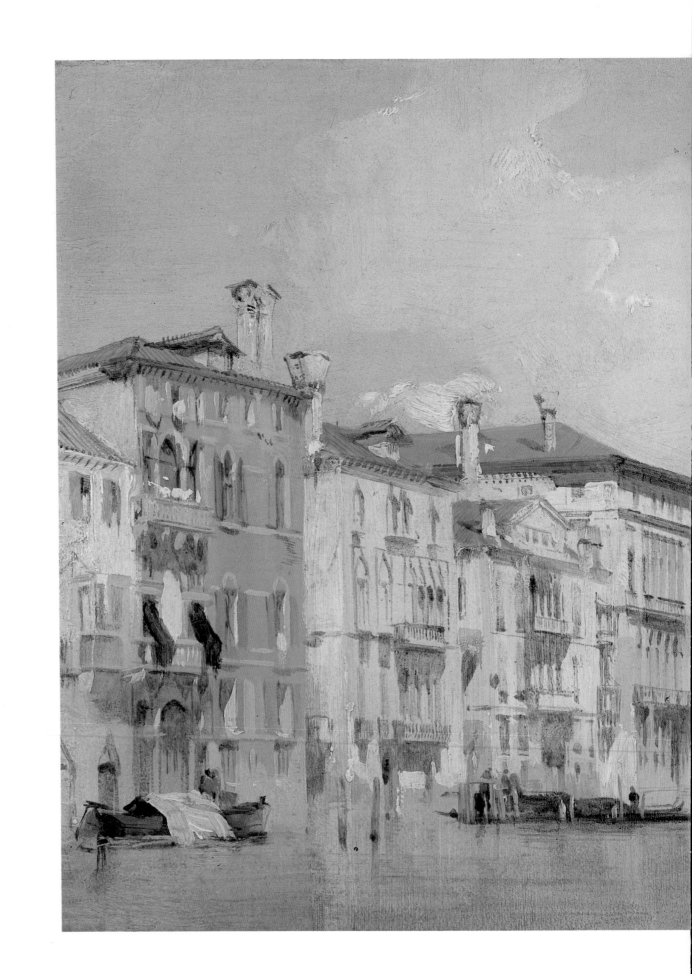

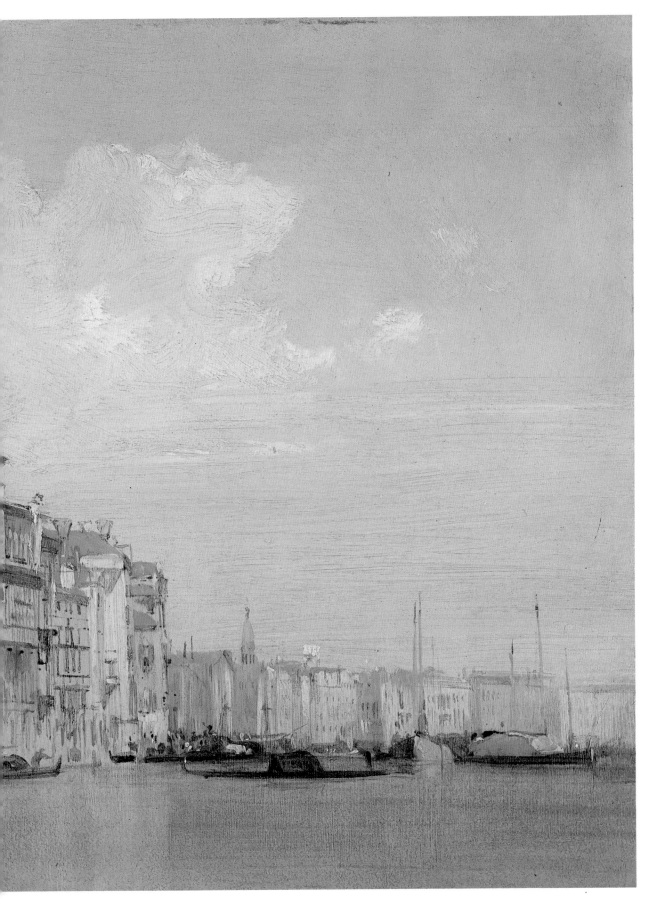

1 *View on the Grand Canal, Venice.*
c. 1826. Oil on board,
9¼ × 13¾ in. (23.5×34.9 cm.)
New Haven, CT., Yale Center
for British Art

INTRODUCTION

Recent attempts by Marcia Pointon and others, to place Bonington in his social and artistic milieu have revealed how complicated the artistic scene was during the first quarter of the nineteenth century, in France as well as in England. Every sort of artist was affected, from the high academic theorist to the lowly journeyman engraver. In spite of the authority of the École des Beaux-Arts in France, and the Royal Academy in England, traditions of what was allowable in art were fast breaking down. In England, it could be argued that the doctrines of Reynolds' *Discourses*, which had been so admired, had never entirely taken root. His rigid outline of the hierarchies of art, and the appropriate way of depicting them were disintegrating, even as he lectured. In spite of the precepts of academic theorists in France, such as Etienne-Jean Delécluze, or conservative patrons of art in England, such as Sir George Beaumont, artists began to pursue their own course. The imaginative world of literature, ancient and modern, could be studied: for example, Dante's *Inferno*, Shakespeare's works, and modern writers such as Sir Walter Scott all provided popular subjects. The history of mankind, from the Fall to the personal antics of Henry IV of France, were all freely made use of. The range of contemporary events dealt with was also extraordinary. Momentous events such as the French Revolution, the Greek struggle for Independence, or the Revolution of 1830 were thought to be suitable subjects for paintings; as were the everyday lives of Normandy fisherfolk (painted by many besides Bonington), or the exact delineations of the inmates of the asylum that Géricault studied.

This wide range of subject could be treated for the first time in a variety of ways. Styles of the past were accepted that had previously been criticized as too bizarre; Rembrandt, and the 'lowly mean masters' of the Dutch school, the 'horrid Gothick' of the early Renaissance, the exotic styles of Egyptian art and Persian miniatures could all provide artistic models. Techniques could no longer be adopted for their appropriateness to the subject, nor be contrasted simply between the linear and the painterly, as with the traditional rivalry between Raphael and Titian. Personal views of places, persons, and natural phenomena could all now be rendered in a wide range of styles and effects.

There was, however, still a distinction made between the sketch and the finished work of art, but this too was beginning to change; Constable in 1825 was not quite sure which was the sketch and which the finished picture of *The Leaping Horse*. His handling of the paint was constantly criticised as too rough, being likened to 'oatmeal', or 'whitewash'. In spite of the academic demands for high finish, younger artists were painting more freely. In England, at least, they could look to the overwhelming example of Turner who, as Farington had described, 'has no settled process but drives the colours about till he has expressed the idea in mind . . .' Bonington too was to receive academic criticism for exhibiting sketches.

As techniques changed, new developments in portable colours made sketching easier, and the newly developed printing method of lithography disseminated the ensuing images to an ever-widening public. For watercolours, seen as an English speciality, the more traditional mixed methods of engraving by aquatint and mezzotint still found favour for their more subtle rendering of half tones and washes. With these methods the English engravers such as S. W. Reynolds, the Fieldings, William Say, and Thomas Lupton, were much sought after in France as well as in England to engrave the antiquarian and topographical views which were increasingly popular.

Patronage, in spite of some ignorant, ill-informed journalism, broadened to the middle classes. Dealers and agents appeared to cater for this activity, while exhibiting societies spread throughout the provinces, particularly in Britain, bringing a wider range of art to a wider public.

All of these tendencies can be found during the Romantic movement which was in full flood during the short period of Bonington's life, and he had a unique part to play in it. Romanticism, if it can be defined, combined the personal exploration of a broad range of subject matter with a freedom from hierarchical stratification of that subject matter, so that landscape as a class became important with an intimate feel for individual natural effects, but without the restrictions of a rigid classical style. Bonington's individual genius, remarked upon by many of his contemporaries, enabled him very quickly to assimilate current trends; his novel artistic education gave him special access to what was important on both sides of the Channel. Even with such a short active career, from about 1820 to his death in 1828, his influence was most evident on his own generation, in technique, style and choice of subject matter, whether for 'fancy pictures' or landscape. Constable found him superficial, and was clearly envious of his facility, but, as his grudging comments of 15 February 1830 show, he did not entirely overlook Bonington:

> But there is a moral feeling in art as well as everything else, it is not right in a
> young man to assume great dash – great compleation [*sic*] – without study
> or pains. Labour with genius is the price the Gods have set upon excellence.

He was not entirely fair. Bonington was brilliant, prolific, and clearly stood out from his immediate contemporaries, and yet died young with a European reputation at the age of 26. Sir Thomas Lawrence, the President of the Royal Academy, equally with a European reputation for dash and brilliance, admired him and bought his work. Eugène Delacroix, Bonington's friend and the epitome of the new Romantic movement, equally admired his 'preciosity of touch,' and for a time each inspired the other. J. M. W. Turner having been a considerable influence on the young artist, painted a series of seacoasts after his death which are obviously indebted to Bonington. Turner was unable to contain that spirit of rivalry which permeated his relationships to masters, old and new, whom he admired.

Bonington's importance was never doubted from the beginning of his career to long after his death, and eventually, his own name was used to describe the style which grew up from his example. 'Le Boningtonisme' may be a modern term, but artists in France and England from the 1820s to the 1840s would have understood what it meant.

We cannot know how Bonington might have developed, but Victorian paintings from history and certain Impressionists such as Boudin and Manet – it can be argued – may well have been influenced by him. Among his own close associates he was clearly a catalyst, not a follower, while later generations have never ceased to imitate, collect, and forge his works. It is the purpose of the present work to see why this was so.

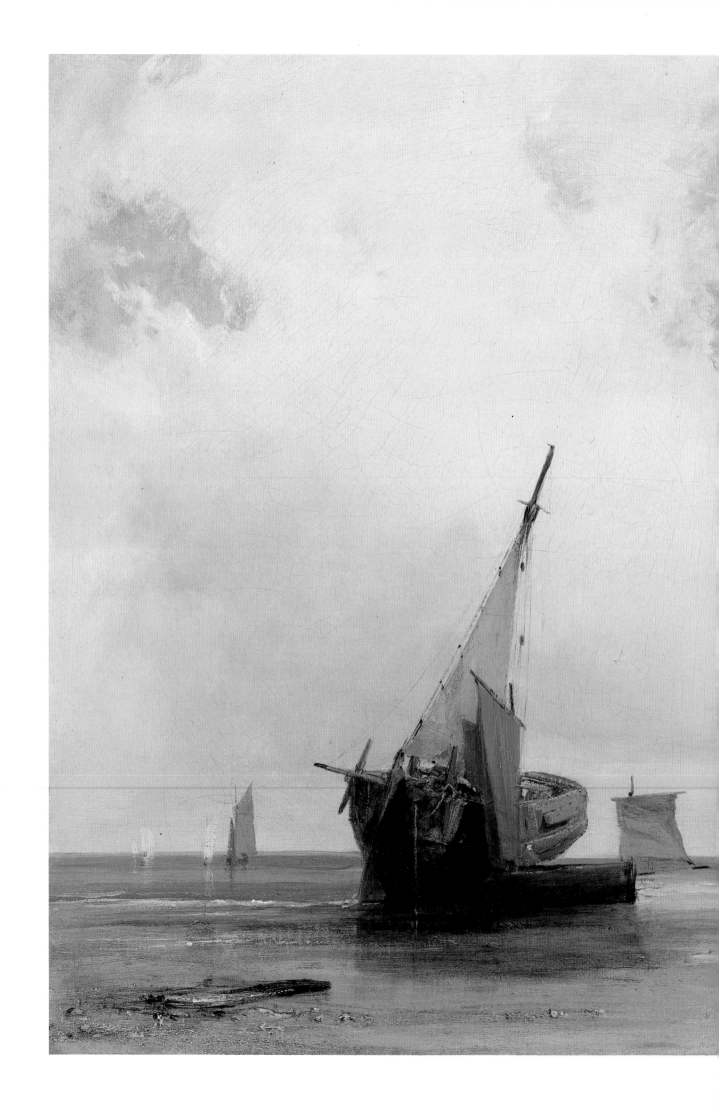

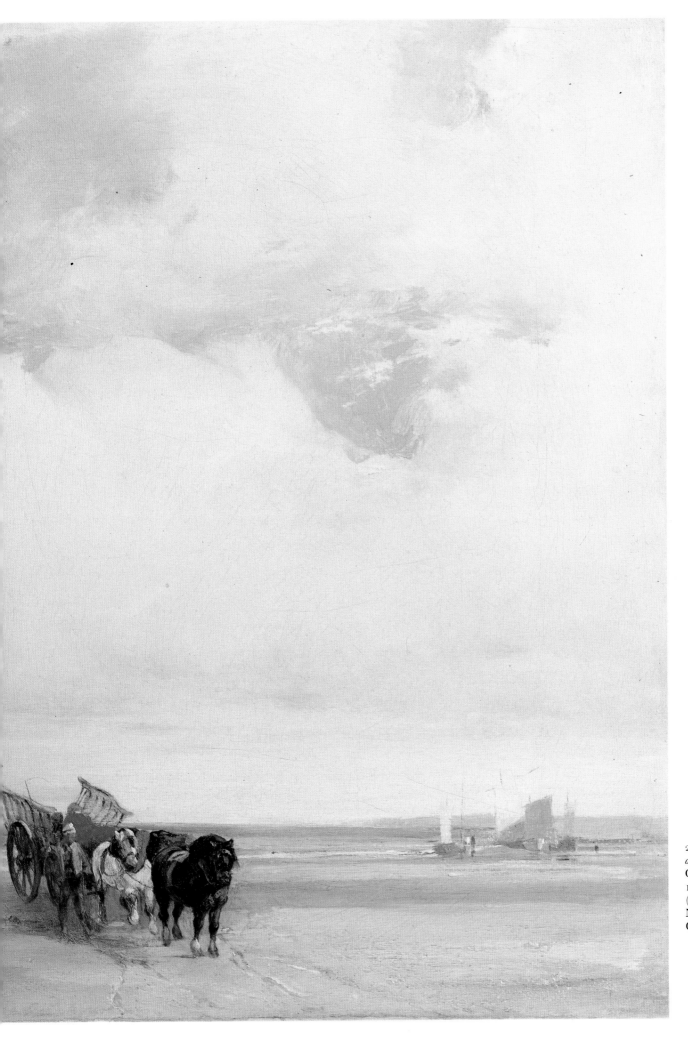

2 *Coast Scene with Horse and Waggon. c.* 1825–6.
Oil on canvas,
$14\frac{2}{3} \times 20\frac{3}{5}$ in.
(37.2x52.4 cm.)
New Haven, CT., Yale
Center for British Art

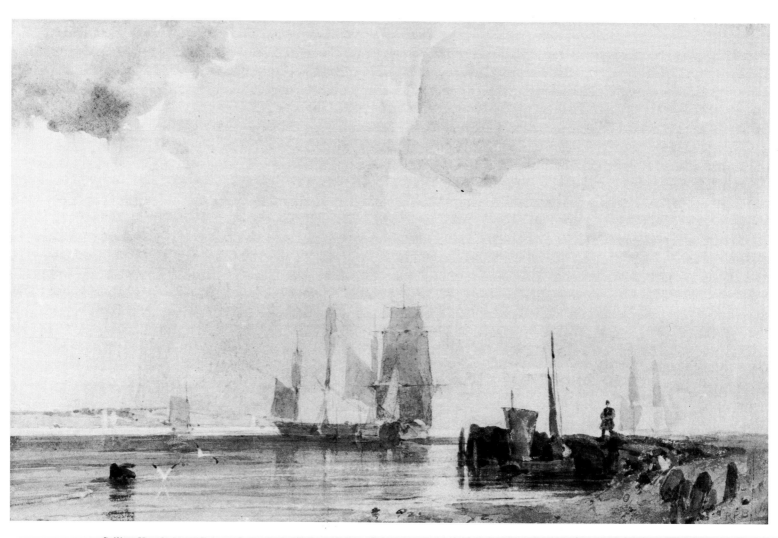

3 *Sailing Vessels in an Estuary. c.* 1922–3. Watercolour, 5¾ × 9 in. (14.6x22.9 cm.) Signed lower right: RPB 18[—]. New Haven, CT., Yale Center for British Art

BONINGTON'S BEGINNINGS

Because he died so young and yet was so precocious, we are forced to look closely at every detail of Bonington's early life and artistic contacts if we hope to explain his special talents. Richard Parkes Bonington was born in Arnold, near Nottingham, on 25 October 1802, the son of Richard Bonington (1768–1835) and Eleanor Parkes (1774–1837), who were both from Birmingham. Their son died at the early age of 26 in 1828, with a considerable European reputation. This was before Constable (aged 43) had finally been made a full member of the Royal Academy, and when Turner (aged 52) had already achieved great personal success. Had Bonington lived to his fifties he would have witnessed the Great Victorian Exhibition of 1851 and the advent of the Pre-Raphaelites. Nevertheless, the seeds of their precise art, so different from Bonington's, may be traced to his example.

His parents had been married at St. Paul's, Covent Garden, in July 1801, but on 28 November 1802, Richard Parkes Bonington was baptized at the High Pavement Chapel, Nottingham, indicative, perhaps, of his father's radical, non-conformist tendencies. In 1815 he stood, unsuccessfully, as a Whig candidate in a local council election. He also seems to have earned his living as a 'Portrait Painter and Drawing master,' while his wife ran a school for young ladies. Bonington Senior had sent a landscape to the Royal Academy in 1798, a portrait in 1808, and had published plates of local views of Nottingham in 1806. There was much communication between the smaller provincial centres, and just as London artists sent their works to the newly founded Liverpool Academy, so in 1811 and 1813, Richard Bonington was also sending landscapes of the Lake District for exhibition in Liverpool. The young Bonington thus came from a middle-class background, with definite cultural and artistic interests, and his own earliest work seems to have been a map drawn for his father's election campaign in 1815.

Because of social unrest in Nottingham caused by the mechanization of the lace industry, his parents decided to move to Calais, where Bonington Senior set up a lace business. He was not known to have any prior interest in lace, but no citizen of Nottingham can have been unaware of the lace trade. The father's main reason for departure, apart from his entrepreneurial instincts, may have been that the genteel activities of a school and the opportunities for patronage in art were declining, due to the violent changes in society that Nottingham was then experiencing.

Somehow, looms were smuggled out to France and, in partnership with James Clark and Robert Webster, *Société Clarke, Bonnington* [sic] *et Webster* was set up in Calais late in 1817. At the father's sale in Nottingham, a collection of paintings, proof prints, and a large

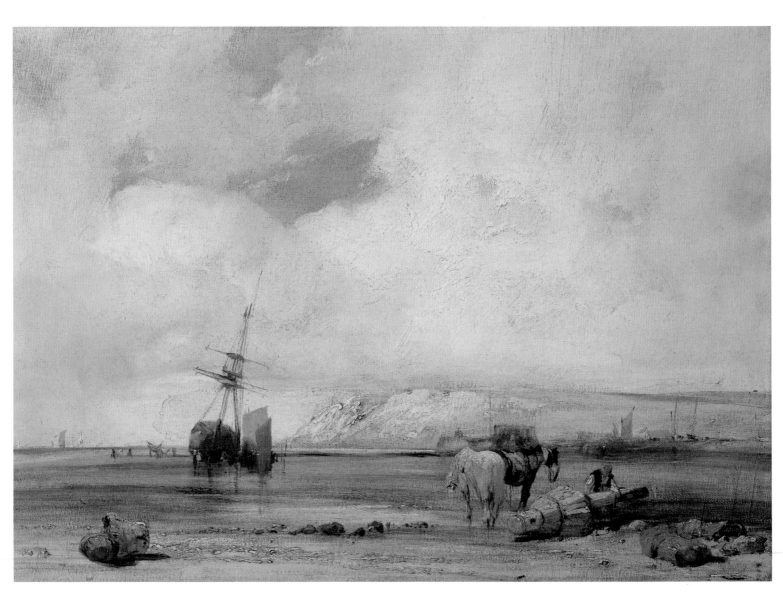

4 *On the Coast of Picardy.* 1826. Oil on canvas, 4.5 × 20 in. (36.8x50.7 cm.) London, Wallace Collection

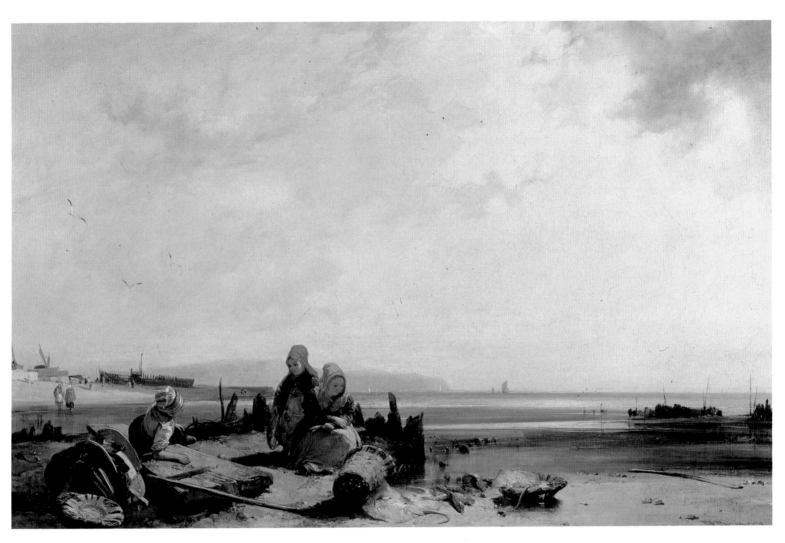

5 *Coast Scene. c.* 1826–7. Oil on canvas, 25½ × 38 in. (64.8x96.5 cm.) Signed lower right: *R P Bonington.* Woburn Abbey

camera obscura were sold, which reveals that the young Bonington was very likely aware of the trappings necessary for a topographical artist. He could have learned the rudiments of drawing from his father, but he also knew of the commercial interaction between engravers and draughtsmen, in which his father had been engaged. The production of topographical works for engraving was to be a considerable part of his own future professional livelihood. Yet he was not to return to England until 1825, for the first of only three visits.

His artistic education was henceforth to be entirely French, but by a quirk of fate the French artist whom he first encountered was Louis Francia (1772–1839). Francia, a native of Calais, had returned there after over sixteen years in England during the Napoleonic wars as an exile from the French Revolution. He had received a sound education and some artistic training in his native Calais, but from his arrival in London about 1790 he became a proficient watercolourist in the most up-to-date English manner. There is no doubt that in France, at least, watercolour was seen to be a particularly English medium for the representation of landscape, and Bonington's career undoubtedly took the form it did because of his encounter with the older French artist with the English manner.

Francia's first exhibits in England at the Royal Academy had been five small views, sent in 1795 from the house of Joseph Barrow, a drawing master with whom he stayed. By 1800 he had become a drawing master himself; he had attended Dr. Monro's unofficial academy in the house in The Adelphi where young watercolourists, most notably Girtin and Turner, had been paid to copy drawings by Canaletto, J. R. Cozens, and others in the doctor's collection; and, most important, Francia became the secretary of a short-lived sketching club known as 'The Brothers', which first met on 20 May 1799. The other members, notably Girtin, were all principally known as watercolourists, and set themselves strict rules for practising landscape composition. In such watercolours as Francia's illustration for the quotation from Cowper's *The Task*, a subject set for their meeting on 28 September 1799: 'The current dashes on the restless wheel . . .' (Huntington Art Gallery, San Marino), on which he worked side by side with Thomas Girtin, the two artists are, not surprisingly, very close in style. The influence of Girtin was to remain very clear on Francia throughout the first decade of his period in London. His view of *Portsmouth Harbour from Portsdown* (Collection: Anthony Reed) of 1808 is a fine example of the influence of Girtin. Girtin had taught the older Frenchman a new more spacious approach to landscape than Francia's own conventional beginnings, and his work adopted something of Girtin's restricted palette and broad, atmospheric washes. Calm estuaries seen at low tide and extended, horizontal landscapes were chosen as subjects by Francia between 1800 and 1808, and hardly surprisingly, similar views were to appear in Bonington's early work.

Francia would also have been aware of Girtin's famous friend and rival, J. M. W. Turner, R. A. Turner is rightly credited with the creation of an heroic and sublime landscape in the period 1800–15, when Constable, for one, was much impressed by his 'wonderful range of mind'. During this period of Francia's domicile in England, however, Turner's exhibited works were as much engaged with pacific scenes of the English coast and intimate, naturalistic river views. Their viewpoint looks out towards the sea, across luminous sands, sometimes towards a rising or setting sun, with, perhaps, a fishmarket with all its paraphernalia taking place in the foreground. These details are all noticeable in such famous examples, among others, as *Sun Rising Through Vapour* (oil, Turner's Gallery, 1810), as well as in watercolours such as *Scarborough* (R.A. 1811). This subject matter and more dramatic sea pieces provided an entire repertoire for Francia, and his young pupil, Bonington.

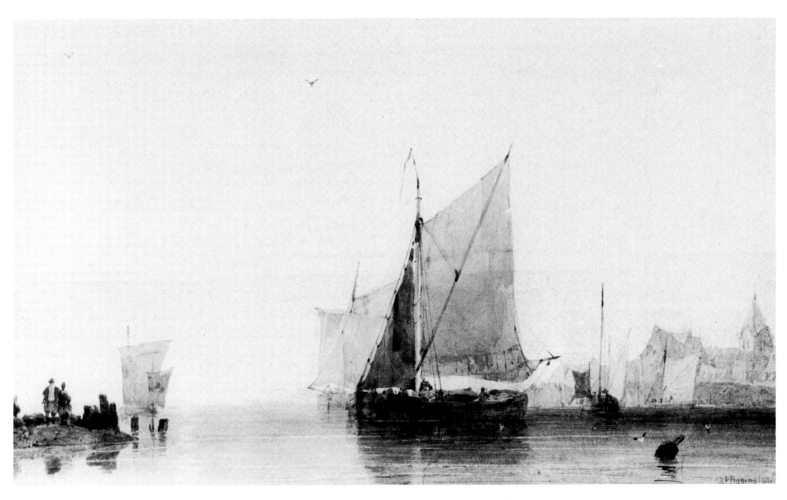

6 *Fishing Boats in a Dead Calm. c.* 1822–3. Watercolour with pencil, faded, $6\frac{2}{3} \times 10\frac{2}{3}$ in. (16.7x26.5 cm.) Signed lower right:
R. P. Bonington. London, Wallace Collection

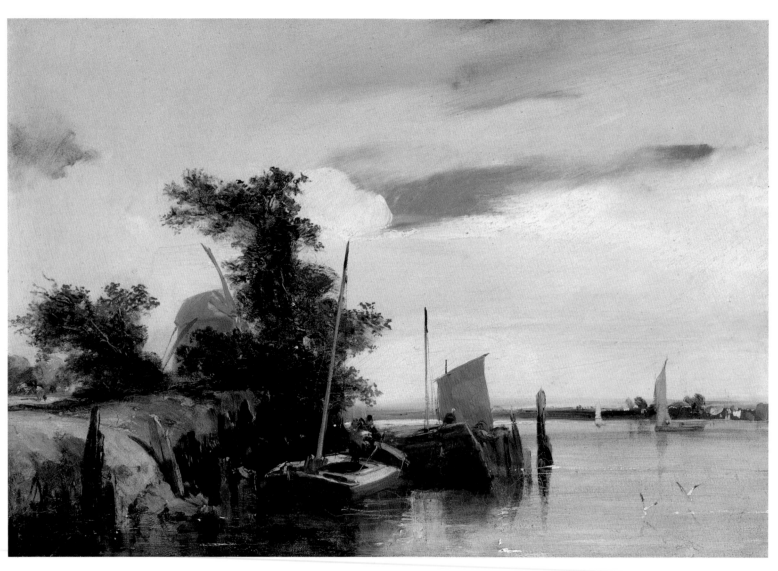

7 *River Landscape. c.* 1825–6. Oil on millboard, 9¾ × 13¾ in. (24.5x35.0 cm.) Signed lower left: *R.P.B.* New Haven, CT.,
Yale Center for British Art

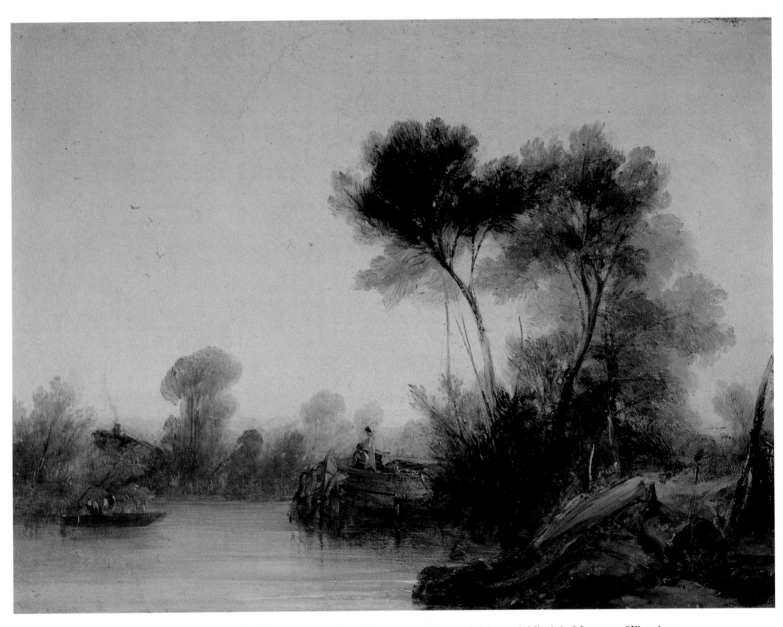

8 *View on the Seine. c.*1825–6. Oil on panel, $12\frac{1}{4} \times 15\frac{1}{4}$ in. (31.1x38.8 cm.) Richmond, Virginia Museum of Fine Arts

9 Louis Francia (1772–1839). *Ships Anchored off a Sea-shore. c.* 1810–16. Brown wash and ink, heightened with white on grey paper, 4 × 7 in. (10.2x18.1 cm.) Signed on spar: *LF* New haven, Yale Center for British Art

Not only would Francia have seen these paintings first hand, he would also have known of similar views, as they were published as engravings after Turner's work. Francia, as a drawing master, may have owned plates of the most famous of these, Turner's *Liber Studiorum*, published between 1807–19, where Turner's categories of 'Marine' and 'Pastoral' would have been of particular interest to them both; but equally there were naturalistic views in a Girtinesque mode along the Thames, and in *The Rivers of Devon* and *Picturesque Views on the Southern Coast of England*, published by W. B. Cooke, for whom Bonington was later to work. A number had already been published before 1815, and it was from these that Bonington was to gain inspiration for subject and style, but Francia's own enthusiasms would have provided the most important introduction to the inimitable English genius of Turner. In Bonington's father's sale of 1834, there were proof plates of Turner's 'marine views' and prints of his river scenery.

Francia himself was to become something of a specialist in marine views, painting estuaries and breezy off-shore scenes, and even attempting Turneresque stormy designs, of which *The Transports returning from Spain, February 1809, beating into St. Helen's Roads* (British Museum) is an outstanding example. *Ships Anchored off a Sea-shore* (Plate 9) is typical of Francia's feeling for the expanse of sea, the light of the horizon, and the swell of the waves. His works come close with their strong sense of movement to the work of Samuel Owen who had become a member of the Associated Artists in Watercolour in 1808, the year that Francia first exhibited there. Francia was to become a member in 1810.

When, by tradition, the young Bonington sat at Francia's elbow at Calais enthusiastically watching him paint in watercolour, the older artist could not only introduce him to the English professional world of watercolourists and their leading exponents, Girtin and

Turner, but also to techniques, styles, and attitudes to landscape painting barely known in France at first hand. Francia knew about the naturalistic style of painting in oil and watercolours favoured by his young English contemporaries, for example, A. W. Callcott, Peter De Wint, David Cox, Henry Edridge, and John Sell Cotman. These artists, in the circle of John Varley, had been encouraged to paint out-of-doors, to look at the world objectively, even using a *camera obscura*, or its more refined version, Cornelius Varley's 'Graphic Telescope', and to record the visible world for possible publication, as Bonington's father had attempted, in engraved plates for profit and edification. Many had already embarked in 1815 on careers producing topographical views in England and the Continent. This now famous generation had a freshness of observation and simplicity of construction, paralleled in the 'Lakeland Poets', which it is not too far-fetched to observe are characteristics of Bonington's early art, drawn from Francia's own experience. It is true that Bonington's later work may, in turn, have influenced Francia, but when Francia took the young Bonington under his wing, as he was to do with his own son, Alexandre, and a number of local French artists such as Jules Collignon, Louis Tesson, and another Englishman, William Wyld, he had much to offer by way of his knowledge and contacts.

One such contact was Benjamin Morel (1781–1860), who lived in Dunkirk, and was a collector and local patron to whom Bonington was introduced by Francia. Morel was a ship-owner and mayor of the town with a varied collection of works of art. He owned examples of older artists' work such as that of Horace Vernet, and by Bonington's contemporaries, Delaroche, Lami, Colin, and Francia. Perhaps, like many shipowners, he liked to encourage young artists and, certainly, later in 1824, Bonington was a welcome visitor to the Morel family and attended the theatre with them. Morel is supposed to have given Bonington a letter of introduction to Delacroix in Paris, but this may have been later, because in 1818 at least, the Bonington family felt confident enough to open a shop in Paris in the rue des Tournelles and, naturally, took their son there. Bonington never lost his association with Francia, to whom he largely owed his initiation into the English style, but his education as a French artist was about to begin.

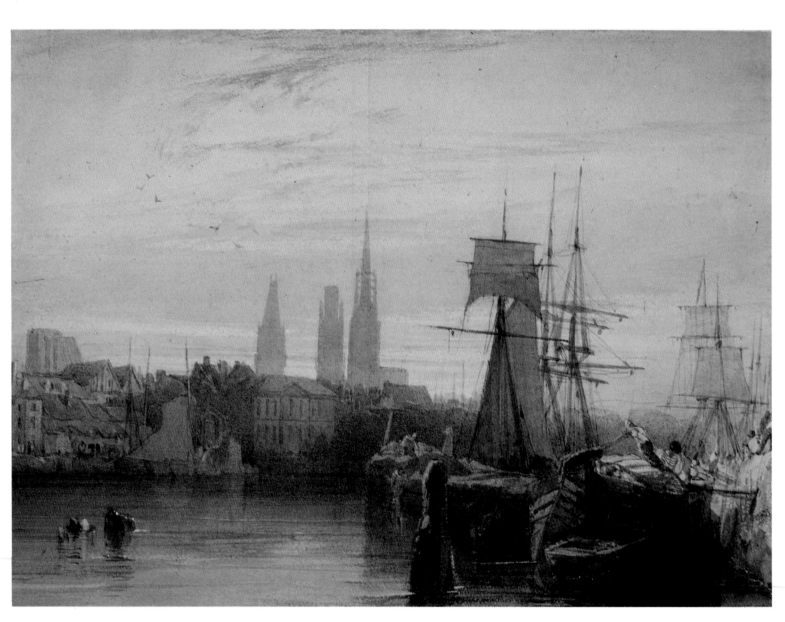

10 *Rouen. c.* 1822–25. Watercolour, body colour, with some gum varnish, $7 \times 9\frac{1}{4}$ in. (17.9x23.5 cm.) London, Wallace Collection

CONSOLIDATION IN PARIS

When his family moved from Calais to Paris, probably at the end of 1818 with the liquidation of the original firm, Bonington's education was to be transformed. There was increased competition in Calais, and prospects in Paris were better for the manufacture and sale of plain and embroidered tulle. The family's first address was in the rue des Tournelles, but by 1820 they had moved to the rue des Moulins. Bonington went with them, but clearly with the aim of becoming an artist rather than a shop assistant, as by April 1819 he was enrolled in the atelier of Antoine-Jean Gros, later to become Baron Gros, (1771–1835), at the École des Beaux-Arts.

Bonington had taken the first step into the highly organized world of French art training, still dominated by the rigid classical theories of Jacques-Louis David (1748–1825), Gros' master, alive and active but exiled in Brussels. David's *Farewell of Telemachus and Eucharis* of 1818 (J. Paul Getty Museum, Malibu, California) gives a good indication of the linearity and 'pompier' nature of his late style. Baron Gros was to paint a companion picture in 1820 of *Bacchus and Ariadne* (Phoenix Art Museum, Arizona) for Count von Schoenburn, which is more indecorous than his master's example, and is typical of Gros' more sensuous approach. Yet, in creating an heroic art dedicated at first to the apotheosis of Napoleon, and later to the Bourbon restoration, Gros (with colleagues such as Régnault and Girodet de Roucy Trioson) was by 1820 the head of a regimented system of instruction.

This system required students to draw first from casts of antique sculpture and then, if considered proficient, to proceed to the live model. They were then required to pass tests of composition and historical landscape, their subject matter chosen mostly from obscure texts of classical legend. For their examination, the students were confined all day long to small painting cubicles for their composition sketches, poring over the dramatic exposition of a stated text. They could use their knowledge of the set poses of the models they had drawn with such accuracy during the previous term, or their memories of the principal figures of antiquity gained from the École des Bosses. Their aim was to win the coveted Prix de Rome, and become distinguished exponents of the grand style of history painting.

Their sketches, however, when seen together have a monotonous sameness of effect which testifies to the rigidity of the teaching. Even the landscape sketches have very little individuality, having been conceived in an idealistic Claudian mode, well away from nature. This system lasted unchanged until 1863. Baron Gros' atelier was open in the Institut weekdays from 8.00 a.m. until evening. Gros attended at 11.00 a.m. and had a reputation as a kindly, if irascible, teacher. It is interesting to note that Alexandre-Marie Colin (1798–

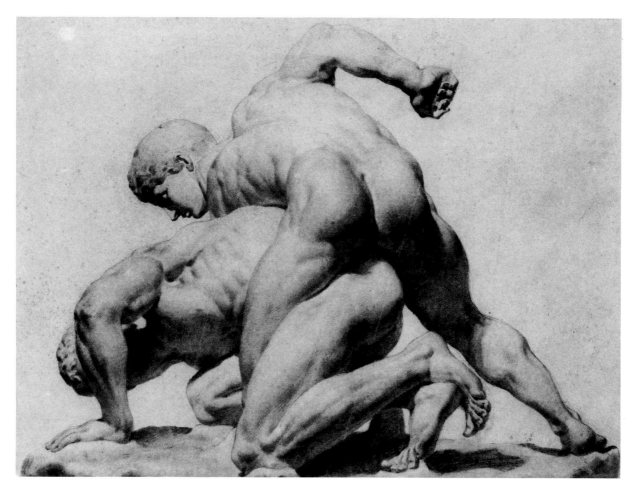

11 *'The Wrestlers', after the antique. c.* 1820. Black chalk and stump, 15¾ × 21 in. (40.0×53.3 cm.) Nottingham, Castle Museum and Art Gallery

1873), Bonington's early friend, received honourable mention for his composition of 1822, as a pupil of Girodet.

It is possible that at the age of 16, newly arrived in the centre of the art world, Bonington considered that this was the best way to a professional career. There were a number of literary and historical subjects in his mother's sale of 1838, one of which was dated 1818, which show that Bonington was not unaware of the value of history painting. They were not, however, classical in subject, and the nearest he came to fulfilling such a course of study was in the patient, academic exercises he drew intermittently during the next three years. One such of *The Wrestlers* is illustrated here (Plate 11). There were eight other academic studies in Mrs. Bonington's sale, and one of *Hercules* is signed on the reverse 'Bonington Eleve de M. Gros'. They reveal that, at least, he had received a careful training in precise drawing with the use of stump and outline that was not so readily available to his English contemporaries. His precision of detail, so noticeable in his later art, was thus undoubtedly helped by this early hand and eye training.

His heart, however, does not seem to have been in such academic tasks. He was not allowed to proceed to the life school, and such life studies as do exist by him seem to have been done privately of the model Mlle. Rose, in the company of Delacroix. The Louvre

at that time provided a unique opportunity to study Old Masters of all periods, where students were allowed to copy directly from any original. Although some of Napoleon's rich haul had, by the terms of the Treaty of Vienna, been sent back to the countries from which they had been acquired by Napoleon (one of whose advisors was Baron Gros), the breadth of the Louvre's display after the war, and indeed of provincial museums such as Rouen and Caen which Bonington was to visit, had no parallel in Europe. London's National Gallery did not yet exist, and the Louvre's enlightened policy allowed as many as fifty or sixty copyists to enter with their easels, thus providing a valuable private academy.

Delacroix writing long afterwards in 1861 remembered seeing Bonington as:

> a tall young man in a short jacket silently making studies in watercolour
> usually after Flemish landscapes. He had already acquired an astonishing
> ability in that genre which at that time was an English novelty.

After his period of tuition with Francia, Bonington's marked ability in watercolour is not in itself surprising. No French artist in Paris at that time would have had access to such a background, and Bonington would have been noticeable, presumably, for copying with his pad and watercolours during the afternoons. Neither is his copying of Flemish and, presumably, Dutch landscapes so remarkable in view of the naturalistic bent of Francia's teaching in Calais. Admittedly, no self-respecting student of the grand style of heroic landscape would have copied them before he had paid attention to Claude and Poussin. Even Constable spent a great deal of time copying and producing pastiches of Claude from Sir George Beaumont's collection, and Turner had been most impressed by Poussin's series of *The Four Seasons*, particularly *The Deluge (Winter)*, when he visited the Louvre in 1802. His well-known rivalry with Claude extended even to his will, where he specified that his *Sun Rising Through Vapour* and *Dido Building Carthage* should hang between two Claudes in the National Collection.

There is, however, very little trace of the influence of Claude and Poussin on Bonington's art throughout his subsequent career, apart from the general effect of all-enveloping light. If, by Flemish artists Delacroix meant Rubens, Jan Wildens, Jan Brueghel, or Snyders, for example, then Bonington must have been copying only details and backgrounds. He does not seem to have learned from Rubens the majestic sweep of a landscape in the way Constable was influenced by Sir George Beaumont's *Chateau de Steen*, although he did make copies after Rubens' *Hunt*. He seems just as likely to have been copying the more naturalistic and less Baroque landscapes of the Dutch School. Dutch paintings, although castigated by academics, had always remained popular during the *ancien régime*, for example, in the Duc de Choiseul's collection, and the school was well represented in the Louvre. James Roberts, an associate at Baron Gros' studio, recalled that Bonington's first copy was a watercolour after a small picture by Gerard Dou, always popular for his skilful and detailed mixture of anecdote and still life, a not entirely inaccurate description of Bonington's later genre scenes. Many copies are precise, individual figure studies, mostly in pencil with occasional watercolour, taken from seventeenth-century artists such as Van Dyck, Terborch, Metsu, van Ostade, Teniers, and De Hooch, and Italian artists such as Paris Bordone, and Titian, as well as copies after engravers. Like Sir Joshua Reynolds' practice in his sketchbooks they record elegant gestures, poses, details of costume or furniture that he felt he could use in domestic interiors, but they are more easily connected with his own later development of a particular historical style.

He also continued his initial interest in landscape begun with Francia. There are drawings and watercolours in existence which have been dated in the period 1818–21, and which reveal a confident version of Francia's style. The later reminiscences of James Roberts, who claimed to have introduced Bonington to Baron Gros' studio, and Paul Huet (1803–1869), another fellow pupil of Gros, both agree that Bonington was already active at this time as an independent creator of watercolours which he later sold through the dealer, Mme. Hulin. He had already begun in 1820 to make excursions in and around Paris in the company of fellow students, such as Colin, Huet, Joseph-Auguste Carrier (1800–1878), and Jules Armand Valentin, whom Marcia Pointon has suggested is Bonington's mysterious friend, 'V', who occurs in James Roberts' manuscript notes as a fellow excursionist. They were all of a similar age, and while Bonington according to Huet, talked 'ceaselessly' of Turner, they also read Sir Walter Scott, Shakespeare, and French history and romances. From their mutual interests developed a new Anglo-French school of the Romantic movement, interested in a naturalistic observation of the landscape, using watercolour with a new-found freedom, and having an eclectic attitude to the past for knowledge of what was worth imitating, while completely ignoring the rigid doctrines of classical subject matter and style. Bonington's influence can be seen in the fact that this loose group of artists gave rise to a style and attitude known as 'Le Boningtonisme'.

Bonington seems to have gained independence to pursue his own interests from the sale of his early watercolours. He was dissatisfied enough with the classes under Gros to be absent twice from the atelier during 1821, for the winter semester, and the following summer period. He travelled northwards to Normandy in the company of Colin, at this time perhaps his closest friend, with 'his knapsack on his back over his long blouse, a flat cap on his head like that of a grand vizier, and his stick in his hand', as he was later described by Virgile Josz. It is not clear whether he had commissions in view, but Baron Taylor's monumental publication, *Voyages pittoresques et romantiques dans l'ancienne France*, was already being planned, and Baron Taylor was gathering an impressive stable of artists to provide him with views to be published: Regnier, Isabey, and Géricault among the French, and Bonington. His father had already modestly ventured into publishing views in Nottingham, but there were many English precedents for this sort of work, and more were published in the 1820s.

Topographical landscapes had been popular in England during the eighteenth century when the growth of antiquarianism, and the rekindling of interest in the 'Gothick' had caused travellers to go in search of authentic medieval buildings. The publication of essays on the Picturesque by the Reverend William Gilpin, Uvedale Price, and Richard Payne Knight had extended this interest, not only into the rougher aspects of nature and more humble country abodes, but also into ruined abbeys, castles and their armour, and townscapes, which were as remarkable for their rich historical associations as for their ivy-covered exteriors. Francia was well aware that Turner and Girtin had produced watercolours for engraving in 'Picturesque Tours' for the armchair traveller. This had become something of a cult, as can be seen by the satire it provoked from Jane Austen in *Sense and Sensibility* and *Northanger Abbey*, and Robert Southey in his *Letters from England* of 1807.

To this fad the French had remained almost sublimely indifferent, ruining their abbeys not for aesthetic effect but with an excess of secularism and iconoclasm, not seen in England since the Reformation, and the Puritan revolution. With the reopening of the Continent to English travellers after 1815, a number of curious tourists and impecunious

artists with a commission in sight joined together to continue a practice begun before the Napoleonic wars. A flood of illustrated books, reproduced the as yet 'unscraped' riches of the French Gothic heritage before it was attacked by Viollet-le-Duc. The watercolour technique provided a rapid means of producing views and there were competent engravers in England who were well known for their ability to reproduce these watercolours successfully in aquatint or mezzotint. S. W. Reynolds was one such important print maker and he actually had a workshop in Paris during the war between 1809 and 1814, and returned to France again in 1824, 1825, and 1826. Conveniently, also, the new print method of lithography as devised by Senefelder, provided an ideal way of reproducing pencil drawings. Engelmann in Paris and Hullmandel in London provided thriving workshops for the printing of lithographic illustrations.

Views of French towns, villages, medieval street scenes, churches, tombs, ruins, prospects of the sea and countryside, with inhabitants wearing picturesque local costumes, all this and more had been drawn by Frederick Nash, who published his *Picturesque Views of the City of Paris and its environs* in London in 1820; by Henry Edridge who had visited France in 1817; by Samuel Prout who had visited Normandy in 1817 and knew Francia; and by John Sell Cotman who visited Normandy three times in 1817, 1818, and 1820. Cotman, with the aid of Cornelius Varley's Graphic Telescope, and supported by the Yarmouth banker and amateur antiquarian Dawson Turner, had produced hundreds of pencil, sepia, and watercolour drawings of his tours through Normandy. These had resulted in a set of ninety-seven etchings, published in two volumes with a letterpress in 1822, and twenty etchings after his work by Mrs. Dawson Turner and her daughters, published in Dawson Turner's *A Tour in Normandy* in 1820. These publications were just two of many which would have been known in Paris.

Accordingly, when Bonington and Colin set off from Paris down the Seine, through Mantes (where Baron Rivet, a later companion, had property) and on to Rouen and Le Havre, and thence along the north coast of France through Boulogne, St. Valery, Calais, and Dunkirk, they were following a well-trodden path and may already have had an inkling of the commercial prospects of such a tour. It could provide them both with a store of marketable watercolours as well as the opportunity to renew old acquaintances. Whereas, however, the English artists travelling through Britain had, say, Percy's *Reliques* in their knapsacks, Bonington's head was full, according to James Roberts,

> . . . of all sorts of historical traces. He loved to study the transitions from one
> style to another. He was fascinated by the works of Sir Walter Scott,
> especially those which had an archeological bent. I have no recollection of
> ever having seen Bonington interested in anything but questions of art or
> matters connected with it. With costumes, all from the middle ages onwards
> appealed to him! His excursions were in accordance with his literary tastes.
> He had Barante's history of the Dukes of Burgundy, and, later, the memoirs
> which had furnished this author with the material for his works-books such
> as the chronicles of Enguerrand de Montstrelet and Froissart, whose archaic
> language had a particular charm for him. One often saw in his hands the
> early essays in French literature, such as those of Gerard de Nevers, Saintre,
> and Lancelot of the Lake; and also all the modern novels which had an
> archeological flavour.

Because of the lack of securely datable work, it is not easy to distinguish between drawings done in 1821, those he exhibited in 1822, and a further group from a tour in 1823. His first tour was most likely concerned with landscape and marine views, with which he would feel most comfortable from his time with Francia. Although Delacroix remembered his producing watercolours in the Louvre, it is not safe to assume that all watercolours, however naturalistic in appearance, were executed on the spot. In this respect Bonington was no different from his contemporaries, such as Turner, Cotman, or Prout. Small pencil jottings of figures and harbours, or watercolours with simple wash effects, were probably the immediate result of his journey, yet his style in pencil for the next few years hardly changes and is, therefore, particularly difficult to date. He certainly returned from this first trip with watercolours, some of which he probably worked up in the studio. The subject and apparent intention sometimes give a clue to their origin, but throughout his career the existence of different versions done on demand, often from earlier designs, makes precise dating a problem.

Both Delacroix and Gros were amongst those who had caught sight of Bonington's attractive watercolours in the windows of the dealers, Mme. Hulin and M. Schroth. They specialized in the works of the young, unconventional, often English artists, and Schroth was to do much for the sale of Constable's work in Paris. Bonington was to exhibit two watercolours *Vue Prise à Lillebonne*, and *Vue Prise au Havre* at the Salon in Paris which opened on 24 April 1822, but unfortunately these watercolours are no longer identifiable. They were purchased by the Société des Amis des Arts for the respectable sum of 430 francs. The Société, a body ahead of its time, had been founded by the Duc de Berry, an important Anglophile, and since his assassination in 1820 it had been encouraged by the Duchesse who was to become an important patron of young artists both from France, and those from Britain too.

There are a number of watercolours by Bonington which can be dated to this very early period. *A View of Calais from La Rade* in the Bibliothèque Nationale, Paris; a *Scene of Fisherfolk on a beach, storm approaching*, sold at Christie's in 1981; and a scene of *Boats Moored in an Estuary* (Plate 15). The first may even date from Bonington's period with Francia, while the other two are notable for their generalized masses, and broad areas of wash, punctuated with the details of gulls with dark wing tips, a useful marine view motif which he probably picked up from Francia in whose work gulls often occur. Three small pencil studies of a *Seascape with Shipping* (Plate 13), and *Calais: the Entrance to the Harbour with Fort Rouge* (Plate 12), and *Calais: Coast Scene* (Plate 14) are works typical of the sketches Bonington drew on the spot between 1821 and 1823. The *Seascape with Shipping* has sharp accents of the pencil to give an atmospheric view of the casual scene. Details of rigging are accurately picked out which reveal his competence as a marine artist at the beginning of his career. Fort Rouge, the antiquated wooden fort at the entrance to Calais harbour, he would have known well from his time there, and he draws it with bold strokes that contrast with his lighter touches for the jetty and waves. His ability to define small detail and rough texture is also apparent. His line is sure, and such small rapid jottings provided him with useful material which, like his copies from Old Masters, he could incorporate into bigger, finished compositions. In a larger drawing of *Honfleur* (half-title page), at the Fogg Art Museum, Cambridge, Massachusetts, he produced a more ambitious composition of a street scene with figures blocked in, showing a fair eye for architectural detail, but without the particularity that an antiquarian publication would require.

12 *Calais: The Entrance to the Harbour, with Fort Rouge. c.* 1821–3. Pencil, 2 × 2⅘ in. (5.1x7.1 cm.) Nottingham, Castle Museum and Art Gallery

13 *Seascape with Shipping. c.* 1821–3. Pencil, 3¼ × 6¾ in. (8.3x17.2 cm.) Nottingham, Castle Museum and Art Gallery.

14 *Calais: Coast Scene. c.* 1821–3. Pencil, 3 × 7⅘ in. (7.9 × 20cm.) Nottingham, Castle Museum and Art Gallery

15 *Boats Moored in an Estuary. c.* 1822–3. Watercolour, 6¾ × 9¼ in. (17.1x23.5 cm.) Private Collection

Three finished watercolours stand out from this early period, and they may well all date from before 1822, even from 1820–1. *St. Gilles, Abbeville* (Plate 17) is a competent essay in the Picturesque style of rendering buildings. It is seen from low down and at an angle with the mass of the church rearing up in exaggerated perspective. Thomas Malton had taught his pupils, Charles Wild who exhibited at the 1824 Salon, and J. M. W. Turner, how to choose such a striking viewpoint, and it was to become something of a visual cliché in the innumerable engraved picturesque views. Bonington may have seen some of Malton's works. Bonington's watercolour, although somewhat faded, is as yet without Turner's dancing displays of light and shade. With its flat areas of simplified washes, particularly noticeable in the patterns of blue in the sky, it could be compared with the watercolour technique of his master, Francia, and J. S. Cotman.

Another impressive watercolour which may date from before 1822, and is similar in handling to *St. Gilles*, is *Rouen Cathedral from the Quais* (Plate 16). Indeed, there is circumstantial evidence that this highly finished watercolour may have been based on sketches of 1821, as the central tower of Notre Dame collapsed with the disastrous fire of 1822. Bonington has created a sophisticated vertical composition in which all elements are subservient to the dominant spire. The water and boats in the foreground are generalized, and he has concentrated on the tonal play of the rooftops to add emphasis to the main feature of his design. It is a remarkable achievement for a young artist, not yet twenty, and even though it is in the English manner of topographical views, he thought highly enough of it to make a lithograph with some changes for his own publication, *Restes et fragmens* [*sic*] *du Moyen Age* in 1824.

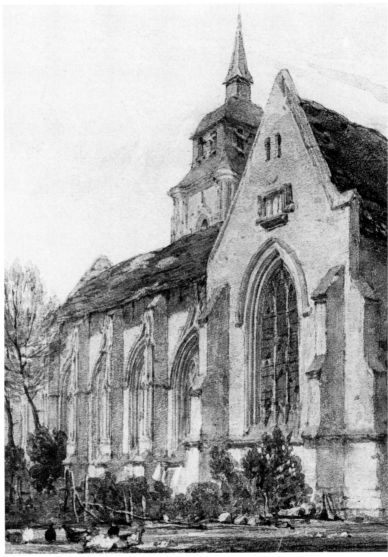

Left: 16 *Rouen Cathedral from the Quais. C.* 1821–2. Watercolour, 15⅘ × 10¾ in. (40.3x27.3 cm.) London, British Museum

Right: 17 *St. Gilles, Abbeville.* 1820–2. Watercolour, 9⅘ × 6⅘ in. (25x17.4 cm.) London, Victoria and Albert Museum

His watercolour of *Dives, Normandy: a Procession around the Church* (Plate 18) may also come from his 1821 tour, although its use of watercolour particularly in the sky is less patterned and more atmospheric than the preceding two examples. Again, the principal building is seen at an angle, but he has now introduced a lively scene of figures in the foreground. James Roberts mentioned Bonington's interest in matters historical and archaeological, and it is true that the architectural details are picked out with great clarity, but English Protestant artists were also interested in costumes and local colour, such as a Catholic procession which seemed to preserve quaint old French traditions.

Two further watercolours may date from about 1822 or afterwards: *Fishing Boats in a Dead Calm* (Plate 6), and *Sailing Vessels in an Estuary* (Plate 3). Both have a certain finickiness of detail and awkward silhouetted figures which contain more than a hint of Francia's style and suggest an early date. They are generalized marine views of the French coast, and are not so much in his topographical, picturesque mode. They are, nevertheless, examples of that prevalent interest in compositions of shipping in estuaries which he had learned from Francia, and which was quite common in England. The subject ultimately stems from a Dutch tradition, and it was a type by which Bonington was ultimately to reach great professional success at the Salon of 1824, and which he was still developing at the end of his life.

It was by his watercolours that he achieved his early recognition and which caused his final break with Baron Gros probably late in 1822. There are varying accounts of Gros seeing Bonington's watercolours in Mme. Hulin's shop and praising them for their colour in front of the class, pretending that he did not know their author, who modestly remained silent. Equally, Gros is supposed to have told Bonington that he was wasting his time and that his abilities lay elsewhere. Probably, in view of Bonington's erratic attendance at the atelier, they both mutually realized that Bonington's talents were best suited to an individual career as a landscapist in watercolour; he had already achieved some recognition as such and could now go on to earn his living.

At the Salon of 1822 engraved views were also exhibited, sent in by the print impresario J. F. Ostervald who farmed out designs by the Comte de Forbin, Cassas, and Cockerell for his publication, *Voyages pittoresques en Sicile*. Bonington had worked up watercolours for the plates, and this was a useful entry to the commercial world. Because of his interest and ability, he was an obvious choice for Baron Taylor's ambitious proposal for his *Voyages pittoresques et romantiques dans l'ancienne France*. This was in progress between 1820 and 1878 and eventually comprised 20 volumes. Baron Isidore Justin Taylor (1789–1879), a naturalized Frenchman, devoted his life to doing for France what had already been done on both sides of the Channel by English artists. His motives were patriotic, and he felt that a proper record of France's monuments would ensure their safety from the damage and neglect they had suffered since the Revolution. English artists and print makers eventually contributed over 200 plates, and notable among them were Bonington and then, later in the 1820s, James Duffield Harding, Samuel Prout, and Thomas Shotter Boys, all of whose work so often comes close to Bonington's. Drawings that Bonington had made in Normandy would already prove useful, but now there was a definite aim for his efforts. It is perhaps from this date that he began his studies of medieval buildings and street scenes where the concentration seems to be on carefully delineated detail. During 1823 and 1824 he was travelling incessantly, although he still maintained a Parisian base in his family's shop and living quarters now at 16 rue des Mauvaises Paroles.

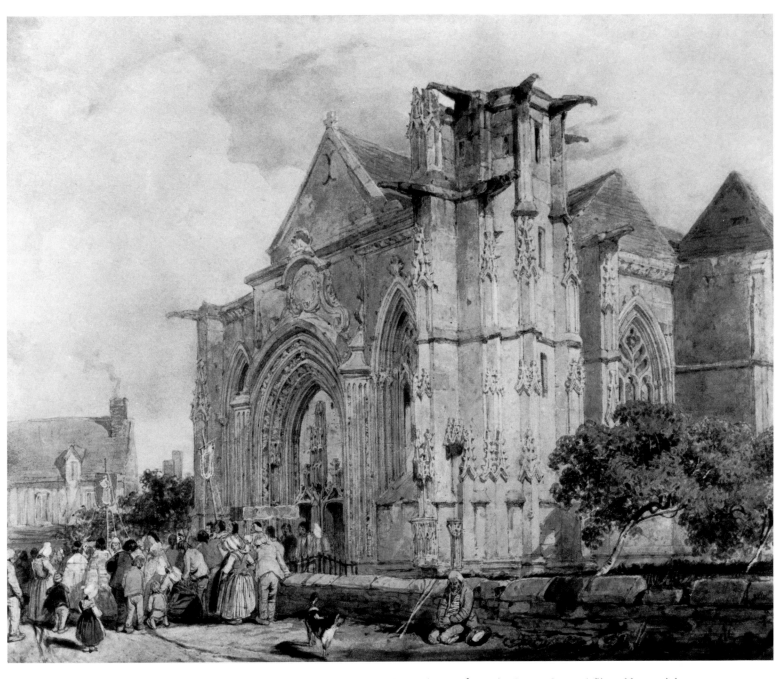

18 *Dives: Normandy; a Procession around the Church. c.* 1822–4. Watercolour, $12\frac{3}{4} \times 15$ in. (32.4×38.1 cm.) Signed lower right: *R P Boning*[*ton*]. Liverpool, Walker Art Gallery

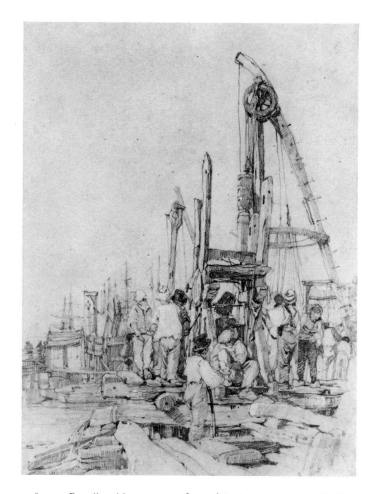

19 *Bridge Builders at Rouen. c.* 1821–3. Pencil on blue paper, 13¾ × 10⅓ in. (35.0x26.3 cm.) Bedford, Cecil Higgins Art Gallery

It is equally possible that he already had ideas for a publication of his own, which was eventually produced as a series of ten lithographs entitled *Restes et fragmens* [sic] *d'architecture du moyen age*, based on drawings from his tour. It would also seem that Ostervald himself had ideas of a spin-off from Baron Taylor's larger undertaking because he, too, was to publish an *Excursion sur les côtes et dans les ports de Normandie* in 1824. During 1823 Bonington seems to have visited Flanders and Belgium which he reached via Rouen and the Pas de Calais, doubtless with all three projects in mind. A pencil drawing on blue paper is of the pile-driving activities connected with the bridge building at Rouen (Plate 19), where slowly during the 1820s a stone-built bridge replaced the pontoon of boats that had precariously existed for so long. Another small drawing, formerly in the J. P. Heseltine Collection, records similar activity at the end of the bridge of boats, but as seen from across the river. The central spire of the cathedral in this small sketch seems reduced in height, so it may date from after 1822. The style of the crowded figures (Plate 19) with the block-like volumes of the workers, probably dates from 1821, and is similar to the drawing of *Honfleur* (half-title page) in the Fogg Art Museum. He then seems to have prepared a watercolour, previously in the collection of Edward Croft Murray, and now in the British Museum. This watercolour in turn, may well be a preliminary sketch for a large finished watercolour in the Fitzwilliam Museum, Cambridge (Plate 20), or another like it, which follows the pencil drawing (Plate 19) almost

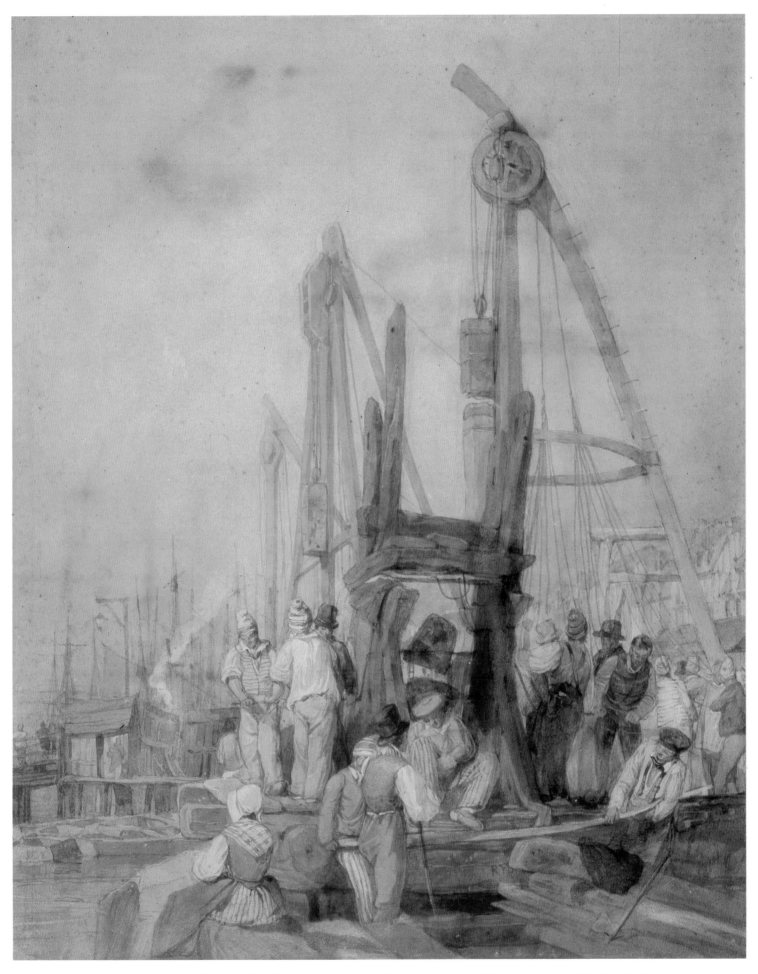

20 *Bridge Builders at Rouen.* *c.*1822. Watercolour, 19⅘ × 15½ in. (50.5x39.4 cm.) Signed on plank: *RPB.* Cambridge, Fitzwilliam Museum

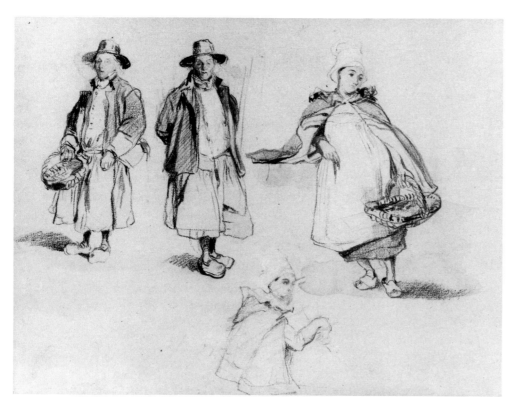

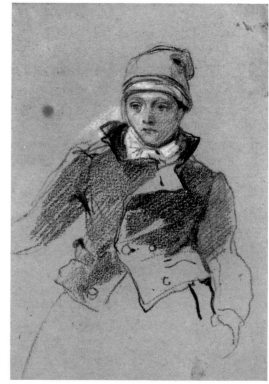

Left: 21 *Normandy Fisherfolk. c.* 1821–3. Black, red and white chalk, $7\frac{3}{4} \times 10\frac{1}{5}$ in. (19.7x25.9 cm.) London, British Museum

Right: 22 *Half-length Figure of a Normandy fisherboy. c.* 1821–2. Red, black, and white chalk, $5\frac{2}{5} \times 3\frac{2}{3}$ in. (13.7x9.3 cm.) Cambridge, Fitzwilliam Museum

exactly, with the sole addition of a seated woman to fill in the void at the left. This is the largest surviving watercolour of Bonington's early period, and in its towering vertical composition can be compared with *Rouen Cathedral from the Quais* (Plate 16). According to an inscription on the *verso*, he was paid the large sum of 200 francs, or as much as he was paid for each of his exhibited works at the Salon of 1822. The fact that he has translated his figures into pounds for a 'Miss C' may suggest it was done later for an English patroness. It is not, however, a conventional choice for a large presentation work. It does not show the impressive cathedral of Rouen which is nearby, it is not a bustling scene of shipping, though rigging and masts are visible, and the picturesque facades of the local buildings along the Quais are hardly discernible. Yet he was obviously very interested in the primitive machinery for driving in the piles, and the crowded scene of colourful workers, an interest we can see in his other early works. In its overall sense of design and accents of colour, it is more than a mere record such as, for example, the Victorian photographs of the assembly of the Crystal Palace.

A further watercolour of Rouen is included here (Plate 10), although it may be dated later. It is obviously based on an early design, as it shows the central tower of the cathedral which fell down in 1822. It is, nevertheless, a highly competent, finished watercolour, with a confident design, and a Turneresque sky. Ingamells has argued that it must date from at least 1825, after Bonington's visit to England, because of its use of gum arabic to give

36

depth to the shadows, a technique which he must have seen there. Certainly, Delacroix was anxious at that time to bring back some of the precious mix. Bonington could very well have been told of such a method by Francia, as the Old Water-Colour Society was worried about its use as early as 1808. The Fieldings, too, might very well have demonstrated its use during 1823 and 1824. The handling and sense of light may well denote a later date, but the crowded composition and details such as the carefully drawn stripes of the bargees' shirts are not dissimilar from the way in which Bonington has painted the workers' clothes in the Cambridge watercolour of *Bridge Builders at Rouen* (Plate 20). Perhaps the Wallace Collection view should be dated c. 1823–5, as an example of Bonington reworking old subjects.

There are individual studies of a fisherboy (Plate 22), and fisherfolk (Plate 21), and children in knitted caps, which show a similar lively interest in the individuality of costumes and figures that he encountered on his journeys. He gathered together drawings of figures for their details of costume and poses that he could use later in finished works, as Watteau, an artist he rather unfashionably admired, had done a century before. His interest in Watteau will be mentioned again later, but Bonington's studies remind us that the Romantic movement, even while championing individuality, continued an eighteenth-century idea that virtuosity was as important as originality. The study of fisherfolk in the British Museum (Plate 21) was to be used in his oil of *Fisherfolk on the Normandy Coast* (Plate 23) and seems to represent the same figures in different poses which occur in a drawing in the Earl of Sandwich's collection.

23 *Fisherfolk on the Normandy Coast. c.* 1824–5. Oil on canvas, 25⅛ × 37¾ in. (64.1 × 95.9 cm.) Private collection

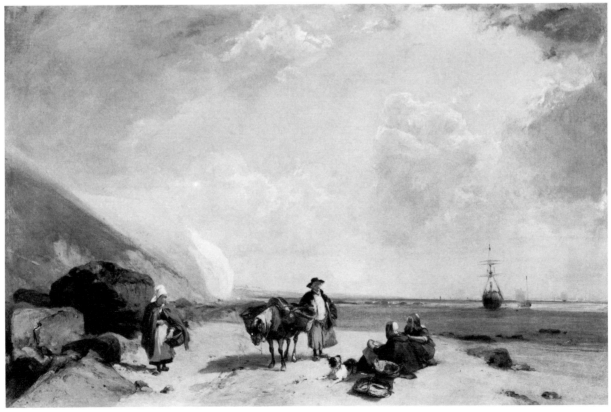

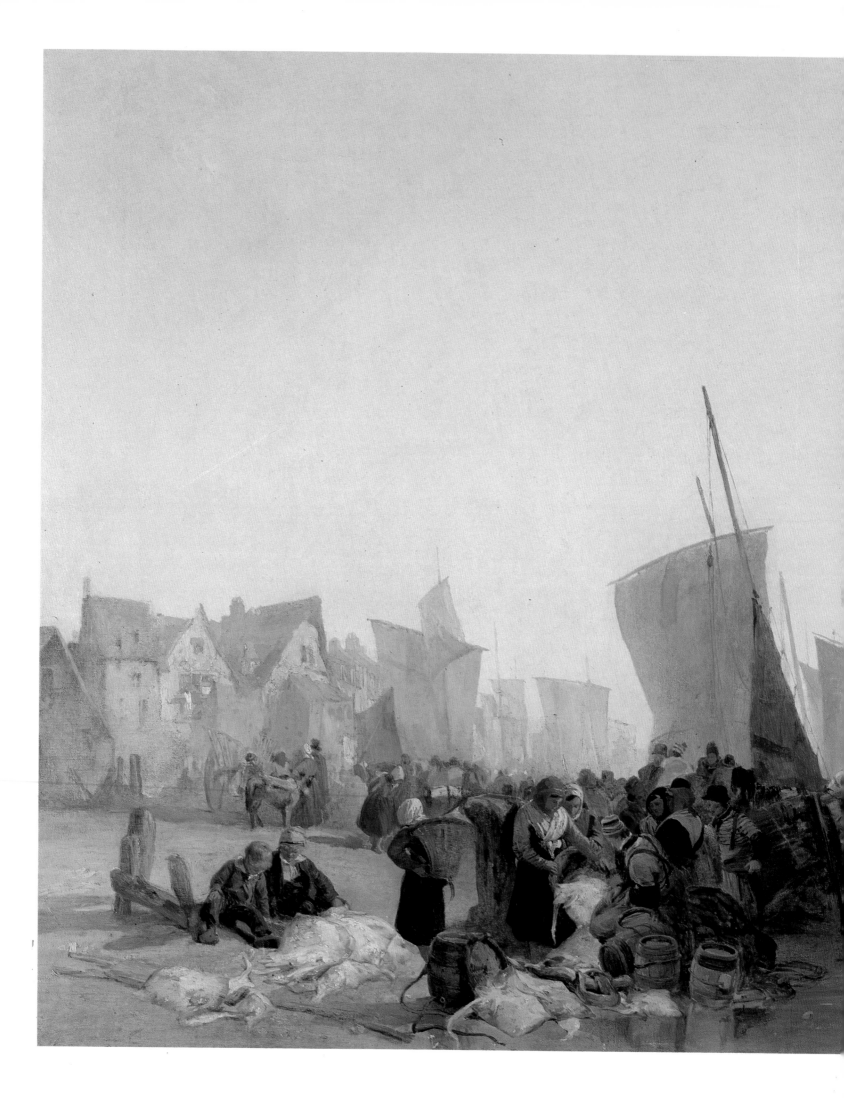

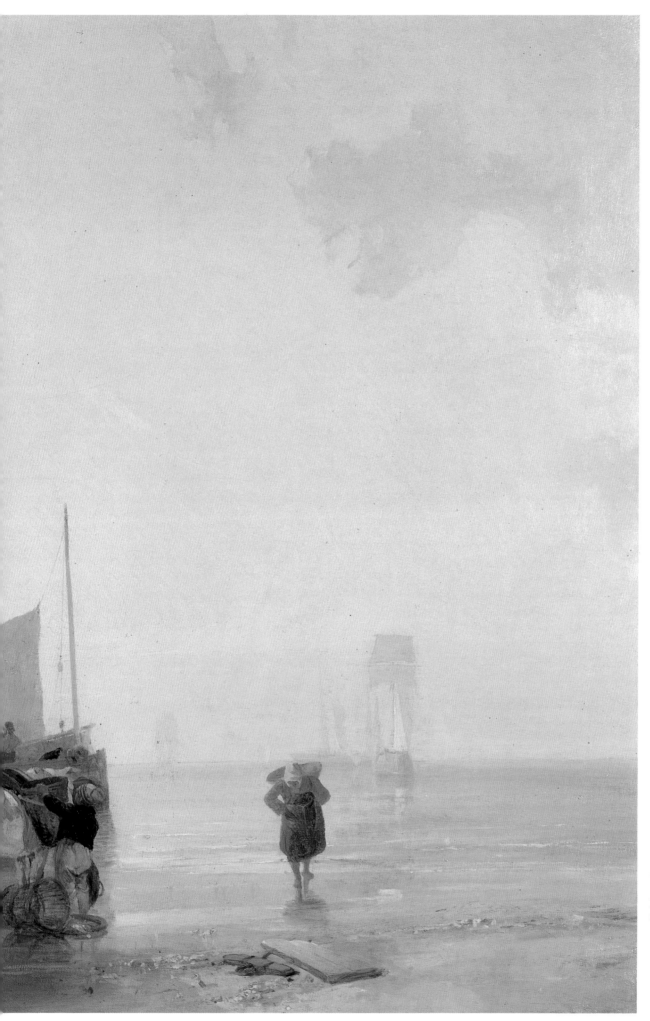

24 *A Fish Market, Boulogne. c.* 1824.
Oil on canvas,
32 × 48 in. (81.3×122.0 cm.)
New Haven, CT., Yale Center
for British Art

25 *Marly from the Terrace of St. Germain en Laye. c.* 1823. Oil on canvas, 11⅔ × 15⅓ in. (28.9x39.0 cm.) Private Collection

Bonington had, by 1823, begun painting in oil as at least one oil sketch seems to be dated in this year, and others can be connected with it. A solitary river scene in an American private collection is, apparently, dated as early as 1821. Who taught him is not known, but he must have realized that in spite of his success with a few connoisseurs he would not be considered in the forefront of artists solely as a watercolourist. His great predecessor, Girtin, had belatedly made experiments in oil, of which only one survives: *Guisborough Priory*. It cannot be considered among his most successful works and merely translates one of his watercolour designs into thin oil washes. Turner, on the other hand, after one or two tentative beginnings in 1797 had quickly become proficient as a painter in oil. Bonington also found his stride almost at once. He must have been aware of the role of oil sketching in the École des Beaux-Arts, but the more formal productions of the students in the historical landscape category had little to do with direct observation, whereas Bonington's first efforts have the seemingly haphazard composition and feeling for atmosphere that was almost an underground movement all over Europe. The private oil sketches of Pierre-Henri Valenciennes (1750–1819), or Georg von Dillis (1759–1841), or J. B. C. Corot (1796–1875) are examples of this widespread tendency. *Plein-air* sketching in oil was not unknown in France, and was certainly encouraged in England by landscape artists (paradoxically often watercolourists) following in the footsteps of John Varley, such as David Cox, Peter De Wint, and John Linnell, while Turner and Constable are famous now for their oil sketches painted out of doors. But these sketches were not meant for public exhibition, and it is not clear if Bonington meant his to be exhibited. *Marly from the Terrace of St. Germain en Laye* (Plate 25) is, apparently,

26 *Normandy Landscape near Lillebonne.* 1823. Oil on canvas, $11\frac{3}{4} \times 18\frac{1}{2}$ in. (29.8x47.0 cm.) Signed lower right: *R P Bonington.* Toledo, Ohio, The Toledo Museum of Art

signed and dated 1823, and has the air of a sketch in front of the landscape. The paint is thin and is applied as if he were laying in watercolour washes. The clouds, however, are painted with a heavier impasto which looks forward to his later methods. It is in a low key and its emphasis on tonal relationships rather than colour is reminiscent of the effects in Corot's sketches done in Italy from 1826 onwards. Corot towards the end of his life spoke of his early admiration for Bonington's watercolours whose 'sincerity was a revelation', and which determined him to become a painter. He could equally well have mentioned Bonington's oil sketches had he known of them at that time.

A recently discovered view of Lillebonne (Plate 26) is another oil which probably dates from 1823. Lillebonne is on the road between Rouen and Le Havre, and Bonington could have painted it on his northern tour into Flanders and Belgium, although it could reproduce his lost watercolour at the Salon of 1822. It is, like *Marly*, a panoramic view across the countryside in which the layers of paint are applied in bands, as if they were watercolour washes. Both have unstructured open compositions, in which Bonington seems to have had some difficulty in successfully articulating the middle ground. Both could have been taken from Girtin's gentle views, for example, *Kirkstall Abbey*, but they are less elegiac and more realistic. The addition of signatures on two of them might denote that they were sold to that particular sort of connoisseur who appreciated the personal spontaneity of small sketches, such as Coutan, or Bonington's friend, Joseph-Auguste Carrier, who are known to have owned similar works.

One further oil can be dated by circumstantial evidence to 1823, the view of the

ruins of the Abbey of St. Bertin at St. Omer (Plate 27). Samuel Prout is said to have told Dominic Colnaghi, the dealer, that he had been with Bonington when he painted it in 1823. Prout had also been commissioned by Ostervald to make drawings for Baron Taylor's *Voyages pittoresques . . .*, and the two artists may have been together gathering material. Bonington would have known of the site from his period with Francia, by whom at least one watercolour of the abbey is known in a French private collection, perhaps one of those Francia produced for Morel, Bonington's early mentor. Prout also drew a pencil study, now in the Victoria and Albert Museum. Bonington's oil is a careful finished work, much closer to Prout's topographical style than Bonington's other oils of the same year. It is carefully drawn with the oil paint applied mainly in thin tonal areas, but the texture of the fabric of the building is in thicker impasto. The vertical composition, with shafts of light and shade falling diagonally through the ruins, could be compared to picturesque watercolours by Girtin and Turner, as if Bonington were translating their watercolours into the oil medium. By concentrating on lofty spaces, the gothic architectural details, and roughness of texture, he has produced a picturesque image of the 1790s in 1823. The only difference is a greater immediacy, helped by a single figure in modern dress, included as a visual accent to comment on the passage of time.

There are more detailed architectural drawings in pencil, of sculpture, old houses, and boats, inscribed 'Ghent' and 'Bruges', which perhaps denote the extent of his tour. His main aim had been to provide material which could be incorporated in the publications

27 *St. Bertin, near St. Omer, Transept of the Abbey. c.* 1823. Oil on canvas, 24 × 19½ in. (61.0x49.5 cm.) Nottingham, Castle Museum and Art Gallery

Left: 28 *Rouen: Part of the Palais de Justice. c.* 1823–4. Pencil, 16 × 11 in. (40.7x27.9 cm.) Calne, Wiltshire, Bowood House

Right: 29 *Beauvais: House in the rue Sainte Veronique. c.* 1821–4. Pencil, 13⅖ × 9¼ in. (34.1 × 23.5 cm.) Calne, Wiltshire, Bowood House

of Ostervald. *Beauvais: House in the Rue Sainte Veronique* (Plate 29) and *Rouen: Part of the Palais de Justice* (Plate 28) are two reproduced here which will stand for many like them, still with the descendents of the Marquess of Lansdowne, for whom they were purchased after Bonington's death. They are similar in size, on the same tinted paper, and with a system of inscribed numbers which seem to denote that they were part of the same series. His academic training, however much he found it tedious, had given him a sureness of touch and stamina for fine detail which is remarkable, given that he had not had the benefit of time in an architectural draughtsman's office, as Turner had done. At exactly this time, 1823, Constable, it will be remembered, was finding the details of Salisbury cathedral difficult to master.

Bonington's drawings have varying accents of thin and thick strokes applied decisively with chalk or pencil, as if they were conceived from the very beginning to be reproduced by lithography. He was, in fact, to use these two in his own publication, *Restes et fragmens* [sic] *d'architecture du moyen age*, for which he himself prepared the lithographic stones before the end of 1823. The ten plates were published in two instalments in June and September 1824, with the images in some cases smaller than the original drawings, which suggests that he must have redrawn them with the greasy lithographic chalk on the prepared porous surface of the stone, rather than tracing them on to transfer paper. Thus by 1823, he had entered into the professional world, with oils, watercolours, and drawings of every sort, and finally, published plates. He was to achieve a remarkable success in 1824.

30 *Near Rouen c.* 1823. Oil on millboard, 11 × 13 in. (28.0x33.0 cm.) Private Collection

SUCCESS AT THE PARIS SALON

In spite of professional commitments in Paris, Bonington spent nearly the whole of 1824 in Dunkirk. It was, as he wrote in December, 'the happiest year of my life'. He stayed with Mme. Perrier, a widow, whose household with her daughters proved to be congenial. He already had connections in that town through M. Morel, and from it he could easily visit Calais, Boulogne, and Belgium. He went there at the beginning of the year with Alexandre Colin, and together in February they wrote a teasing letter to James Roberts in a mixture of French and English about the fun they were having at the Dunkirk carnival, and wishing he were with them. They were like two young men on a 'bummel':

> Dis moi quand vous serez disponible que je puisse m'arranger to meet you
> remember me à tout le monde . . .

Bonington wrote. Colin has left drawings from this trip, and one in the Musée Carnavalet, Paris, shows Bonington asleep on a pile of luggage, possibly on board a boat during an excursion. A portrait of Bonington, also by Colin (Plate 33) probably records Bonington's appearance at about this time. 'We all loved him,' as Delacroix later remarked to Thoré, and James Roberts wrote a memory in 1837:

> Bonington's outward appearance at that time was particularly boyish owing
> perhaps to round plump cheeks and as he had not a large mouth the fleshy
> rotundity of his lips contributed to that effect of boyhood and alluded to,
> yet a nice observer would observe in his eye unequivocal marks of intelligence
> . . .

Another observer wrote in the *Révue Britannique*, rather more romantically, after his death:

> a mingling of firmness, and tenderness, contemplativeness and melancholy,
> was visible in his expressive countenance.

For all the cheerfulness of his time with Colin, he nevertheless did not neglect his work, and asked Roberts in the February letter about the progress of his lithographic plates for *Restes et fragmens* . . . , and also about the new date for the postponement of the Salon which was to open later than usual that year, and to which he was to send an unprecedented number of works.

By April, Colin had returned to Paris and his young wife, and Bonington wrote to him in French. Few of his letters survive, and this to Colin has at least been preserved in

31 *Near Boulogne. c.* 1823–4. Oil on canvas, 12⅔ × 17⅓ in. (31.5x43.9 cm.) London, Tate Gallery

Opposite: 32 *In the Forest of Fontainebleau. c.* 1824. Oil on board, 12¾ × 9½ in. (32.4x24.1 cm.) New Haven, CT., Yale Center for British Art

transcript. It deserves to be quoted in full for the glimpse it gives of Bonington's personal character, and his working habits at the age of 21:

Dunkirk, 5 April 1824

Dear Friend,

I was very glad to receive your letter, and hope it will not be the last. It gave me very great pleasure except for the annoyance you mention, and that I hope will have been cleared up before you receive this. Since your departure young M. Morel has taken me to a concert – an amateur concert; so so; not so bad. Sometimes I go down of an evening to talk to my kind hostess, sometimes I read papers right through to the imprint; sometimes I do this, sometimes that. Ah, and sometimes I work. And one way and another I do nothing great. The ladies down below are beginning to discover my weak side. They have told me that I shall not have the pluck to finish my letter this evening, and that is exactly why I am going to finish it. But all the same, I shall give it to you abridged . . . And I believe I have said nearly everything. I had a good many things to tell you, but I am yawning already.

33 Alexandre-Marie Colin (1798–1875). *Portrait of Bonington. c.* 1823–4. Pencil, 8⅓ × 6⅔ in. (21.2x16.9 cm.) Oxford, Ashmolean Museum

Let me see. A splendid storm since you left. I saw it from the end of the
enclosure. I heard everything. My friend, it was superb! I was simply soaked.
The young man in the pilot office is very amiable, and sends you kind
messages. He gives me good advice and knows his business just as though
he *pinxit*. I don't forget the bottle of champagne. I hope you had a good
dinner at M. Du Somerard's. I should have. I am expecting to be
complimented on the condition in which I packed you off to Paris – fat,
plump and with a good appetite; thoroughly fit, in fact. I am sure it was
noticed at M. Somerard's dinner – 'Just look how he eats!' 'Yes. He takes
a meal as big as himself.'
The butcher is quite well, the pleasant old dog! I saw him at work yesterday.
On my word of honour, he was red up to his face. And there was a regiment
of red sheep upside down.
Many thanks for the trouble you have taken over my drawings, etc. I must
not forget the fisherman's costumes. Give my regards to Mme. Colin (please
don't forget) and to the rest of the family!

He also included in the letter drawings of fishing boats, and some musical notes, which
may refer to a ditty they sang together, perhaps with Mme. Perrier's daughters. He does
not give the impression of working hard in this chatty letter. The young Bonington remains
elusive, but his life cannot have been entirely taken up with pleasurable jaunts to the fashion-
able Boulogne-sur-Mer along the coast, or idle sketching from a boat. His conversation with
the man in the pilot office shows he took his task of marine painting seriously, and he was
to be praised for the accuracy of his detail. Not only beach scenes, and harbour views, but
also compositions made inland along the rivers must have been begun or planned in water-
colour or oil, as so many finished works of high quality seem to be datable to this year,
as well as the production of finished watercolours for engraving with which he was also
involved.

From the end of 1823 or the beginning of 1824 can be dated an oil *On the Seine,
near Mantes* (Plate 34). Mantes, where Baron Rivet had a property, is not far from Paris,
and the local churches of S. Maclou and Notre Dame can be seen in the distance. The
paint is applied fairly thickly in areas, as with a number of his early oils, but it is a more
carefully contrived, finished composition than his oil sketches in front of the motif which
have already been reproduced. The grouping of the boats is carefully arranged in a central
mass, and the wispy trees come more from art than nature. It is probably based on prints
of Turner's river scenes, as Turner in the original was as yet unknown to him, though as
a name he was 'ceaselessly' talked about. Turner's trees in works of about 1810, as reproduced
in aquatint, have a similar, insubstantial featheriness, which Bonington was to adopt in
a number of river scenes from this time. *River Scene in Picardy* (Plate 128) is composed in
the same way with a central focus on the planes of the sails, but with atmospheric edges
where the trees dissolve in light. He was to ring the changes on these gentle river scenes
for the remainder of his career; other versions exist, for example, of *River Scene in Picardy*,
and the popularity of such subjects with collectors can be gauged from the many publications,
by other artists, Turner above all, devoted to the river scenery of Europe. Perhaps Bonington
quickly realized that he could cash in on a bourgeois vogue, but his later versions are remark-
ably indistinct as to topography, and clearly he had an aesthetic intention.

Beach scenes were another speciality which he had begun early, but which he developed in oil in 1824. A number are reproduced here as examples of the small-scale works for which he hoped to find a ready market. His letter to Colin of April 1824 mentions fishermen's costumes that he must have drawn, rather like the studies in Plates 21 and 22, to ensure that his paintings had verisimilitude, but whether his oils were painted on the spot for his seascapes is doubtful. A painting such as *Normandy Coast Scene* has a casual air, particularly in the shorthand for the figures, as does a larger canvas of an inland view, *Near Boulogne* (Plate 31). There is another identical version of this small landscape in a private collection, and this may well also be by Bonington. The existence of different versions in watercolour, or in oil, of pictures datable to *c.*1824 gives an indication of Bonington's increasing success which later copyists were to exploit. The mood of these small seascapes is, however, personal and elusive. They do not carry the heavy emotional weight that others in England and France exploited, expressed for example in Byron's *Childe Harold*:

There is a rapture on a lonely shore . . .
by the deep sea, and music in its roar.

Neither are there the patriotic overtones of the British sea painters, 'associations flattering to our pride,' as William Daniell's text for his *Voyages around Great Britain*, 1814–15 (308 aquatints) was proud to point out.

Bonington's small oils of *c.*1823–4 have either a sense of casualness and atmospheric spaciousness, or they are observed closely, and concentrate on the solidity of things. There

34 *On the Seine, near Mantes. c.* 1823–4. Oil on canvas, 12⅓ × 18 in. (31.3x46 cm.) London, Wallace Collection

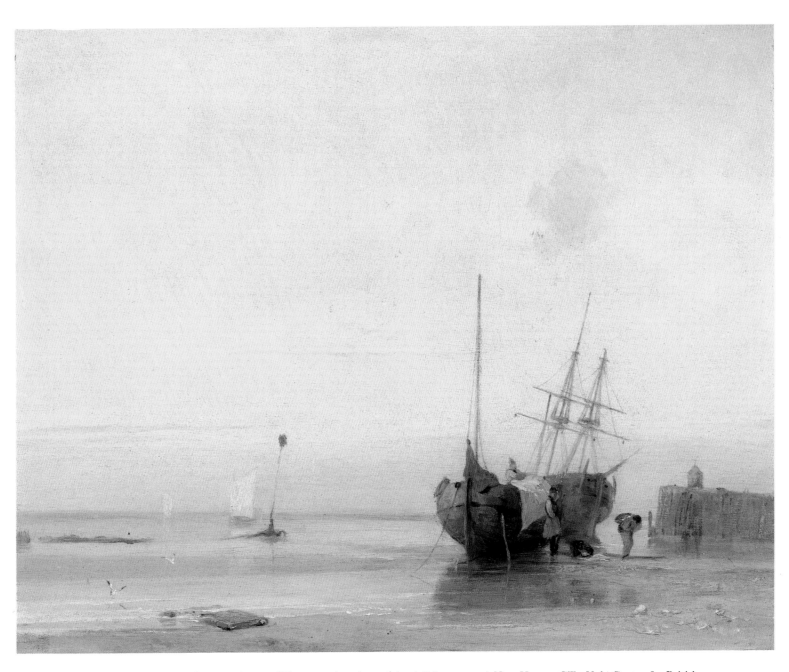

35 *Normandy Beach Scene. c.* 1823–4. Oil on panel, $11\frac{1}{3} \times 13\frac{1}{3}$ in. (28.8x34.0 cm.) New Haven, CT., Yale Center for British
Art

36 *Rouen: Rue de la Grosse Horloge.* 1824. Lithograph, 9½ × 9⅘ in. (24.2x25.1 cm.) London, British Museum

are oils which approach the object closely, for example: *In the Forest of Fontainebleau* (Plate 32). It has the thick impasto of his early oils, but with this the concentration is on the mass of the rocks, with the foliage left insubstantial. Bonington was never entirely a realist in his depiction of nature, but as with many of his young contemporaries, an exact depiction of the things they saw was a very necessary part of their art, often realized with a gritty sense of the texture of paint to match the directness of their gaze. Rubens and Rembrandt provided historical examples, while Turner, and particularly Constable, found such sketching an essential part of their homework. What the academic critics did not like was the tendency to bring this rough work out into the open for public exhibition.

The opening of the Salon of 1824 was delayed until 25 August, and Bonington made a serious attempt to be well represented by all aspects of his career to date. He exhibited four oils: *A Study in Flanders* and three seascapes, one of which was described as *Marine des pêcheurs débarquent leurs poissons*, and another, *A Sandy Beach*, lent by one of Bonington's early patrons and the host for Colin's dinner, M. du Sommerard. In addition, there was a watercolour of Abbeville, and, apparently, other watercolours were added which he had done for Ostervald. There was also an example of perhaps the finest of his designs for Baron Taylor's lithographs, *Rouen: Rue de la Grosse Horloge* (Plate 36). The exhibition is now remembered as the famous triumph of Romanticism, where the English, principally Lawrence and Constable, but also watercolourists, including Thales and Copley Fielding, J. D. Harding, Prout, John Varley, and other more minor artists with French connections, were criticized

37 *Gisors: Vue Générale de l'Église de St. Gervais et St. Protais.* 1824. Lithograph, 8½ × 10½ in. (21.6x26.7 cm.) Printed by
G. Engelmann. London, British Museum

by academic French critics for ruining French art. Equally to some French, notably
Delacroix, the triumph of modernism was begun.

Bonington's lithograph was the culmination of over a year's work for Baron Taylor's
second volume of the *Voyages pittoresques et romantiques*. This particular print and *Gisors: Vue
Générale de l'Église de St. Gervais et St. Protais* (Plate 37) were two of the five views that were
published in the Normandy volume. He was to contribute further in 1825 to the Franche
Comté volume but these images were based on other artists' designs. What detailed drawings
Bonington must have produced for his most prestigious project so far we do not know. They
must have been more carefully finished than the architectural details that he used for his
own *Restes et fragmens* (Plates 28, 29). How exactly he supervised Engelmann's lithographs
through to their final printing is equally uncertain. He must have travelled back from
Dunkirk during the first half of 1824. With these prints Bonington had produced his most
ambitious townscapes to date, which mark the culmination of his eye for topographical detail,
and his ability to render swirling crowd scenes. Some of the individual figures and carts
occur in other works, so he must have had separate studies by him, but on the whole, apart
from occasional uncertainties of perspective, against which Ruskin was to fulminate, they
are the equal in power of organization of any similar town views executed at that time
– Cotman's Normandy views, for example.

Contemporary accounts of the Salon suggest that there were also exhibited a number
of watercolours connected with Ostervald's *Excursion sur les côtes . . . de Normandie. Fécamp*

38 *Fécamp*. 1824 Aquatint, 8¼ × 11⅓ in. (21.0x28.9 cm.) London, British Museum

(Plate 38) is an example of one of those which was engraved in aquatint by Newton Fielding (1797–1856). The English engravers were well known for their ability to reproduce water-colours into the more complicated and subtle medium of aquatint, and members of the Fielding family of artists and engravers were already established in Paris by 1824. Thales (1793–1827), Newton (1799–1856), and Theodore Fielding (1781–1851) had already been employed by Ostervald during 1821–2, and during 1823 and 1824 Delacroix's *Journals* often speak of meeting with 'Fielding', and it is not always clear which one. Both Thales and Newton drew and painted in watercolour, but Newton seems to have been employed mostly, as an engraver for Bonington's watercolours, for example. He may have accompanied Bonington in the Pays de Caux in Normandy during the summer of 1824, as a Newton drawing in a sketchbook now in the Victoria and Albert Museum, London, is connected with Bonington's later watercolour of the same scene (Plate 125). Thales visited Switzerland during the summer and then returned to England to the highly organized family workshop in Newman Street, London, while Delacroix took over his studio in the rue Jacob, so a close connection between these topographical artists and print makers, and Bonington and Delacroix, is further confirmed. It is not surprising that Anthony Van Dyck Copley Fielding (1787–1855), already successful as President of the Old Water-Colour Society, would exhibit at the Salon of 1824. His nine exhibits, probably all watercolours, were praised for their poetry and truth by Paul Huet, and won Copley a gold medal. There is no doubt that Bonington was helped by their example and presence in Paris, but his own art had already taken an individual turn.

Bonington's and Constable's works, however, were to cause the most stir, a remark-able achievement for someone not yet twenty-two. Constable, it will be remembered, was forty-eight. Both were also to receive gold medals, and both were to be complimented for their truth to nature by those critics who were inclined to support the new. Both, on the other hand, were criticized for their baleful effect on young French artists, for their lack

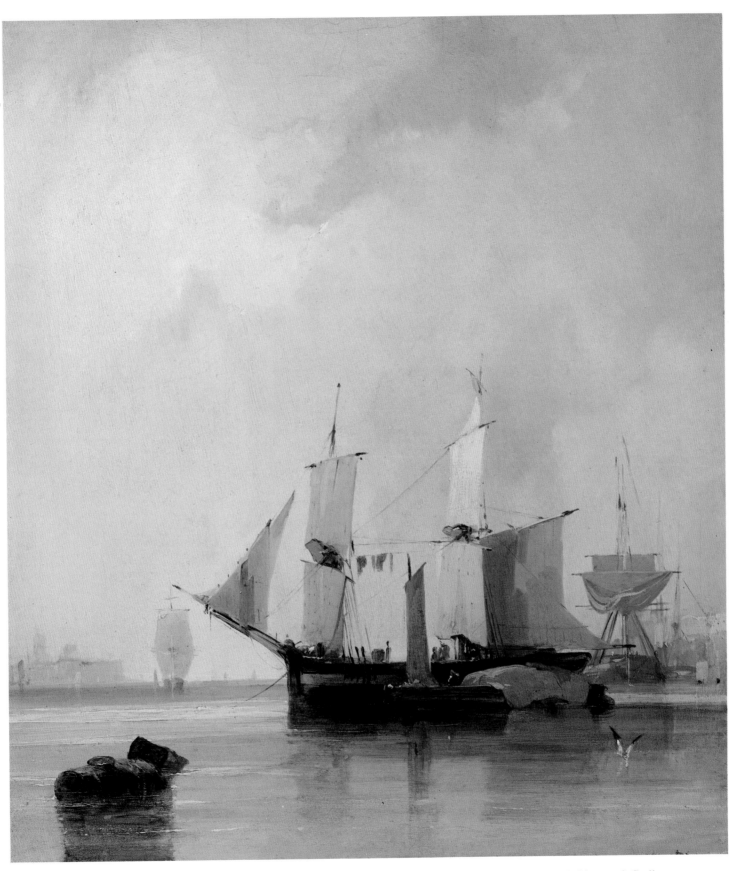

39 *Ships at Anchor (Sea Piece, Ships in a Calm). c.* 1824–6. Oil on board, $13\frac{3}{4} \times 11\frac{3}{4}$ in. (34.9x29.8 cm.) Liverpool, Sudley
Art Gallery

of classical ideals, and the sketchiness of their execution. Auguste Jal described the growing reputation of Bonington in 1824:

> M. Bonington also takes his place among the marine painters. He is an Englishman transported to Paris, where he has generated a mania. For some time, the amateurs have sworn by him; he has produced followers and imitators. His paintings are, from a distance of several feet, the accent of Nature, but they are, in truth, only sketches. I prefer M. Isabey's pictures. M. Bonington's figures are indicated with spirit, but they are too slack!

Étienne Delécluze, the conservative critic of the *Journal des Débats*, was much more severe about Bonington's interest in everyday subjects, which offended his ideal of what art should be. Indeed, he raised the classic French objection that Constable, Copley Fielding, and Bonington were 'Shakespearian', rather than 'Homeric'. Realistic, even ugly content, lack of finish, like colloquial speech, and the resultant loose handling were marks of a lower art, according to Delécluze. English artists had been aware of similar criticism from academic quarters for twenty years.

> M. Bonnington [sic] has made a large number of watercolours which are distinguished from work in this genre by their size and the vigour with which they are executed; but in order to judge the talent of this painter, one must study a marine in which are seen fishermen unloading their fish. The exactness and finesse with which are rendered the wan effects of the sky and sea on the Channel coast are genuinely worthy of praise, but I avow that a sad sky, a surging sea, and salty fishermen arguing in the middle of a pile of fish have little attraction for me. The truth of the imitation enhances for me the aversion, and by an involuntary movement I step aside where I am able to see the radiant landscape of Greece and Italy or of certain sections of France. No, I will never accept that in order to please it suffices to be true; I would even say that I would prefer to see a bad failure of the beautiful Bay of Naples than a pile of pike executed by the most able master.

His intransigence when confronted by the new can be compared to Ruskin's outburst against Whistler, that a coxcomb had flung a pot of paint in the public's face.

Thiers and Stendhal on the other hand praised the English contingent, including Bonington, for their truth to nature which overrode all other considerations. One of Bonington's seascapes was acquired by the Société des Amis des Arts which, as it were, spoke for the acceptance of the new landscape style, and Bonington's outstanding position within it.

Patrick Noon has plausibly suggested that the largest of Bonington's exhibits, and the one that caused Delécluze's unhappiness, allowing for a conflation of two different works, was in fact *A Fish Market, Boulogne* (Plate 24). It is, after all, his largest surviving sea piece with fishermen unloading a catch, and on a number of later occasions when his work was being generally praised, his beaches, 'humid and brilliant with the rising sun,' are singled out in a way that most aptly describes this picture. It may even have been the painting that Baron Rivet unsuccessfully offered to the Louvre. Certainly, it has a distinguished provenance after the 1830s when it was owned by James Carpenter, who admired Bonington's works, and published prints after them. It then passed to Munro of Novar, the great collector of British art. *The Times* in 1878 thought it should be in a national collection. It is now an outstanding presence in Paul Mellon's collection of British art at Yale.

The reasons for the special position of this masterpiece are not hard to see. Its overall effect of light which boldly envelops everything else, and which is made clearer by recent cleaning, is overwhelming: yellowish but with a cool hint of dawn, now that the old varnish has been removed. Its composition follows on from his earlier works, with a mass of boats and figures in the centre and dual atmospheric and linear perspective at the edges. It is not absolutely certain that it represents Boulogne, but similar buildings to those at the left exist in other representations of the port. The figures are an amalgam of all his studies on the coast with figures wearing striped knitted caps juxtaposed with the women and their white shawls. The isolated woman, silhouetted frontally at the right stooped under her pannier, occurs again at the left but seen from a back view. The two seated boys at the left come straight out of sketches, now lost, but we have seen their like with woollen caps before (Plate 22). The horse seen from the rear is to occur again in Bonington's seascapes.

In Baron Gros' studio, Bonington would have learned something of the requirements of figure composition, but none in his lively but compacted composition strikes an heroic pose. His figures have the air of having been carefully observed from the life, and put together in the studio, as Turner's figures in, say, the *Dort* have been. Bonington has not only created a dense mass of tumbling life, but has offset this with the subtle, tonal interplay of the flat shapes of the sails. Against these complex forms, nearer the eye, as Constable so often did, there are the thickly painted scumble of the sand, and the rosy hues and details of the skate and flat fish, which Delécluze so loathed.

Noon has pointed out Bonington's artistic antecedents in the British school, Turner and Crome for example, but particularly the watercolourists, such as Joshua Cristall. The transparency of *A Fish Market, Boulogne*, with the general haziness of the sea, sky, and the buildings at the left, owe much to a watercolour technique. To the French, however, Dutch paintings of the beach were better known for their interest in everyday scenes of fisherfolk, transformed by light. The academic critics would have seen such a reference as a disadvantage, but not the younger artists. Cuyp would have come to mind on both sides of the Channel for his golden glowing effects of light, and only when Bonington's essay in this vein is actually placed side by side with Turner's deliberate confrontation with Cuyp, his *Dort or Dordrecht, the Rotterdam packet boat becalmed* of 1818, is Bonington put slightly at a disadvantage. That he can be compared with Turner and Constable in the same breath, as he was in 1824 when he won a gold medal at the age of 21, is a measure of his achievement.

His success at the Salon may have given him the confidence to proceed with works during the remainder of 1824 and 1825 which show a steady advance in variety and sophistication. There is an impressive group of sea pieces, river scenes, and landscapes in watercolour and oil which can be assigned to this period. Many must have been done in the studio, and because of the paucity of actual dates they are difficult to place exactly. He continued seascapes until his death, often reworking older designs in different media, and their ordering can only remain somewhat subjective. Whereas the critics had praised his modernity for its truth to nature, this was only a relative phrase. As with other romantic artists, he was also creating what might be described as a conceptual series, where his brightness of colour and freedom of handling are naturalistic rather than the result of painting directly in front of nature. He was used to providing small works for sale within an intimate market, and if he had found his voice it was not yet ready for the greatest of dramatic roles. He did not yet apparently feel, as Constable did, that he was single-mindedly driving in a nail for the moral truth of nature.

40 *Beach Scene. c.* 1823–4. Watercolour, 5⅓ × 7⅕ in. (13.6x18.2 cm.) New Haven, CT., Yale Center for British Art

To this period of 1824—5 may be dated the watercolour *Beach Scene* (Plate 40) and *Normandy Beach Scene* in oil (Plate 35), although the simplicity of figures in the oil may denote an earlier work. This is almost a trial run for the larger *Fish Market, Boulogne* (Plate 24), and is conceived with its thin bands of oil paint as if it were a watercolour. The two works are, in this respect, almost analogous; only the thicker brushstroke for the sails and the texture of foreground details distinguish the oil from the watercolour. The oil may be the earlier of the two, as well, because of its slight awkwardness, whereas the dry strokes of wash and sloping composition of the watercolour are effects Bonington was to create later. Neither, however, is conceived as a bright colouristic object, and they both have that evenness of tone which is noticeable in his works of *c.*1823–4.

The *Sea Piece* in oil (Frontispiece) and a related watercolour (Plate 41) can also be dated to *c.*1824, as a third version in watercolour in Budapest is dated 1824. These are much less static works than the previous two. There is a liveliness in the movement of the waves, to which the sloping elements of sails and masts contribute further variety. These two works continue the tradition of Francia, of whose technique the pen and brown ink in the watercolour may be a memory, but there is a flickering effect of light and shade, achieved by silhouetting the dark sails against the light sky and the white cliffs. Both the oil and the watercolour are high-keyed with a particular use of a bright blue for the patches of sky appearing through the translucent clouds that was to become habitual in his work. By 1843 his effects of bright light and the transparency of the sea were appreciated for themselves when the oil was sold in Paris, but Bonington had doubtless looked at Turner's early marine views in print form, which he owned at some point. Turner was adept at expressing the feeling of being out at sea in a boat recording what he saw, which Bonington has also attempted to realize. Bonington's gaze, however, is wide-eyed, and there is no sense of an impending storm, or any apparent emphasis on the puniness of man against the elements.

41 *Boats in a Choppy Sea off the Normandy Coast. c.* 1824. Watercolour with pen and brown ink, $5\frac{1}{2} \times 8\frac{1}{3}$ in. (13.9x21.3 cm.)
New Haven, CT., Yale Center for British Art

A further watercolour which is similar in style, and may be connected with the previous watercolour and oil is *Shipping off the Coast of France* (Plate 42). It is related to an oil, previously in the collection of Lord Astor of Hever, which may have been that exhibited in 1827. Because of the connection between the Manchester watercolour, where Bonington has used a dry brush and scraping to represent highlights by the white of the paper, the Whitworth watercolour may possibly be later than *c.*1824–5.

An oil, *Ships at Anchor* (Plate 39), can also be connected with the watercolour and hence may be datable *c.*1824–5. The ships are seen from the side, as in the Manchester watercolour but at anchor in the calm of a port, rather than in a choppy sea. This was the sort of view Bonington could see every day in Dunkirk where he stayed again for most of the remainder of 1824. His eye for the reflections in the water and the patterns made by sails is very apparent. He has introduced that particular note of yellow ochre that he was to use so often to offset the white of the sails. The composition as a whole looks back to similar harbour scenes by Willem van de Velde, the Younger (1633–1707), to whom every marine painter of the nineteenth century was indebted and from whom Bonington would also have learned the device of a dark sail silhouetted against the light sky.

Bonington's watercolour of *The Château of the Duchesse de Berry* (Plate 43) has also been dated to 1824, and a similar but not identical view seen from a different angle was painted by Paul Huet in watercolour (Plate 44), possibly at about the same time. Huet's watercolour is much more vigorous than Bonington's and has the air of having been executed on the spot. Huet himself emphasized that the English were not entirely alone in painting

42 *Shipping off the Coast of France. c.* 1824–5. Watercolour, 6½ × 9¾ in. (16.5x24.8 cm.) Signed, on sail: *RPB*. Manchester, Whitworth Art Gallery, University of Manchester

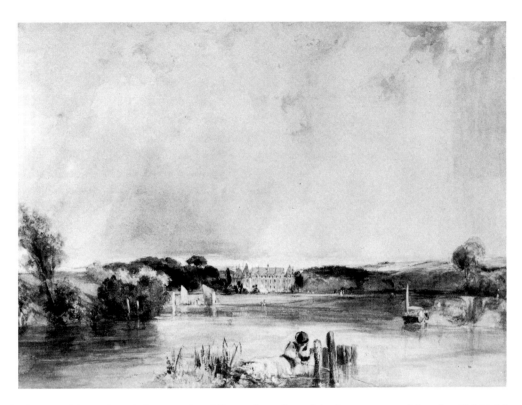

43 *The Château of the Duchesse de Berry. c.* 1825. Watercolour, 8 × 10¾ in. (20.3x27.4 cm.) London, British Museum

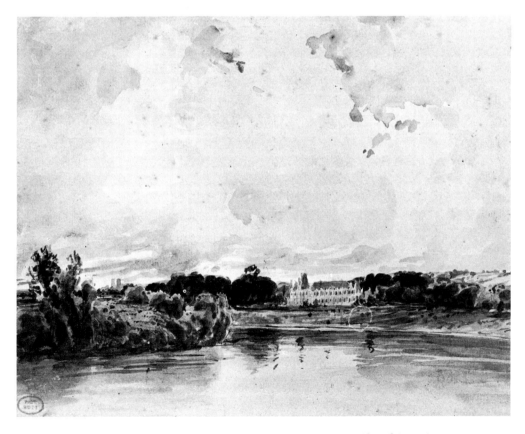

44 Paul Huet (1803–69). *Château of the Duchesse de Berry c.* 1824–6. Watercolour. 6⅓ × 9¾ in. (16.2 × 24.7 cm.) Paris, Musée du Louvre

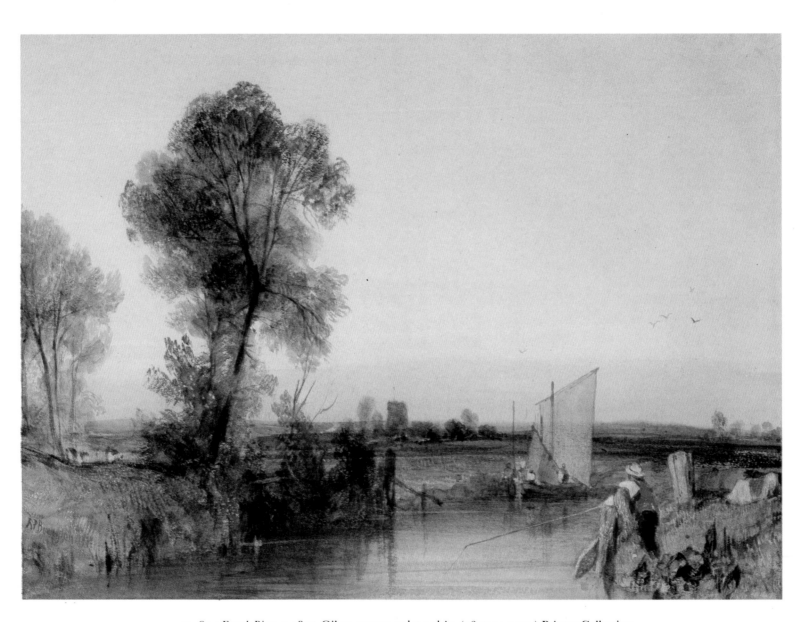

45 *On a French River. c.* 1824. Oil on canvas, $10\frac{1}{4} \times 13\frac{1}{2}$ in. (26.0x34.3 cm.) Private Collection

in watercolour; Delacroix, for example, had received lessons from Soulier. There seems no doubt, however, that Bonington's pre-eminence from 1820 was well known to a whole group of French artists. Huet's use of washes is in a more direct, French style, compared with the subtleties of Bonington's view, which is a consummate, finished study based on his knowledge of a long tradition of English country-house views. It is, however, not merely a 'tame delineation of a given spot', for which practice Fuseli castigated topographical view painters. Bonington has transformed the placid lake scene into a lyrical evocation of a moment made timeless, as he did with his river scenes.

The feathery trees again hark back to Turner, while in both views the white house in the distance with the light coming directly towards the spectator may reflect the fame of Girtin's *White House at Chelsea* in the Tate Gallery, almost a talisman for Turner, and probably seen by Francia. The pictorial device of the stumps, reeds, and boys fishing in the foreground of Bonington's watercolour may nevertheless denote some knowledge of Constable, particularly his *Stratford Mill* of 1820, which Bonington could have seen in the summer of 1825. Huet spoke of Constable's 'magnificent lesson' at the Salon of 1824 and the pollarded willow at the left of Huet's watercolour owes as much to Constable as Bonington's trees do to Turner. Perhaps both works were painted well after 1824 when Constable could have been assimilated by them both. Bonington during his lifetime would not have the benefit of knowing prints after Constable, but he had seen his work in Paris and was to see it again in London in 1825. Bonington's style of watercolour with its vibrant clouds and deft dry strokes could equally well fit a date of 1825, rather than 1823 or 1824.

Marcia Pointon has argued that Bonington's work may be an act of homage to that influential and Anglophile patroness of the arts, the Duchesse de Berry (1798–1870), who did so much to spread an awareness of English art and culture throughout France. At her chateau at Rosny, artists were well received, including Huet, and she apparently sponsored the dealer Schroth. She was to be painted by Lawrence in 1825. Bonington had received at the Salons of 1822 and 1824 good reasons to be grateful for the patronage of the Société des Amis des Arts which she had continued to support after the death of her husband. Bonington's watercolour is no less a compliment to her for having been painted between 1824 and 1826. Bonington's view is not dissimilar to the oil version in the collection of Sir Martyn Beckett, which is certainly later.

After the summer of 1824 Bonington returned to Dunkirk and Mme. Perrier, and he there wrote to Colin:

Dunkirk
Monday 1 November 1824

Dear Colin,

It is nothing in my favour that I am answering your letter so soon. I have
not worked for three days, and I feel still less inclined for it today, so there
you are. We have had to wait. I say 'we' because these ladies are at least
half responsible. But they have granted their forgiveness in consideration of
the portrait of the little girl, so now you know how things stand.
I ought to dine today with the M. Morel of Arras, but as I have a rash on
my face it is quite impossible. However, I don't mind. They are writing a
letter of excuse downstairs . . . Here I have the harbour stretching away to
some fine ships on the horizon.

I ought to tell you that I have lunch downstairs now, and likewise that I
dream of being able to return sooner than I had intended; but I haven't two
farthings worth of courage, particularly today.
And you. I bet you are working like an ox. Write as soon as possible and
tell me everything. If my letter is not so long as yours do not blame me . . .
I am going downstairs immediately to spend the evening with the ladies and
Mme. Jacquet. I am requested to tell you lots of things, and to ask you once
more not to forget the portrait. Write me something jolly: make me laugh.
I hope you will see Francia: they tell me he left Calais a few days ago.

He was obviously still in touch with Francia and the 'portrait' referred to may be of one
of the daughters. Bonington occasionally painted portraits, but he had less recourse to it
as a professional activity than Constable.

He had returned to Paris by the beginning of December when he wrote two letters
to Mme. Perrier which give an engaging picture of his life in the 'city of mud and dirtiness'
as he described Paris. The first is dated 3 December:

Mesdames

While I was spending a happy time with you I did not know what was
waiting for me on my return. I found that my father had been in bed for
eighteen days, and I have severely reproached the friends who for fear of
worrying me allowed me to neglect him. Thank heaven he is now
convalescent and I am no longer anxious. I have renewed my acquaintance
with this city of mud and dirtiness, and it seems very distasteful when I recall
the one I have just left, where everything appeared so smiling and so clean,
and harmonized so well with my tastes . . .

He went on to complain of boredom and that he was going to work as a distraction; also
that he has no facility for writing 'as I have for making a bad sketch, and that which you are
pleased to call my 'charming facility' suddenly disappears when it is a question of writing . . .'

. . . I may travel the world over, but I shall never have evenings like those
at Dunkirk, and next spring Colin and I, on our way back from England,
hope with your kind permission to return through your part of the country,
which I always regret leaving . . .

He finished by saying:

. . . As for the fashions, I hope to send them to you. The other day I
ransacked boxes, toilet tables, wardrobes, etc, etc. etc. More than one lady
was willing to assist us in so laudable a project – and we talked of shawls,
hats, trimmings, marabouts, gauzes, muslins, trocaderos – my head swims
with their beautiful names . . .

He wrote again on 24 December in a similar lighthearted manner where once more his
letter is full of the latest fashion news from Paris,

Black! nothing but black! and ostrich feathers – . . . a Rossini overture . . .
a hectic life where there is someone here asking me for drawings; then the
woman who mends for me brings my stockings; then the shoe black; then
the bootmaker . . .

46 *River Scene, Sunset. c.* 1824–5. Oil on canvas, 9⅘ × 12⅘ in. (25.1x32.7 cm.) London, Victoria and Albert Museum

He did, however, say that 'the happiest year of my life was that in which I stayed at your house . . .'His feelings for the nuances of fashion would not have been unusual in the son of a manufacturer of tulle, but his history paintings of 1825 were to reveal a delight in the surface of things, even when he might have been striving for greater profundity. Clearly, in 1824, he hated the dirt of Paris after the freshness of the coast, but the sparkle of his pictures was as much generated in his studio during the winter, as it was created out of doors. He was never quite as idle, nor so superficial as his letters suggest.

A number of sombre river scenes may also be datable to the beginning of 1825 before he went to England, although it is possible that one or two were painted after his return as at least one bears a 'Davy' label, that is, R. Davy of 83 Newman Street, London, the artists' colourman, and supplier of prepared millboard and panels. It is, of course, equally possible that these could have been available in Paris through the Fieldings. *On a French River*, previously in the collection of Lady Mersey (Plate 45) has an evening glow which can also be found in a small picture, *River Scene, Sunset* (Plate 46). This may also have a later London connection, as before it passed into the possession of Sheepshanks, the great collector of British art, it was owned by George Cooke the engraver, who in 1825 was engraving Turner's *Picturesque Views on the Southern Coast of England*. Both of these small oils reveal

Turner's considerable influence in the general effect of evening light, in the details of the trees, and the clouds caught by the rays of the setting sun. We have seen how Turner's influence was apparent even before Bonington left for England, but there is no doubt that his visit later in 1825 was certainly of benefit in enlarging his perception of this 'great reformer', as Delacroix was to call him.

One further influence is also apparent in *On a French River*, and that is of Constable. The impact of *The Haywain* is generally admitted to be all-important, but Constable's other exhibit at the Salon of 1824 was the impressive *View of the Stour* of 1822 (Huntington Art Gallery, San Marino). It, too, has certain elements from which Bonington (and Huet) could learn: the mass of trees at the left, for example, the pollarded willows, and the diagonal of the river running from the horizon down to the bottom left. Principally, Bonington seems to have borrowed the figures fishing, with the light falling on their shirts, and the boat at the left in the shadow of the trees. Bonington was able to see the same motif of a boat moored at the left in the midst of trees in Constable's major exhibit at the Royal Academy in 1825, *The Leaping Horse*.

The *Landscape with Timber Waggon* (Plate 47) has been generally cited as revealing most clearly Bonington's indebtedness to Constable. The prominent feature of the timber waggon has been rightly connected to Constable's waggon in *The Haywain* seen in reverse, with his borrowing running even to the extent of the bright touches of red on the horses' harnesses, and the single touch of red for the figure in the middle distance, a favourite device of Constable's. The reflections in the water and the texture of the stones in the foreground of Bonington's picture are also reminiscent of Constable's handling in his 1824 Salon exhibit. Constable had, after all, been pleased when the Comte de Forbin hung his picture lower, so that his details could be seen close at hand, as well as the general effect from far away. Bonington's picture may, however, be a later reworking of one, or possibly two, other oils which extend the composition at the left. In the version now in the National Gallery of Canada, at Ottawa, the waggon is much more centrally placed, and is thus close to *The Haywain*, allowing vistas to be seen across to the left and to the right, as essential aspects of Constable's picture. The way of painting the dense clump of trees in the centre of the Ottawa picture can, however, be linked only very loosely to Constable's example, as this technique is one that Bonington had actually used before.

The trees in *Landscape with Timber Waggon* equally have none of Constable's careful devotion to their study. They are wispy and ethereal, and seem to show that Bonington was as much aware of Gainsborough's poetic landscape, some of which, incidentally, Francia had etched in 1810 for a publication which was to be re-issued in 1823. Above all, Bonington's use of light in this painting is its most distinguishing factor. It pervades the whole scene, and makes even his figures seem transparent. The light from the left, for example, is picked out on the woman's sleeve, and both figures are full of individual touches, very unlike the bulky solidity of the figures in his earlier works. Their handling and the use of light are much closer to his *French Coast with Fisherfolk* (Plate 77). Bonington was to send this painting for exhibition to the British Institution in London at the very beginning of 1826, so presumably he had worked on it in the latter half of 1825. This may turn out to be a better date for the *Landscape with Timber Waggon*. So far, however, his knowledge of British art had all been received at second hand, with the exception of those few works, notably by Constable and Fielding, which he had seen in Paris. His art was to undergo further changes as a result of his all-important trip to London. The learning would continue.

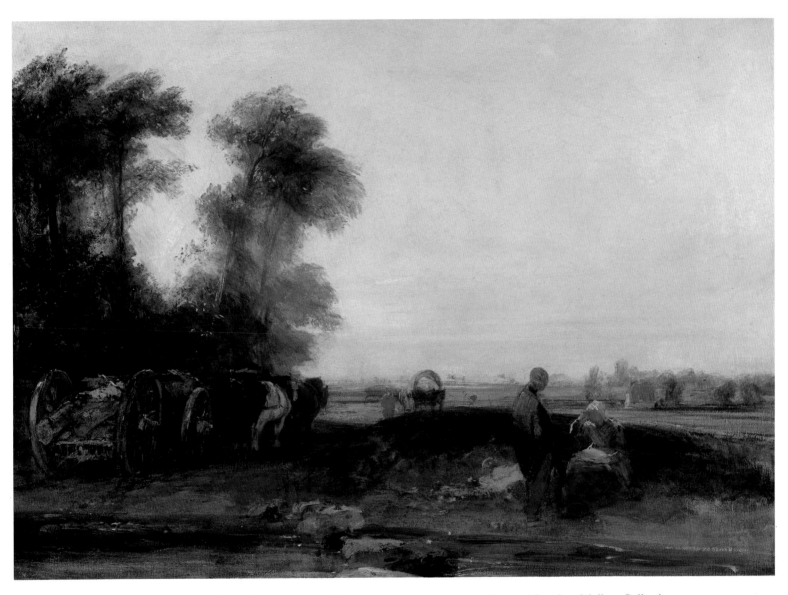

47 *Landscape with Timber Waggon. c.* 1825. Oil on canvas, 20 × 27 in. (50.5x68.7 cm.) London, Wallace Collection

48 *Meditation. c.* 1826. Watercolour and body colour with gum varnish, $8\frac{1}{4} \times 6\frac{2}{5}$ in. (21×16.2 cm.) Signed and dated, lower left: *R P Bonington* 1826. London, Wallace Collection

LONDON AND DELACROIX

Bonington had suggested in his letter to Mme. Perrier that he and Colin planned to visit London in the spring of 1825. In the event, they did not arrive until mid-May. They bore with them a letter of introduction from Francia to J. T. Smith, Keeper of Prints at the British Museum, in which they were described as, 'two dear friends, artists of enormous talent, pupils of Gros and Girodet . . .'. John Thomas Smith (1766–1833) is now best remembered for his engaging volumes of reminiscences about the London art world, *Nollekens and his Times* (1828) and *A Book for a Rainy Day* (1845), but no better guide to the artistic whirl of London could be imagined. Smith had given early encouragement to Constable, but he was fully cognisant of the practical world of prints, as well as being keeper of the fine collections in the British Museum, including Rembrandt, which he could show the two young artists. Francia requested leave for them to copy the Elgin marbles, but also asked Smith to take them to see Karl Aders' celebrated collection of German and Flemish primitives, which would have been much more to their fashionable tastes than copying Greek sculpture. Smith knew Stothard and Flaxman, who were both admirers of Aders' collection.

Meanwhile Delacroix had arrived in London on about 20 May, and was staying in lodgings which Thales Fielding had found for him in Charles Street, not far from the Fieldings' house in Newman Street. He had French artist friends (Enfantin, Isabey, and Poterlet) who had also arrived, but he was later to remember how much he enjoyed being with Bonington in London. He too had a letter of introduction, to Constable, and there is every reason to think that he did in fact visit Constable's studio.

In the summer of 1825 contemporary British art was more available than it had ever been. Apart from the private houses to which it was possible to gain admittance, the Royal Academy, already open in May, would have been of prime interest. Constable's principal exhibit was *The Leaping Horse* (Royal Academy), the picture that he thought best expressed his feeling for the freshness of landscape: 'lively and soothing . . . calm and exhilarating . . . fresh and blowing'. It was his most expressionistic work so far, but Bonington was perhaps temperamentally unsuited to assimilate at once such a violent display of Constable's roughest texture. Turner was represented by his large view of *Dieppe* (Frick Collection), a view that Bonington would have been particularly interested to see, but it was large, and 'too southern for truth', and full of 'fairy hues', as contemporary critics complained. Etty, whose studio Delacroix also visited, exhibited his large *The Combat : Woman Pleading for the Vanquished* (Edinburgh, National Gallery of Scotland), but this was perhaps more to Delacroix's taste for large, violent figure compositions than to Bonington's. Lawrence, whose famous *Master*

Lambton was much praised, would also have been of interest, as would Richard Westall's portrait of Byron, if only for the fact of its sitter.

There was, however, a unique opportunity to see a large collection of British art which had been gathered together in Pall Mall by the Directors of the British Institution, as a change from their normal summer loan exhibitions of Old Masters. This was also open in May, and for French artists would have been a revelation as there was virtually no opportunity to see British art in France. Among contemporary artists, Constable managed to send his *Stratford Mill* of 1820 (National Gallery, London), and *The White Horse* (Frick Collection). The anglers in *Stratford Mill*, Constable's most exquisite picture, were surely the artistic antecedents behind Bonington's similar figures. Bonington had thus received the opportunity by 1825 to see four of Constable's most recent, major six-foot canvases, as well as the small works which Schroth and Arrowsmith had for sale in Paris. Delacroix could have seen not only these but also those that remained unsold in Constable's studio. It is doubtful if Bonington went there.

There was a further exhibition of contemporary British art at the newly begun Society of British Artists in Suffolk Street, where Haydon and Martin exhibited, but Delacroix and Bonington already had contacts with the Fieldings, and the Cooke family of engravers, who could provide a further entrée to the current scene. W. B. Cooke had Turner watercolours at hand which he was engraving for *The Rivers of England* series, and it is not impossible that they visited Turner's own gallery in Queen Anne Street. These connections were to provide Bonington with future work, through W. J. Cooke. Francia also introduced Bonington and Colin to John Renton (1799–1840), later a history painter of subjects from the reign of Charles I, and an illustrator of Sir Walter Scott, both of interest to the young Anglo-French visitors. Henri Monnier reported on 24 June that they were all still in London, so that it is inconceivable that they did not compare notes about what could be seen.

The newly founded National Gallery had opened in 1824 at 100 Pall Mall in Angerstein's old house, which was but a step away from the British Institution. It was open daily. Apart from the major masterpieces by Claude, the Carracci, and Titian, there was Sebastiano del Piombo's overwhelming *The Raising of Lazarus*, which with good reason at that time was numbered first and valued highest in the National Gallery's inventory. There were other works, perhaps, which would have been more to Bonington's taste: for example, Hogarth's *Marriage à la Mode*, Wilkie's *The Village Festival*, 1811 (Tate Gallery), and the Van Dycks. In 1825, the small Correggio of *The Madonna with the Basket* had just been acquired, receiving considerable publicity. Small cabinet pictures by Correggio would have been of interest to Bonington. The Keeper of the National Gallery was William Seguier, who by all accounts had a finger in every artistic activity, and was a friend of J. T. Smith. Equally interesting to Bonington and his friends would have been an exhibition in Reynolds' old house in Leicester Square, of *Portraits of eminent characters and celebrated persons*, from the reign of Henry VII onwards. This must have been fascinating for their antiquarian interests, but there is no evidence that they actually saw it.

Bonington and Delacroix, with Edouard Bertin, did, however, visit the famous collection of armour owned by Dr (later Sir) Samuel Meyrick in Upper Cadogan Place in July. Meyrick had published his famous collection of armour, now mostly in the Wallace Collection, as *A Critical Enquiry into Ancient Armour* in 1824. He had attempted to establish a serious chronology for armour. Meyrick's other aim stated in his preface was to make his researches available for writers, painters, and dramatists to avoid anachronisms. As research into cos-

49 *The Page. c.* 1825–6. Oil on canvas, 18⅓ × 14¾ in. (46.5x37.5 cm.) New Haven, CT., Yale Center for British Art

Left: 50 *Studies after Armour, 1460.* 1825. Pencil, 7¾ × 5¾ in. (19.7×14.6 cm.) London, British Museum

Right: 51 Eugene Delacroix (1798–1863). *Studies of Armour from the Meyrick Collection.* 1825. Pencil, 7½ × 11 in. (19x28 cm.)
London, Wallace Collection (Library)

tume had introduced, as he saw it, 'An historical correctness with which our ancestors were unacquainted' – by which he meant presumably the publications of Joseph Strutt (1797) – so now 'no painter should falsify history by delineating the character on his canvas in habits not known until many years after their death,' as Frederick Fairholt saw the situation in 1860. Bonington was not quite to live up to this Victorian aim, but given his habit of making copies from older pictures, this was a wonderful opportunity to seek his historical facts at first hand.

Delacroix and Bonington worked together, side by side, and some of their drawings have been confused with one another. The *Studies after Armour* (Plate 50) by Bonington, is after a suit of armour in the Meyrick Collection which Delacroix also copied (Louvre). Another drawing by Delacroix (Plate 51) shows how close the two artists were in style. Bonington's drawings, of which many more survive, have his careful love of detail gained from his topographical excursions into Normandy, whereas Delacroix's drawing style is much freer. During the second half of the year both were to put to good use their time of study in London.

Through the kindness of William (rather than Richard) Westall they were also able to continue their quest for medieval objects in Westminser Abbey and Westminster Hall, copying tombs and architecture, notably the hammer-beam roof in the Hall which Delacroix was later to use in a painting. They could also have seen the effigies with their remnants of real costume. Westminster Abbey would have been seen with its tombs of all ages, as an English *ad hoc* version of the Musée des Monuments Français which Alexandre Lenoir

had created in the convent of the Augustinians in Paris. Delacroix mentions an excursion on 26 May up the Thames to Richmond, and it is interesting that Bonington was to base one of his history pictures on a painting in Hampton Court (Plate 55). Delacroix further seems to have visited the Meyrick Collection in Gloucestershire, and perhaps Cornwall and Essex in August, but Bonington was apparently so busy looking at art or copying armour, that there are hardly any certain landscape drawings by him. That methods of watercolour interested Delacroix on the other hand is known from a few watercolour landscapes by him, and his anxious enquiry to a friend in Paris as to whether he had received a packet of gum arabic that he had been given by Thales Fielding and which he wishes to give to 'M. Auguste'.

It is not clear how, or when, they all returned to Paris, nor whether Bonington and Colin visited Mme. Perrier as promised. Delacroix was still in London on 25 August, writing a letter of farewell to Etty, so they may have returned independently, rather than stay in St. Omer as has been suggested. The visit to London and the increasing association with Delacroix obviously meant more to Bonington than his friendship with Colin; the latter would seem to have undergone some cooling towards the end of the year. From September 1825 to January 1826, Bonington was to share Delacroix's studio in the rue d'Assas. In January 1826 Delacroix thought there was 'a good deal to be had from the company of that jolly fellow, and I promise you I'm the better for it', but clearly Delacroix with his energy and talent undoubtedly affected the young artist's development.

Although by 1825 Delacroix had already painted a number of small pictures with historical or English literary references, he was best known for his works dealing with one of the great epics of Western literature, *The Barque of Dante*, 1822 (Louvre), and an actual scene from the Greek war of Independence, *The Massacre at Chios*, 1824 (Louvre). Bonington had so far produced nothing in this vein, only copies after engravings of medieval sculpture and costume, figures from a variety of pictures from the past, and studies of armour in London. With a head full of Sir Walter Scott and old French chivalric tales, he perhaps needed the stimulus of the older French artist to express these romantic musings in paint. Dissatisfied as Bonington was with the heroic certainties of the 'classiques', there was already an alternative tradition of French history painting that he could look to. Even Baron Gros had painted *Francis I welcoming Charles V to St. Denis* in 1812, and during the first quarter of the nineteenth century the number of pictures devoted to scenes from French history had increased tremendously. As a quasi-French artist, Bonington's historical works were also to deal mainly with scenes of French history.

From the Napoleonic period, France's past was used to justify the present. In 1806 Napoleon was painted by Ingres as an imperial icon, with deliberate references to mediaeval images of Charlemagne, but with the exile of Napoleon new images from French history had to be found which would speak of national reconciliation for all classes. For the Comte de Blacas, a noted royalist and friend of the Duc and Duchesse de Berry, Ingres had painted Henri IV playing with his children on the arrival of the Spanish ambassador, a scene that Bonington was also to paint (Plate 52). For the royalist, Henri IV could be seen as a strong king who provided the Bourbon restoration with legitimate heirs; for the liberal, Henri IV could be interpreted as one who reconciled the Catholics and Protestants, just as the new monarchy would legitimize a happy union between the bourgeoisie and the aristocrats. Bonington's subject pictures should give some clue to his political and moral stance, as his style of landscape had already given some idea of which side he was on in the academic hegemony. Freedom of handling and a freedom to choose lowly subjects had already deter-

52 *Henri IV and the Spanish Ambassador.*
c. 1827. Oil on canvas,
15 × 20⅔ in. (38.4x52.4 cm.)
London, Wallace Collection

Left: 53 *Sheet of Studies after J. Strutt. c.* 1822–5. Pencil, 8½ × 5¾ in. (21.5x14.3 cm.) London, British Museum

Right: 54 *Anne Page and Slender. c.* 1825. Oil on canvas, 18 × 14⅘ in. (45.7x37.8 cm.) London, Wallace Collection

mined him to an anti-academic position, and whether he liked it or not, he would be seen to be on the side of the liberals.

He had already subscribed to and made copies from Willemin's *Monuments français inedits pour servir à l'histoire des arts*, published between 1808 and 1839. He had made drawings after Joseph Strutt's *A Complete View of the Dress and Habits of the People of England*, 1796–9, which had been issued in France in 1797 (Plate 53). Roy Strong has pointed out how from an amalgamation of *Ladies of High Rank of the Fourteenth Century* and *Persons of High Rank of the Fifteenth Century*, Bonington was to produce his oil painting of *Anne Page and Slender* (Plate 54) from *The Merry Wives of Windsor*, I, i, line 227. He has illustrated the scene where Page invites Slender to enter her father's home. His conscious medievalizing of the subject, it is tempting to think, was the direct result of his trip to England, although Shakespeare was a favourite with Delacroix too. The figures are deliberately elongated, flattened, and 'gothicized' very differently, say, from C. R. Leslie's anecdotal picture of Slender exhibited in London in 1825. It is a rare example of treating a medieval subject in a deliberately medieval style. In this respect he could be compared to Samuel Palmer and 'the Ancients' around William Blake, whose work he would have seen at the Royal Academy in 1825, and whose small scale would have been of interest. They also knew Aders whom Bonington had visited. Bonington, however, has not been too precise about his century, mixing fourteenth and fifteenth centuries, with shoes from a different plate. Bonington was constantly to mix different elements to achieve an overall effect. The awkwardness of Slender's pose gives emphasis to his shyness, and the two figures are placed against suitable Gothic architecture, doubtless culled from his own *Restes et fragmens* . . . A drawing of the same subject is in the British Museum, and a vignette was in his father's sale.

Another English subject, the watercolour of *The Earl of Surrey and Fair Geraldine* (Plate 55) is included here, although it may date from 1826 after his trip to Italy, because of its Venetian colouring. His subject pictures were often treated in different versions in watercolour and oil, giving some idea of their popularity and the fertility of his invention. These and his landscapes, were to give a particular impetus to 'Le Boningtonisme'. They range from 1825 to the end of his life, but some are grouped together here because of the obvious similarities of conception. The Earl of Surrey is based on a painting at Hampton Court which Bonington could have seen; it was then thought to be by Holbein, and represents Henry Howard, Earl of Surrey. The confident figure of the poet is seen as a sixteenth-century Englishman posed against a Venetian staircase. The obviously Venetian figures at the head of the staircase are in the manner of Veronese. Surrey's 'love Geraldine' also looks decidedly Italian, while in his use of gum arabic varnish in his watercolour Bonington has attempted to reproduce the luminosity in the shadows, for which the English so admired the Venetian painters, and which had infected watercolour painting.

55 *The Earl of Surrey and Fair Geraldine. c.* 1825–6. Pencil, watercolour, body colour, and gum varnish, $5\frac{1}{2} \times 4\frac{3}{4}$ in. (14x11.9 cm.) London, Wallace Collection

By far the majority of Bonington's designs, however, are taken from French history: Francis I, Henri III and IV, Richelieu, Mazarin, and Anne of Austria,; and subjects from literature, Sir Walter Scott, Faust, or Don Quixote, had a particular fascination for the young French intelligentsia. Don Quixote was to become an almost proto-typical Romantic symbol, as six editions of Cervantes were published between 1820–7. For his inventions, Bonington plundered the past for types, poses, expressions, and costumes. Reynolds may have advised his young students to look to examples from his predecessors, but only he could have appreciated the variety of plagiarism on which Bonington embarked. He borrowed principally from the seventeenth-century Dutch and Flemish, Van Dyck, Rubens, van der Venne, Terborch, De Hooch, Frans Hals, Ochterveld, Jan Steen, Rembrandt, and in mood from Vermeer (a very avant-garde choice), and also Bosse's engravings. The Italians were also not safe from his raiding, particularly the Venetians: Titian, Veronese, and Tintoretto. It is a significant roll call of artists in the eclecticism of the Romantic movement, but in Bonington's case he borrowed as much for their elegance and suavity of expression as for deliberate examples of the heroic style. Indeed, the small scale of his works, the intimate psychology of his figures and disregard of grand passions, even the personal brilliance of his touch seem to speak with a deliberate lowering of the voice against the stridency of the academic machine.

A few examples of Bonington's many copies in pencil will have to suffice to show his method. *Anne of Austria* (Plate 56) shows his delicate pencil style for catching a gesture or details of costume. Bonington's copy is actually from two engravings, the full-length figure from Jean Ruget de la Serre, *L'Histoire et les portraits des Imperatrices . . .* Paris, 1648, and the hand holding the cross from Michael Lasne, after C. Champaigne. They were to be used in his late painting of 1828, *Anne of Austria and Mazarin* (Plate 57). In his later work, Bonington has succeeded in suggesting a moment of tension between the Queen and her advisor, who is painted in his loose, later style. Its operatic confrontation finally achieves the emotional intensity of Wilkie's art, but in 1825 and 1826 Bonington's works were not so direct. The psychological relationships of his figures were tender, but ambiguous.

The earliest of his designs for *Henri IV and the Spanish Ambassador* was in watercolour, and in it Bonington was deliberately provoking comparison with Ingres, whose picture of 1817 was exhibited at the Salon of 1824. Bonington has taken the head of Marie de Medicis from Rubens, the ambassador from van der Venne, both in the Louvre, while the costume of the ambassador can be connected with a pencil drawing of *c.*1822. The children may have been based on the Van Dyck of the children of Charles I, or after Abraham Bosse. Bonington has chosen the same incident, which supposedly took place in 1604, as Ingres and Revoil who had embroidered the description in an 1786 history of France by making the intruder the Spanish ambassador. He had entered as Henri IV was giving the Dauphin a piggy-back. Bonington's composition is not essentially different from Ingres' version, except that it reverses the action. Both based the head of the king on a painting by Pourbus, but whereas the Ingres painting is hierarchical, suitable for the royalist Comte de Bracas, with the Queen firmly centred on her throne, and every pose carefully distinguished, Bonington's watercolour is spatially ambiguous, and the details less well defined. It was, however, a popular image of the king as a domesticated father, and was owned successively by two of Bonington's principal collectors: Coutan, who also owned the oil version, and Lewis Brown, the Bordeaux wine shipper.

Left: 56 *Anne of Austria. c.* 1825. Pencil, 7½ × 4¼ in. (19.1x10.8 cm.) Nottingham, Castle Museum and Art Gallery

Right: 57 *Anne of Austria and Mazarin.* 1828. Oil on canvas, 13¾ × 10½ in. (34.9x26.7 cm.) Signed and dated: *R P Bonington* 1828. Paris, Musée du Louvre

Left: 58 *Seated Woman from De Hooch. c.* 1822–5. Pencil, 5 × 3 in. (13.0x7.6 cm.) Nottingham, Castle Museum and Art Gallery

Right: 59 *Sheet of Studies with a Standing and Seated Woman after Terborch. c.* 1822–5. Pencil, 5¼ × 4⅓ in. (13.3x11.1 cm.) Nottingham, Castle Museum and Art Gallery

Bonington returned to the composition again, in a painting which was exhibited at the Salon of 1827 (Plate 52), included here to show his increasing facility with oil, which he gained rapidly within the space of two years through his study of Venetian painting. His interest in costume details is obvious, but also in studio bric-a-brac, such as the ravishing still life of the Chinese pot at the left. His sense of colour in, for example, the vivid pink of the child's dress is much more sure than in the earlier watercolour. His lighting is also much more dramatic in the mysterious half shadows which envelop the ambassador and Marie de Medicis.

Delacroix in 1861 looked back in admiration on Bonington's powers of rapid invention and facility in handling during their time together. Delacroix undoubtedly learned from Bonington too. His own small pictures of Turkish and Indian subjects, scenes from French history and literature – for example *Louis d'Orleans, Charles V and Odette, Jane Shore, Don Quixote,* and *Tasso* – were all produced in the period they were working together, but though vigorous, they lack Bonington's elegance of touch and suavity of manner. The small watercolours and oils which he produced in 1825 and the following spring, are evidence of his fertile imagination. Not all of his designs, however, were based on French history. Many recreate a personal world from his copies and drawings, which show off his virtuosity. In this he could again be compared to Watteau a century before, who had combined permutations of his drawings to create small cabinet pictures where the subjects are vague and personal. A pencil study from De Hooch of *Card Players* in the Louvre (Plate 58) was rapidly jotted down for its animated expression which he might use later, but his powers of conveying

Left: 60 *Knight and his page. c.* 1825–6. Sepia and pencil, $5\frac{3}{4} \times 4\frac{1}{2}$ in. (14.6x11.5 cm.) Melbourne, National Gallery of Victoria

Right: 61 *Le Retour. c.* 1825–6. Pencil and wash, $4\frac{4}{5} \times 3\frac{4}{5}$ in. (12.4 × 9.9 cm.) London, British Museum

convincing, psychological relationships were not yet the rival of Wilkie. Typical are studies after *The Concert* by Terborch (Louvre), (Plate 59), where his figures are static, and chosen for pose, or convincing historical detail. He was to use this sheet for a number of designs, for example, *The Visit* (see further Plate 65) and *Meditation* (Plate 48). They, perhaps, contain the essence of Boningtonism.

Delacroix later thought that Bonington wanted to be a great modern history painter, and working with Delacroix he could not have been unaware of these greater aims, but only in his later finished compositions, still small in scale, was there a development of dramatic power and psychological insight. He was still searching to use his knowledge of the past to produce muted comments, rather than major statements. There are designs connected with an unrealized picture of medieval romance which demonstrate this uncertainty. *A Knight and his Page* (Plate 60) is an accomplished study in chiaroscuro which highlights the armour he had studied in Dr. Meyrick's collection. An oil sketch (Plate 49) takes the initial idea of a haughty knight and subservient page a stage further. With many obvious repaintings, he concentrates on the costume details, the striking 'Venetian' sleeve of the page, and the rich colour of the tapestry background. The knight is, however, plunged into darkness, which suggests that Bonington was moving towards a subject of the beautiful trusting page contrasted with the stern master. But what is it really about? Delacroix complained that Bonington's facility did not allow him to stay with a subject. A further design in pencil and wash, *Le Retour* (Plate 61), develops this initial idea. Now the knight, with his lady and servants, returns from the battle. Another related design was also published by Bonington in 1826 as *Le Retour* in a series of small lithographs entitled *Cahiers de Six Sujets.*

62 *Female figures, gondolas etc., c.* 1826. Pen and sepia ink, 9⅘ × 13½ in. (24.9x34.3 cm.) Edinburgh, National Gallery of Scotland

These six subjects Bonington obviously saw as saleable commodities in the vein of Stothard's vignettes. Their titles, *Le Repos, La Prière, La Conversation, Le Silence Favorable, Les Plaisirs Paternels*, and *Le Retour*, were indicative of the deliberate shying away from the demanding predicament of the history painter. The drawings and paintings which can be connected with this series of prints are based on an intimate reworking of his studies so far. He had copied an engraving after Van Dyck's *Francesca Bridges* in a drawing (Plate 64) which he was to use in reverse for the old woman in his watercolour of *Meditation* (Plate 48), dated 1826. The tapestry from *The Knight and Page* is suggested in elegant shorthand, the girl's dress from Terborch, and the seventeenth-century chair, are all described with great feeling for their actuality. An engraving of the design was published during Bonington's lifetime by S. W. Reynolds as *Meditation*, but when the watercolour was sold in 1832 as *Reading from the Bible*, the woman was described as attentive. By 1837, in Lewis Brown's sales, she was thought to be inattentive. What Bonington was painting here (and an oil version once existed) was the beginnings of art for art's sake. There is no obvious moral in the picture, other than what we care to read into it – an older person's faith contrasted with a younger person's smart indifference. Contrast this with the severe moral lessons which Bonington's Dutch seventeenth-century prototypes were meant to imply. His watercolours were, in a manner of speaking, small romantic songs without words.

The *Child at Prayer* (Plate 63) has been interpreted as an historical scene of Anne of Austria teaching the young Louis XIV. As such it could have had historical ramifications during the Bourbon restoration as an image of the true virtue of the Catholic monarchy, for which the prominent lily would have provided an obvious symbol. In none of the contemporary sales in which the painting appeared, however, is it so described. It appears as *Mother and Child at Prayer*. Given the occasional ignorance of auctioneers, the message must be primarily in the simple relation of a small child praying to his mother. The details, however, of the languid pose, the elegant hands, the still life with its tassel, the crucifix on the wall, and the bold opposition in brilliant oil of the black and crimson of the two principal figures, were what connoisseurs, and painters such as Delacroix, could admire in Bonington's art, rather than the story. It is not at all clear that the elegant mother is even listening. The many attempts to fix the pose, which are obvious on a rare sheet of studies in Edinburgh, may denote that the picture was being worked on after his trip to Venice. There is a prominent gondola and Venetian skyscape at the bottom of the drawing (Plate 62).

63 *Child at Prayer. c.* 1826. Oil on millboard, 4⅕ × 11 in. (35.9x27.9 cm.) London, Wallace Collection

Left: 64 *Francesca Bridges, after Van Dyck. c.* 1825–6. Pencil, 4⅔ × 3¼ in. (11.3x8.3 cm.) Nottingham, Castle Museum and Art Gallery

Right: 65 *The Visit.* 1826. Watercolour, body colour and some gum varnish, 5 × 3⅔ in. (13.0x9.2 cm.) Signed lower right: *RPB 1826.* Paris, Musée du Louvre

With such exquisite inventions Bonington was to create an individual type of subject painting, with only a delicate sense of moral rectitude, unlike his seventeenth-century proto-types or his nineteenth-century followers. The Victorians were to develop the anecdotalism of such scenes into detailed, moral tracts, like Charles W. Cope's *Life Well Spent* of 1862 (Christopher Wood Gallery), where the mother is surrounded by her children, wrapped in their goodness. The Bible is prominently displayed on the table and the message of an industrious Christian family is carefully spelled out.

In works such as *The Visit* (Plate 65), a watercolour dated 1826, and the oil *The Use of Tears* (Plate 68) of *c.*1826–7, there is a decided development in emotional expression. The seated old woman in both is loosely related to the drawing after Van Dyck (Plate 64), but in *The Use of Tears* she has a more active role. With her finger in a prayer book, she is apparently giving comfort to the younger woman. The looming presence of Rembrandt, whose works Bonington could have studied through J. T. Smith, can be cited in the drawings and etchings by Rembrandt of Saskia on her bed of sickness. His powerful drawings are, however, morally neutral, even though we now know he was observing her on her deathbed. Bonington's paintings are more sentimental, with the personal contacts emphasized. They still have a long way to go before the sentiment becomes entirely overt, or the realism so laboriously put together as in Mrs. Alexander Farmer's *An Anxious Hour*, 1865 (Victoria and Albert Museum), or Luke Fildes' *The Doctor*, 1891 (Tate Gallery).

The measure of Bonington's progress in dramatic expression can be seen in his painting of *Don Quixote* (Plate 66). Hugh Honour has demonstrated how this free spirit became a symbol for the Romantic period. For Sainte Beauve: 'Everyone is Don Quixote at some time and everyone Sancho', while for Alfred de Vigny, Don Quixote was 'the elevated spirit who is always scorned and ostracized'. Bonington did not aspire, perhaps, to these spiritual heights, or the complication of Delacroix's design. His *Don Quixote* is a person 'who creates and inhabits a world of enchanted castles'. He has translated the dramatic chiaroscuro of Rembrandt's *Philosopher* and filled his study with all the 'collectibles' of his antiquarian interests. The mood is emphasized by the strong light and shade, and with rapid flicks of his brush the light picks out the crevices of the dusty, crowded interior. To his technique for rendering the surface of things, he has added an increasing ability to describe states of mind, with the Don's rapt study of his old volumes. His success may be noted by the number of versions, and copies, as well as the number of prints after it.

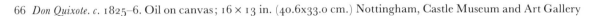

66 *Don Quixote. c.* 1825–6. Oil on canvas; 16 × 13 in. (40.6x33.0 cm.) Nottingham, Castle Museum and Art Gallery

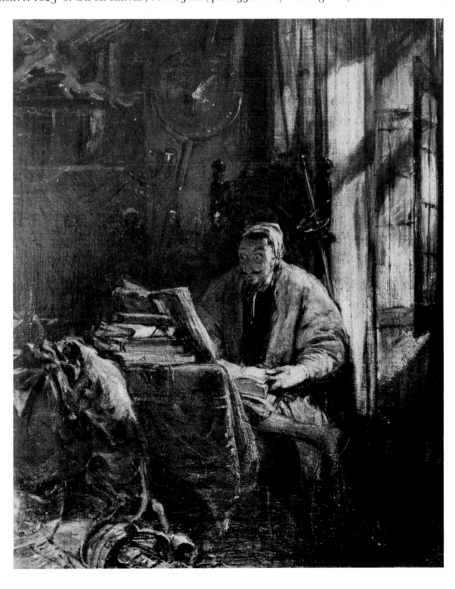

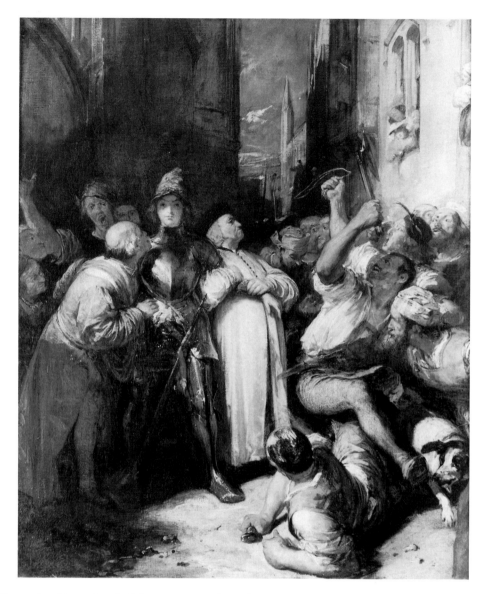

67 *Quentin Durward at Liège.* 1825–6. Oil on canvas, 25¼ × 21¼ in. (64.1x54.0 cm.) Nottingham, Castle Museum and Art Gallery

His increase in expressiveness is most marked in his *Quentin Durward at Liège* (Plate 67). The teeming novels of Sir Walter Scott are finally grasped, and, doubtless encouraged by the example of Delacroix's *Barque of Dante* and *The Massacre at Chios*, Bonington has attempted to represent the difficult psychological drama of a calm, even passive hero in the midst of a riot. In Chapter XIX of *Quentin Durwood*, Quentin was recognized as a member of Louis XI's Scots guard, and thus thought to be a representative for freedom against the tyranny of the Duke of Burgundy. Nothing further from Quentin's mind can be imagined, and whatever the contemporary historical relevance, ironically, Bonington reacted like his hero, and withdrew. His one incursion into the violent world, already apparent in Delacroix and Wilkie, was not to be repeated. Tumbling figures, and a whole range of expressive physiognomy, including open-mouthed peasants shouting directly at the spectator, taken from Jan Steen, or Brouwers, had not been used before, and he was not to venture towards this extreme of Romantic figurative painting again.

68 *The Use of Tears*. 1826–7. Oil on canvas, 15⅓ × 12½ in. (38.7x31.8 cm.) Boston Museum of Fine Arts

69 *Studies of the Count of Palatiano in Greek Costume.* 1825. Pencil, 11 × 9 in. (28.0x22.8 cm.) Nottingham, Castle Museum
and Art Gallery

One major influence of Delacroix was to introduce Bonington to a new experience
of Middle Eastern exotica. During his stay with Delacroix, and at the beginning of 1826
when he moved into the same building, 11 rue des Martyrs as Jules Robert Auguste, (1789–
1850), Bonington was introduced to a wider circle of friends and interests. M. Auguste,
as he was known, was a trained artist, but rich enough to collect exotic costumes, decorative
objects, carpets, and illuminated manuscripts from the Middle East and Asia Minor. One
of their friends, the Count of Palatiano, was painted by Delacroix and Bonington on a num-
ber of occasions in the costume of a palikar. A number of oil sketches and drawings survive
from this dressing-up party, which probably took place in Delacroix's studio. The Count
proudly posed in his Greek costume for portraits by both artists, now known from prints.
Their drawings have been confused (Plate 69), but the finest surviving oil sketch by Boning-
ton (Plate 70) is a brilliantly handled piece of self-conscious exoticism, very much in the
tradition of eighteenth-century bravura oil sketches, especially admired by French connois-
seurs. There exist a number of variants (Plate 72) and copies.

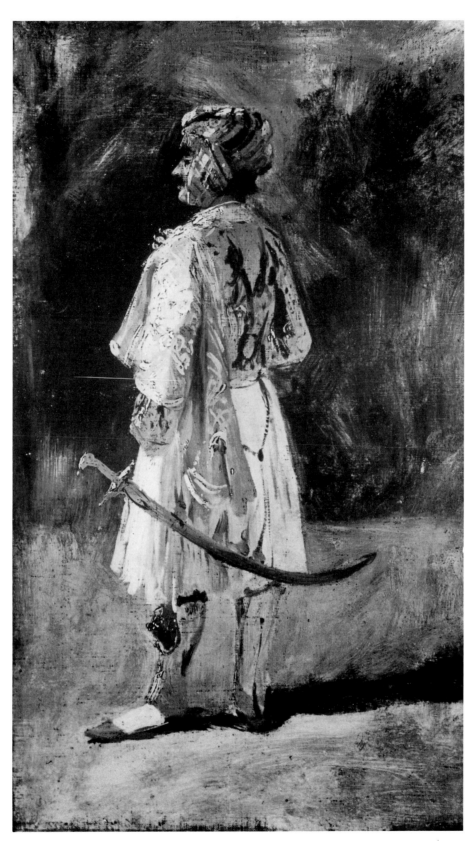

70 *The Count of Palatiano in the costume of a Palikar.* 1825. Oil on canvas, $13\frac{3}{4} \times 10\frac{2}{3}$ in. (35×27 cm.) Private Collection

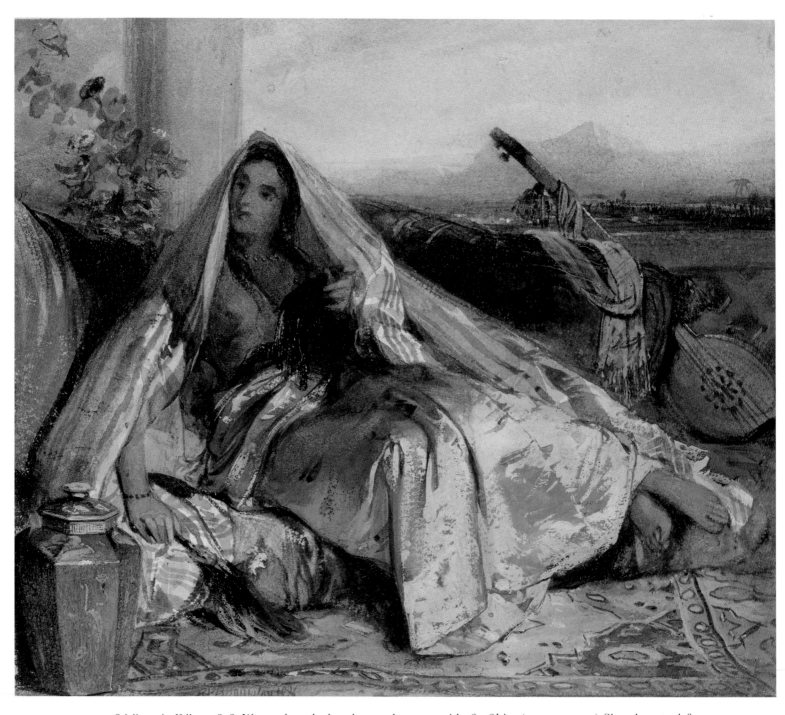

71 *Odalisque in Yellow*. 1826. Watercolour, body colour and gum varnish, 6 × 6⅘ in. (15.5x17.4 cm.) Signed centre left: *R. P. Bonington 1826*. London, Wallace Collection

72 *The Count of Palatiano in the Costume of a Palikar, profile*. 1825. Oil on canvas, 15¼ × 9¼ in. (38.7x23.5 cm.) Athens, Benaki Museum

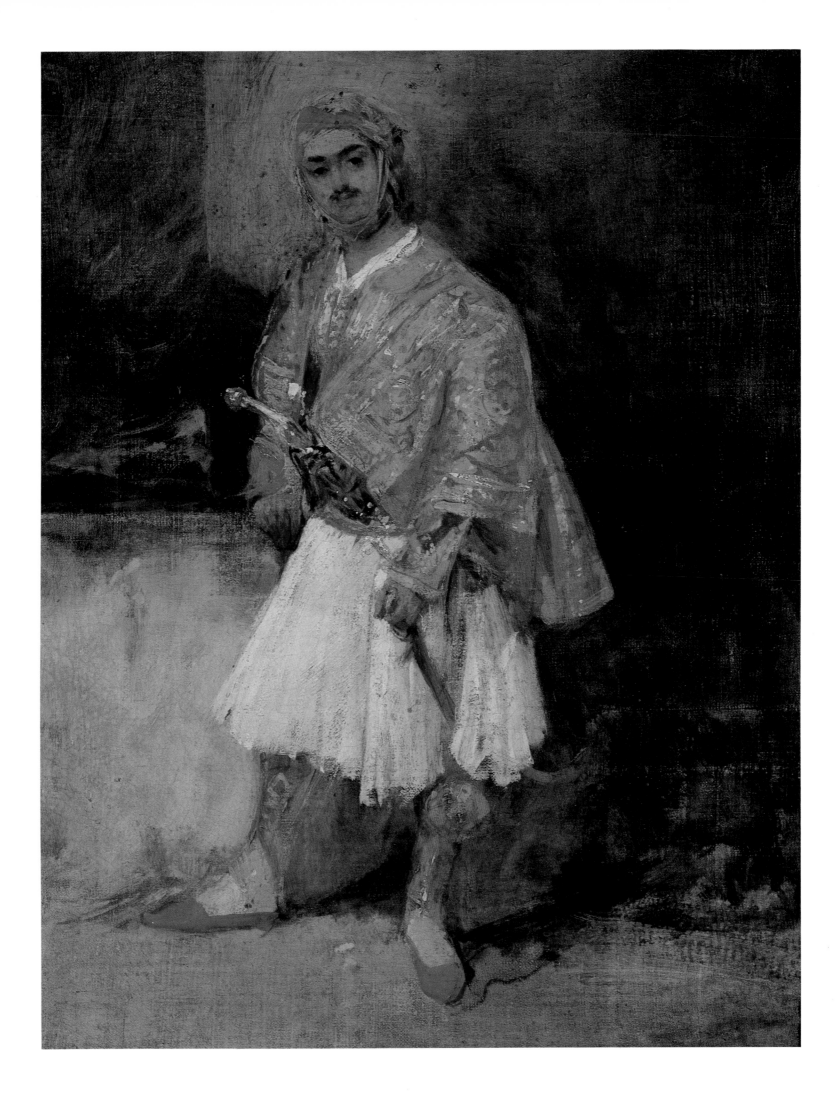

The cause of Greek Independence was much in the news, and Byron's death had become a symbol of romantic allegiance. In contrast to Bonington's cabinet pictures, Delacroix may already have been working on his large, rhetorical picture of *Greece Expiring on the Ruins of Missolonghi*, which he was to exhibit at the second edition of *Exposition au profit des Grecs* at the Galerie Lebrun in August 1826. Delacroix had sent his *Combat of the Giaour and Hassan*, largely based on Byron's *The Giaour* of 1813, and his important *Execution of the Doge Marino Faliero*, which he had only just finished in April 1826, to the first edition of the Galerie Labrun benefit for the Greeks in May 1826. Bonington was seemingly oblivious to the tactlessness of his exhibit of *A Seated Turk*, (Plate 74) which was shown when he was already en route for Italy. This painting, newly discovered and originally owned by Sir Thomas Lawrence, is almost identical to the design of his watercolour in the Wallace Collection (Plate 75), signed and dated 1826. There are other variants of this design, one of which may be a copy in Dublin.

Bonington's response to this new stimulus was to paint imaginative works which react sensuously to the oriental paraphernalia with which M. Auguste had surrounded himself. Bonington had painted *Anne Page and Slender* (Plate 54) in a medieval style, so he drew in watercolour a scene from the *Arabian Nights* in the flat, calligraphic manner of a Persian miniature. The example in the Wallace Collection, if not by him, is from his circle. Apart from colonial artists in India copying Indian miniatures, only Rembrandt and Flaxman had hitherto thought it worth while to imitate such jewel-like objects. He also painted a number of odalisques. One in yellow dated 1826 (Plate 71) placed a western model in a richly coloured oriental interior; she has a red-striped head-dress, and there is a large blue Chinese pot in the foreground. The *Turk Reposing* (Plate 75) has equally splendid Persian pots in the background, with tiles and abstract floral hangings. The way in which M. Auguste and the young artists around him deliberately enthused over out-of-the-way objects, is part of the subsequent history of modern art in that these objects were appreciated contrary to accepted norms, and painted in a modern style to match. The gaiety of the studio life can be gathered from a letter by Bonington to Thomas Shotter Boys:

> Try and come this evening. Rivet and a few friends will be here, avec the
> french modes & tout cela pour rejouir le chretien, M. Auguste a qui
> appartient les honneurs de la soirée ne sera pas moins aise de vous voir que
> votre ami Bonington.

Delacroix was also to paint *A Seated Turk* (Louvre), and his oil painting of an *Odalisque Reclining on a Divan* (Plate 73), is similar in technique to Bonington's watercolours; Delacroix's glazes take the place of the gum arabic in the watercolour. Delacroix's choice of pose, however, is much earthier and more direct, with overtones of Rubens, than Bonington's demure models. In strong contrast to Bonington's modest exotica, Delacroix was about to embark at the end of 1826 on his enormous painting of *The Death of Sardanapalus*, a painting whose riot of savagery and flesh beggars description. Delacroix obtusely professed not to understand why this picture was attacked. Bonington's sensuousness, on the other hand, found its outlet in the feeling for surface glitter and rich colouring, which Delacroix knew was Bonington's significant contribution when he wrote to Thoré in 1861:

> Nobody in the modern school, and perhaps previously, possessed that
> lightness of execution which, particularly in watercolour, makes his works
> seem like diamonds by which the eye is charmed and delighted
> independently of all subject and all imitation.

Delacroix, in referring to 'the modern school' expresses the style of 'Le Boningtonisme'.

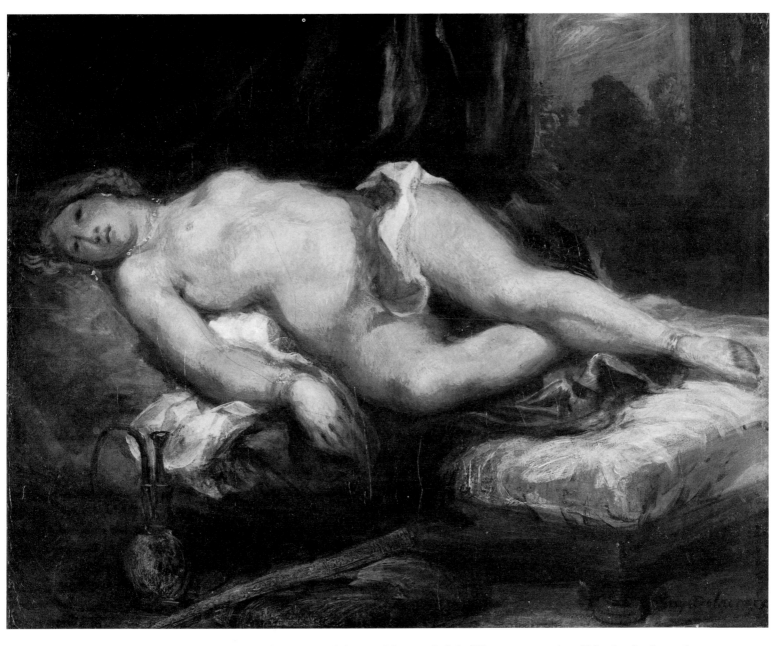

73 Eugene Delacroix (1798–1863). *Odalisque Reclining on a Divan. c.* 1826–8. Oil on canvas, 14⅘ × 18¼ in. (37.8x46.4 cm.) Signed lower right: *Eug. Delacroix*. Cambridge, Fitzwilliam Museum

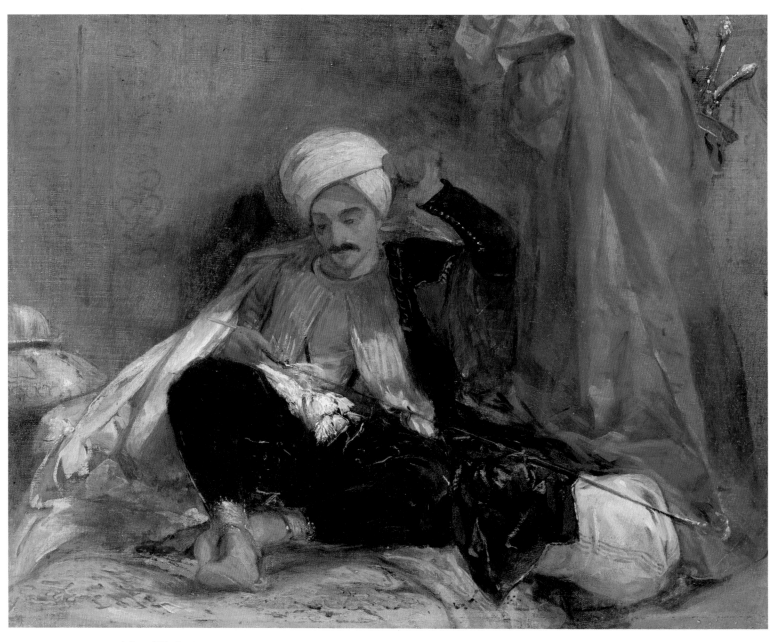

74 *A Seated Turk*. 1825–6. Oil on canvas, $13\frac{1}{4} \times 16\frac{1}{4}$ in. (33.6×41.3 cm.) New Haven, CT., Yale Center for British Art

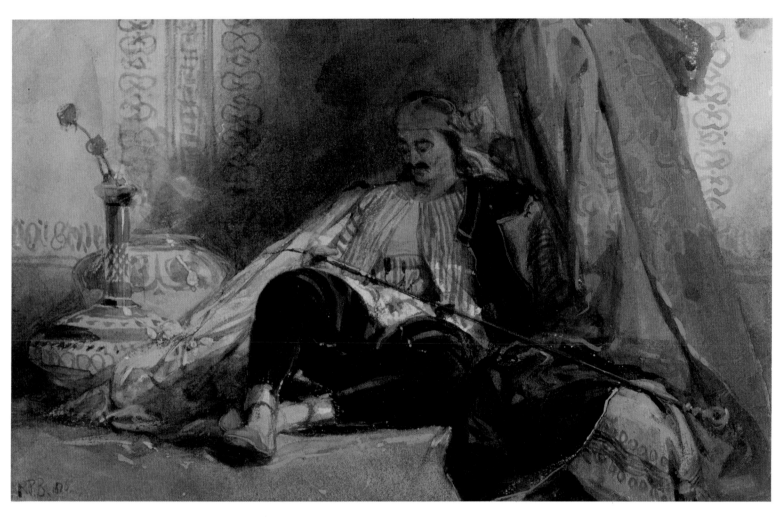

75 *Turk Reposing*. 1826. Pencil, watercolour, body colour, with gum varnish, 4⅔ × 7 in. (11.3×17.7 cm.) Signed lower left:
R.P.B. 1826. London, Wallace Collection

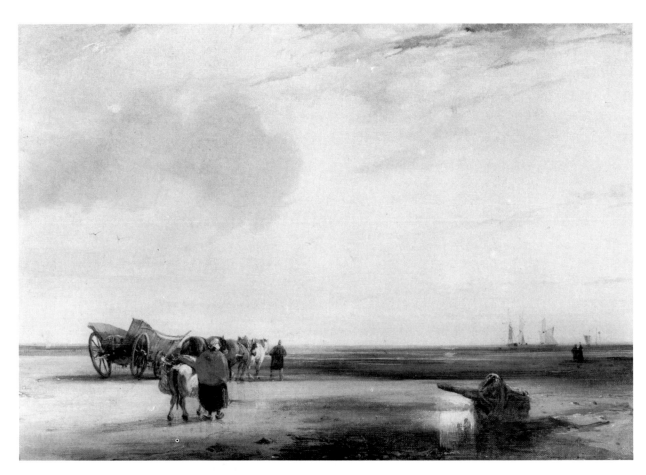

76 *Fisherfolk on the Sands. c.* 1825–6. Oil on canvas, 14½ × 20½ in. (36.9x52.1 cm.) Anglesey Abbey, Cambridgeshire, National Trust

In spite of these new explorations, Bonington did not abandon his well-established landscapes, which reach a high point during 1825–6. He must have worked on them at the same time as his small subject pictures, but they were no less important for his reputation. *Fisherfolk on the Sands* (Plate 76) contains all the elements of his previous seascapes: carts and fisherfolk on an open beach, with distant ships silhouetted on the horizon, but instead of the crowded composition of *A Fish Market, Boulogne* (Plate 24), his figures now move in a diagonal across the sands away from the spectator. Such compositions are reminiscent of innumerable English watercolours of figures crossing the sands at Morecambe Bay, or at Traeth Mawr on the estuary of the River Glaslyn, with Snowdonia in the background, such as Copley Fielding was to paint in a version of 1838 (Wallace Collection). The motif of the cart and horse seen from the rear may also derive from one of Constable's scenes of *Yarmouth Jetty*, 'thrown into' his bargain with Arrowsmith, the French dealer in 1824. *The Coast Scene with Horse and Waggon* (Plate 2) is a further development of this theme with a waggon and horse coming directly towards the spectator, possibly a memory of a similar group in his print of *Gisors* (Plate 37). The two seascapes have a new-found clarity of light and touch, which marks a definite advance on his seascapes of *c.*1823–5. This is particularly noticeable in two further beach scenes: *On the Coast of Picardy* (Plate 4), which once bore a date of 1826; and *Near Quilleboeuf* (Plate 78), which is close in style. There is here a new sense of spaciousness and the fall of light, both of which are rendered with most subtle accents,

from the sharp delineation of masts and posts, to the delicate tonal relationships of the sails. There is a drawing in the British Museum of the fallen crow's nest which appears in the foreground of *On the Coast of Picardy*. Both paintings have horses in them, again perhaps inspired by Constable's eye for their flanks; and small touches of red, with a detailed texture in the foreground, may also come from his example. The distant dunes in *Near Quilleboeuf* are painted like a watercolour, and the smoke curling into the vortex of the clouds may have come from Turner. The foreground of this painting, however, seems rather unresolved when compared to the Wallace picture, which was probably sold as a finished work to the Duke of Bedford, directly from Bonington's studio. Edward Morris has pointed out that A. W. Callcott had advised the Duke to visit Bonington's Paris studio in 1826, indicative of Bonington's growing reputation in England that year; and the Duke was to purchase another fine seascape which is still at Woburn (Plate 5).

In fact, Bonington had sent two oils to the British Institution in January 1826, which meant that they must have been ready for delivery by December 1825. One, *French Coast Scenery*, was bought by the Countess De Grey, and because of its overall size, which the British Institution alone among exhibiting organizations listed in the catalogue, it is just possible that it was the *Fish Market, Boulogne* of 1824 (Plate 24). The other, a smaller picture, has recently come to light at auction, *French Coast with Fisherfolk* (Plate 77). When his work appeared at the British Institution, the London critics had never heard of him. 'Who is R. P. Bonington?' the *Literary Gazette* asked on 4 February 1826, but went on to praise him:

> We never saw his name in any catalogue before yet here are pictures which
> would grace the foremost *name* in landscape art. Sunshine, perspective,
> vigour; a fine sense of beauty in disposing of colours, whether in masses or
> mere bits. These are extraordinary ornaments to the rooms. Few pictures
> have more skilfully expressed the character of open, sunny daylight than the
> one under notice; and we have seldom seen an artist make more of the simple
> materials which the subject afforded. With a broad pencil he has preserved
> the character of his figure and accessories; also a splendid tone of colour,
> glowing and transparent.

A more sympathetic notice for a young artist's first appearance in London can hardly be imagined, and Constable would have been pleased to have received such praise. In its present state, the small coast scene is rather rubbed, but its scale, Turnerian effects of light, and the slight sentimentality of the two figures, obviously made it attractive to Sir George Warrender, Bt., M.P., who bought it from the exhibition. Its popularity may be the reason for the existence of a variant also dated 1826. Bonington's elegance and finish both approach the style of William Collins whom Constable so despised for his hackneyed coast scenes; this together with Bonington's obvious success and use of 'eye salve' in a branch of art that Constable did not hold in great esteem may have given rise to his jealousy as cited earlier. Constable may well have been prompted, in turn, to take on Turner, Callcott, Collins, and Bonington, with his large, untypical *The Chain Pier, Brighton* (Tate Gallery), begun after Bonington's success, and exhibited in 1827 at the Royal Academy, where it sadly remained unsold.

To 1826 can be assigned a further group of finished works which stand as the epitome of Bonington's seascape style. His favourable reception at the British Institution may have spurred him to paint large variations of his themes, and they were bought by the sort of

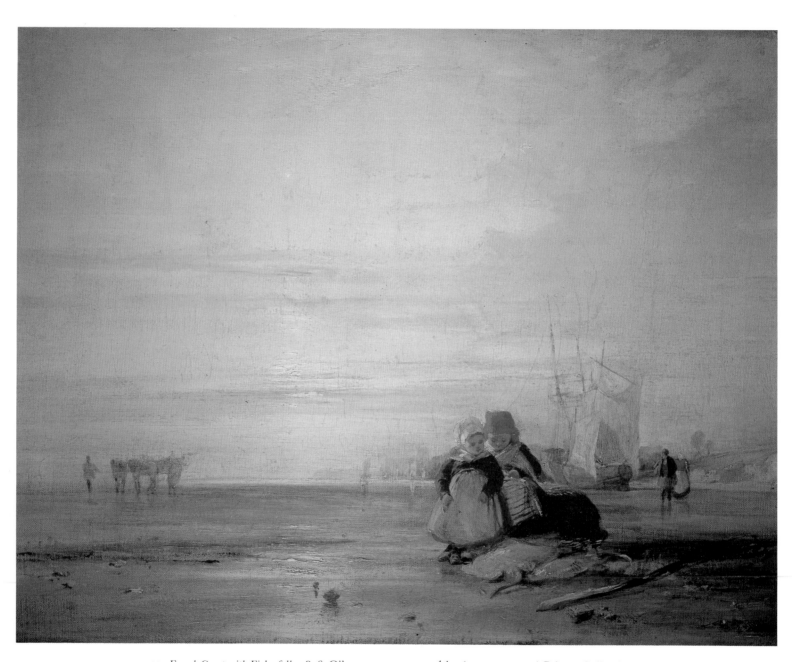

77 *French Coast with Fisherfolk*. 1826. Oil on canvas, $17 \times 20\frac{4}{5}$ in. (43.0x53.0 cm.) Private Collection

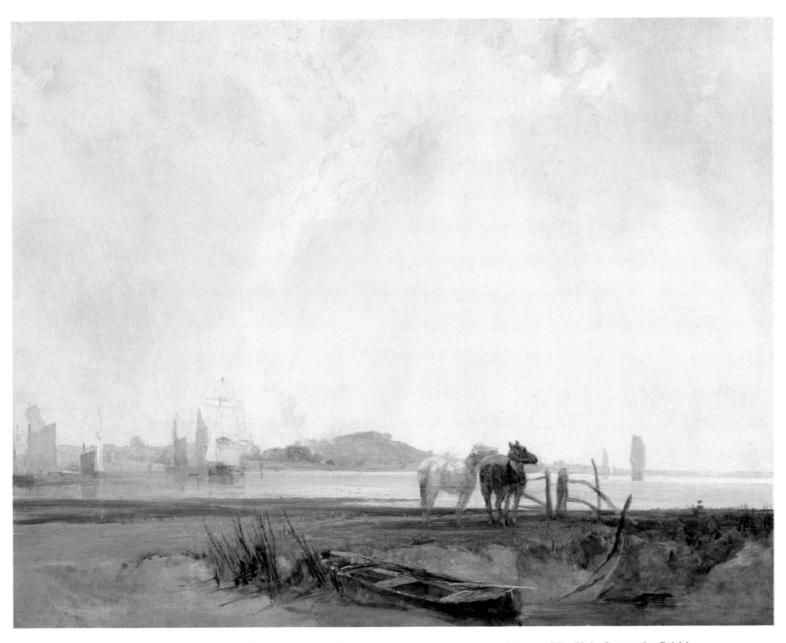

78 *Near Quilleboeuf. c.* 1825–6. Oil on canvas, $16\frac{1}{2} \times 20\frac{1}{2}$ in. (42.0x52.0 cm.) New Haven, CT., Yale Center for British
Art

79 *Trees and cottage by a river. c.* 1825–6. Black chalk, $6\frac{1}{4} \times 8$ in. (15.9x20.3 cm.) New Haven, CT., Yale Center for British Art

aristocratic patrons who were Directors of the Institution. In fact, all of his first English patrons were either Governors or Directors of, or subscribers to, the British Institution: including Countess De Grey; Sir George Warrender; the Duke of Bedford, who was Vice President and Hereditary Director; Lord Charles Townshend; the Marquess of Lansdowne; and Sir Robert Peel. The word must have spread as Bonington became the establishment's new smart boy wonder. *Fisherfolk on the Normandy Coast* (Plate 23) belonged to Lord Charles Townshend, and has figures which look back to his earlier sketches on the Normandy coast (Plate 21), but they were now fully integrated by the dappled light into the whole expanse of sand and sky. *Coast Scene in Picardy* (Plate 81) successfully developed his 1824 *Fish Market* (Plate 24), but as with *Landscape with Timber Waggon* (Plate 47), the figures are dissolved by streaks of light. There are details which have occurred before, the torch posts on the jetty, for example, but his subject pictures on a small scale may have helped his handling of the chiaroscuro. The figures have a new-found emotion, such as the melancholy fishergirl in the foreground of the Hull picture, a detail which Constable would have scorned, but which the rich patrons of William Collins, such as Sir Robert Peel, Lord Charles Townshend, and the Duke of Bedford would have admired. The Duke made a further purchase of the *Coast Scene* (Plate 5), and its calm harmony best suited the taste of his circle.

Bonington did not neglect his other successful style of inland waterway painting. His trip to England in the summer of 1825 had demonstrated to him Turner's success with river scenes, and *The Landscape with a Pond* (Plate 83) has all the 'open, sunny daylight' which the *Literary Gazette* admired at the British Institution. Marion Spencer, however, was the first to realize that it entirely drew upon art for its inspiration, being an almost literal copy of Rembrandt's etching *Cottage with a White Paling* (Muntz 151). A drawing of *Trees and Cottage by a River* (Plate 79) may be connected with the painting. In it Bonington has translated the fine strokes of etching into thick strokes of chalk, as if it were a lithograph. His knowledge of Rembrandt must have been increased by his access to the collection at the British Museum under J. T. Smith's care, and his subject pictures were also influenced as has been shown. It is not clear, therefore, whether the small *River Landscape* (Plate 7) was executed on the spot. The Turnerian trees, the geometry of the stumps and barges, masts, and sails, and his Francia-like gulls, all have appeared before, but the windmill seems an interloper from Rembrandt. *A View on the Seine* (Plate 8) provokes the same question. It bears a Davy label so it may have been done after his return from London, a theory which is acceptable on grounds of style. Its clarity is obvious, but again Bonington was developing his technique in the studio.

He does, however, seem to have travelled to Calais sometime at the end of 1825, perhaps to see his pictures safely off to London. A charming sketch of *Stagecoach Passengers* (Plate 80) may have been drawn at this time, as his confident strokes in black chalk are not unlike those in the landscape drawing (Plate 83). His industry and ability to make rapid

80 *Stagecoach Passengers. c.* 1825–6. Pencil, $4\frac{3}{4} \times 7\frac{1}{3}$ in. (12.0x18.7 cm.) Oxford, Ashmolean Museum

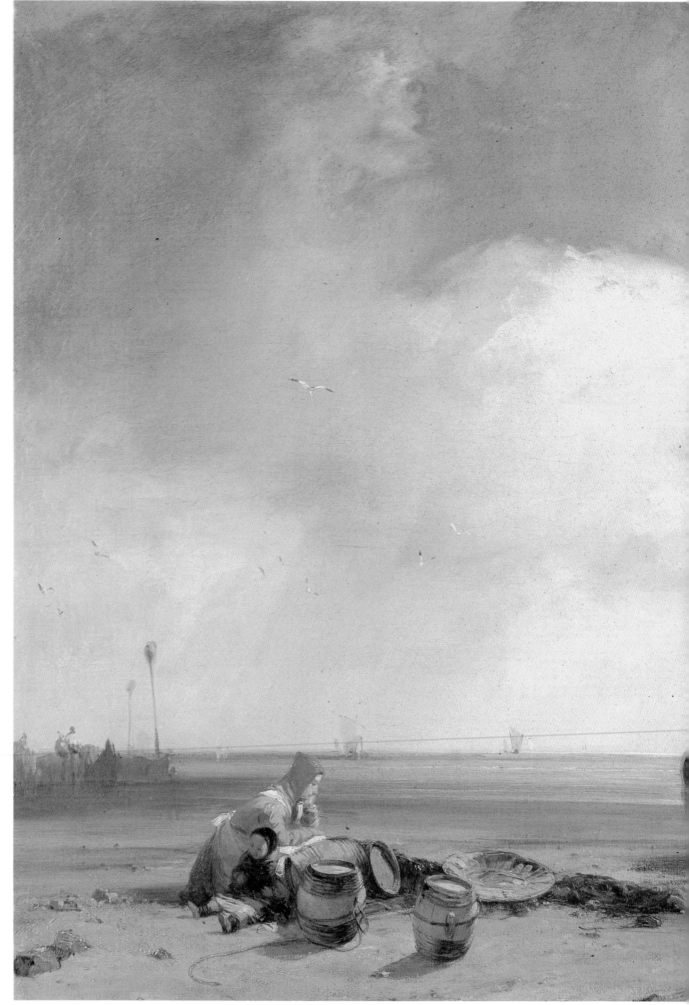

81 *Coast Scene in Picardy.*
c. 1825–6. Oil on canvas,
26 × 39 in. (66.3x99.0 cm.)
Signed lower right:
R. P. Bonington.
Kingston-upon-Hull,
Ferens Art Gallery

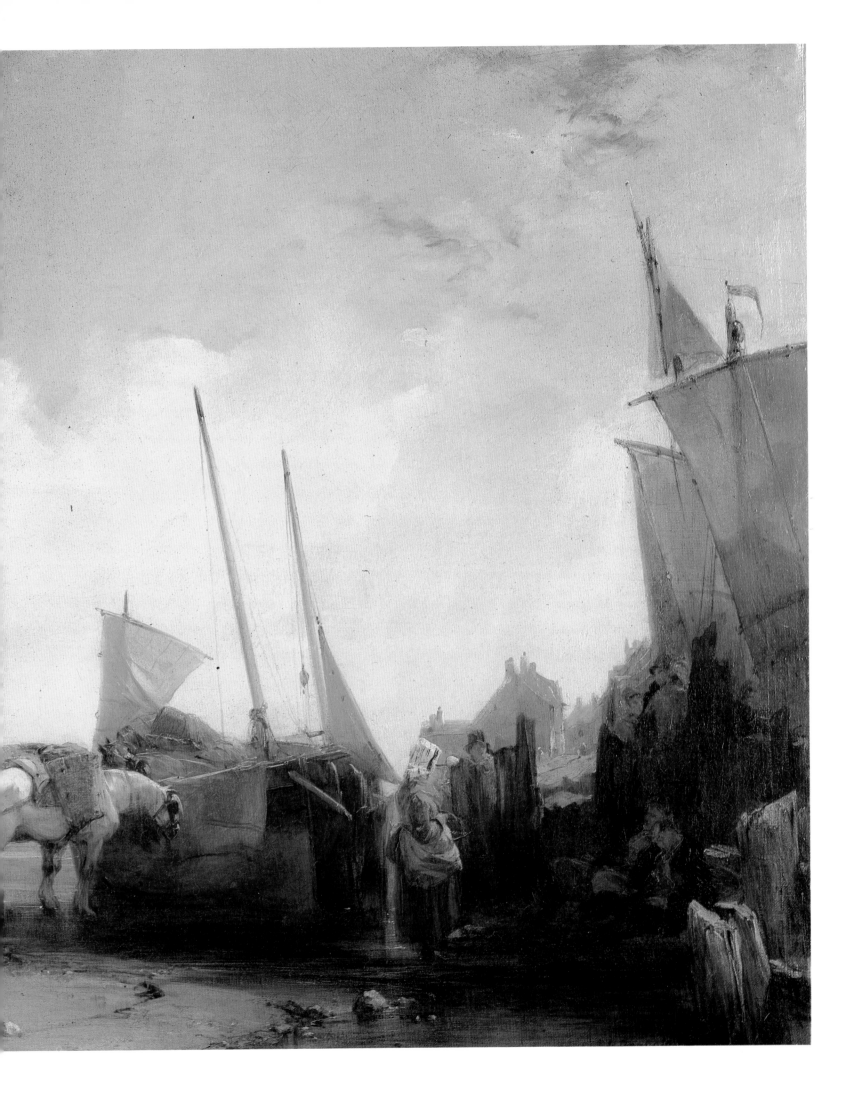

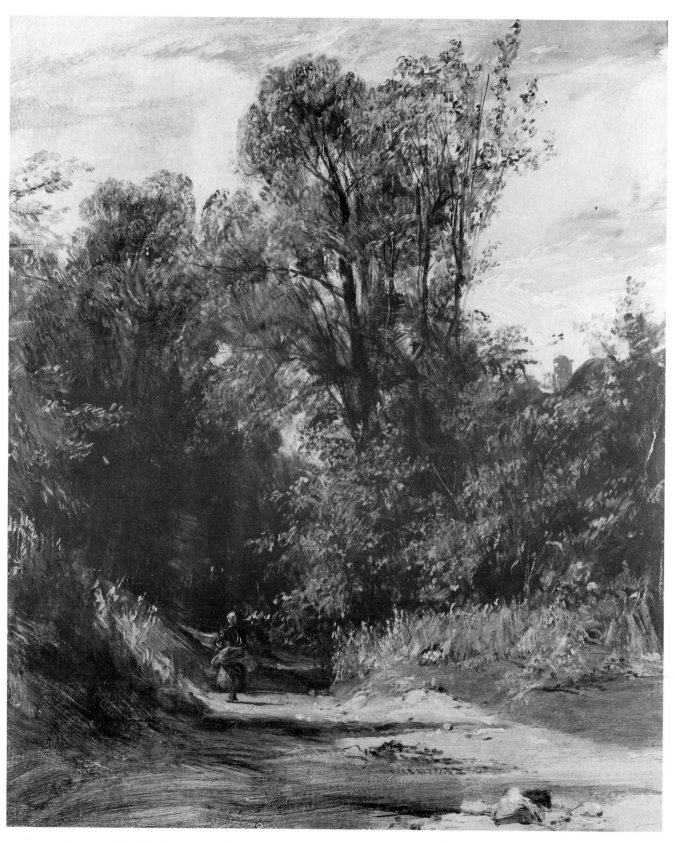

82 *A Lane through a Wood. c.* 1825–6. Oil on panel, 11 × 9 in. (28.0x22.9 cm.) New Haven, CT., Yale Center for British
Art

jottings on the spot, of which this is a fine example, were not in doubt. A letter written much later in the nineteenth century by the watercolourist James Taylor gives a glimpse of him, probably at this time:

> It was at the hotel at Calais that I first met Bonington. He was with the French landscape painter, Francia, and at the same hotel was S. W. Reynolds, the engraver. . . . Bonington had been making studies in the neighbourhood of Calais, and so, finding myself so warm an admirer of his talents, we struck up a friendship and agreed to take lodgings together in Paris. This we did, and studied together in the Louvre and at home, painting night and day . . . After a time we took a house with a painting-room for horses, which had belonged to Horace Vernet.

This last must refer to the same house as M. Auguste's, in the rue des Martyrs, which helps to date Taylor's recollections to 1826.

Taylor would also probably have seen examples of Bonington's talents in pastoral landscape painting, different again from his inland waterway pieces. *A Roadside Halt* (Plate 84) seems to be dated 1826, and *A Lane through a Wood* (Plate 82) is one of a number of versions, but it does bear a Davy label, which with its style suggests a date of *c.*1825–6. They are both clear in light and brilliant in handling, and both were deservedly popular images. They encapsulate a moment of time or a particular encounter which Bonington had explored in his subject pictures, while his knowledge of Constable would have given him examples of placing such figures in a landscape; but whereas Constable's *Cornfield* is based on a real lane, where he once actually saw a boy drinking, Bonington's works are connoisseur's pictures, where the figure, by the broken edges of paint, is dissolved in light. The experience of the light and romance of Italy during 1826 was to enlarge his perceptions significantly.

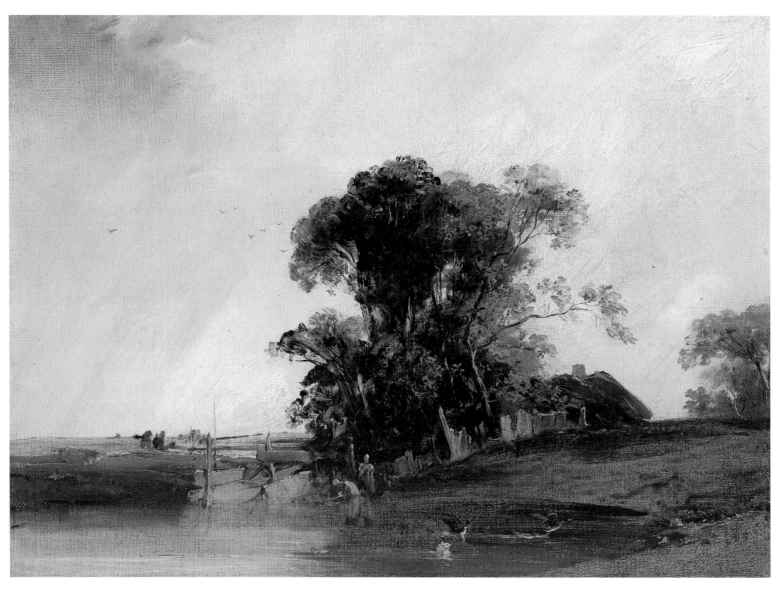

Above: 83 *Landscape with a Pond. c.* 1825–6. Oil on canvas, 10$\frac{1}{5}$ × 13$\frac{3}{4}$ in. (26.0x34.9 cm.) Cambridge, Fitzwilliam Museum

Opposite: 84 *A Roadside Halt. c.* 1825–6. Oil on canvas, 18$\frac{1}{4}$ × 15 in. (46.4x37.9 cm.) Signed lower right: *RPB 182[6?]*. New York, Metropolitan Museum of Art

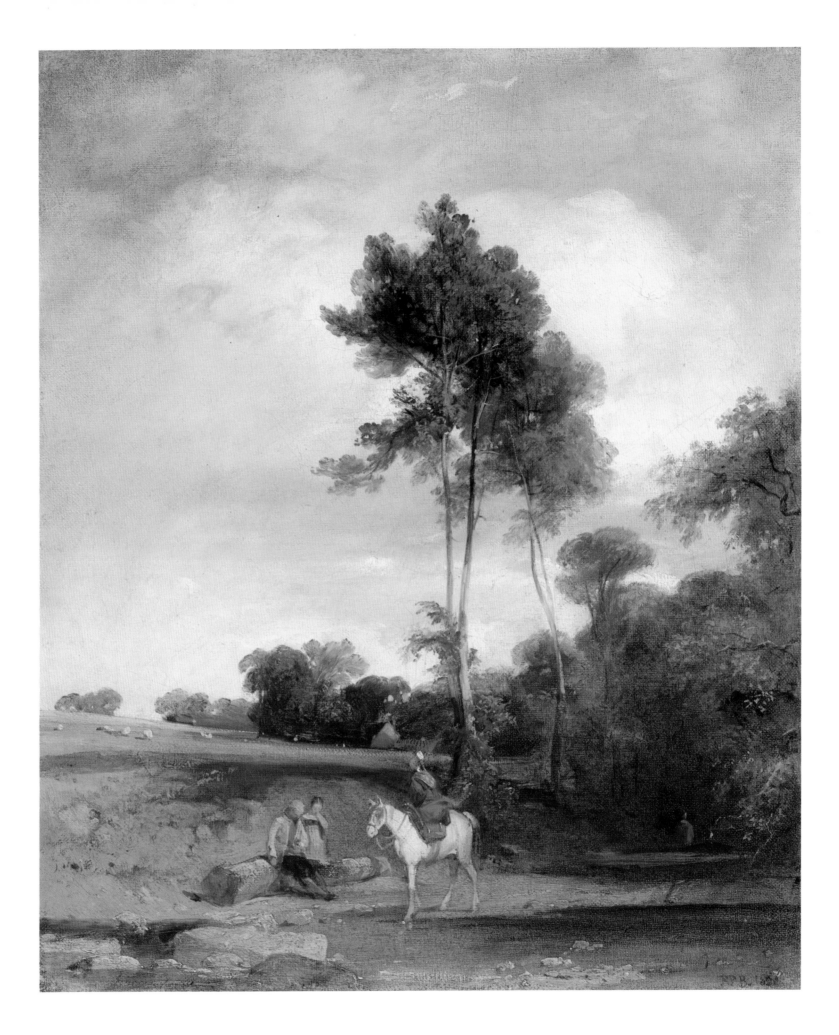

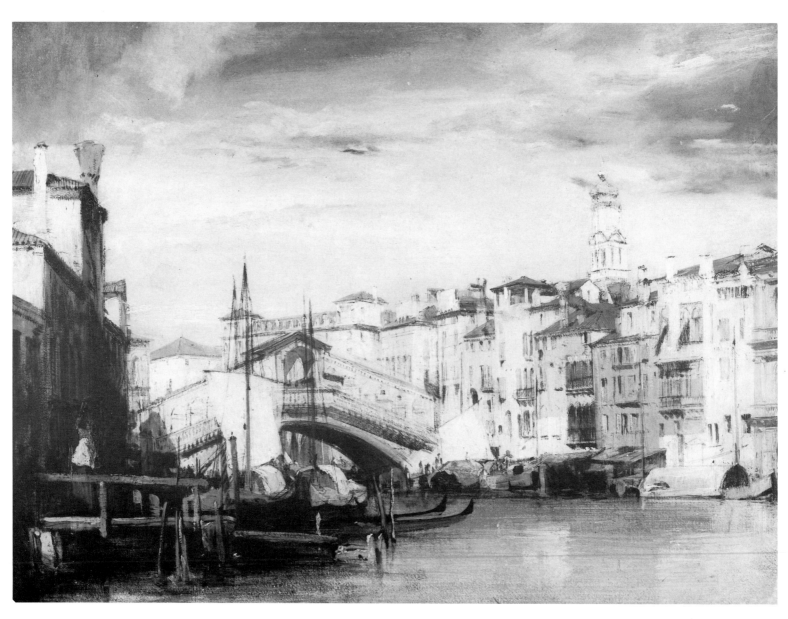

85 *Venice: the Grand Canal, looking towards the Rialto. c.* 1826–7. Oil on millboard, $10\frac{1}{2} \times 12\frac{1}{2}$ in. (26.7x31.8 cm.) Private Collection

VENICE

Venice and its art had been a source of Bonington's subject matter long before he ever visited it, through his hours in the Louvre and his association with Delacroix. Bonington's name, and that of Turner, will now be forever associated with the city, as a result of the journey Bonington began in April 1826, but, unlike Turner, he went there only once, and did not have time to assimilate its romance to produce ethereal visions, as Turner had. His interest in the Gothic undoubtedly would have predisposed him to curiosity about Venetian Gothic architecture, while his copies after Titian, Tintoretto, Paris Bordone, and others must have made him want to see their works still in their original settings. Both Bonington and Turner were undoubtedly impressed by the romance and historical associations of Italy.

Most immediately, Bonington would have been aware of Delacroix's large painting, *The Execution of the Doge Marino Faliero* (Plate 86) which was finished in April 1826 after nearly a year's work, and sent to the Galerie Lebrun for the Greek exhibition. There is an obvious debt in the painting to Venetian art and architecture, in the grand staircase of the Doge's palace, the heads taken from Titian and other Venetian painters which Delacroix had seen in the Louvre, and its rich air of historic costume, pomp and ceremony.

But Delacroix was also making a political statement in his romantic vision. He was glorifying the democratic traditions of the city-state which was now under Austrian rule. He was emphasizing the present, sad decline of Venice, as other romantic artists and writers were to do, Wordsworth included. Through its democratic institutions, Venice had provided a message for the modern world. Byron's play, on which this painting depends, had the same theme. In effect, too, Delacroix was praising Venice for having executed its Doge as a traitor who had wished to become sole dictator. Paul Delaroche in his morbid painting of *Cromwell examining the Corpse of Charles I* (Salon 1831, Nîmes Museum) was to address a similar subject, as it affected the generation of 1830. Bonington, as it turned out, was not able to emulate such a dramatic programme, but Delacroix's important statement would at the very least have re-kindled his desire to visit *La Serenissima* to see what he could make of her.

He left Paris on 4 April with Baron Rivet, whose journal, as it has been transcribed, gives what information we have about their tour together. They were about the same age, came from the same circle of romantic artists, and were interested in the same things. They travelled rapidly through the Franche Comté, not apparently pausing to make the sort of drawings which Baron Taylor had published, although Bonington did some architectural studies in Dôle, en route to Geneva, and the Simplon pass. The several studies on one sheet

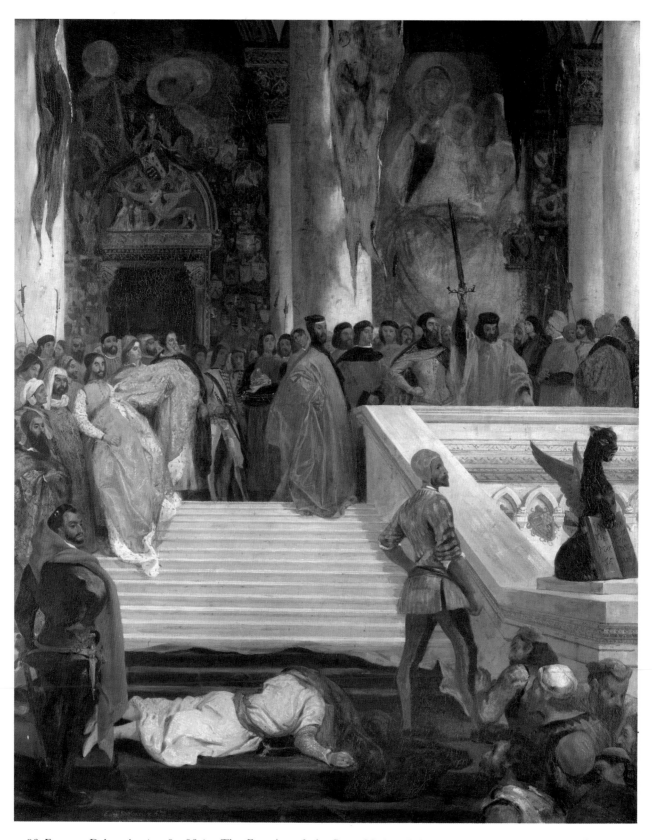

86 Eugene Delacroix (1798–1863). *The Execution of the Doge Marino Faliero*. 1826. Oil on canvas, $57\frac{2}{3} \times 45$ in. (146.4×114.3 cm.) London, Wallace Collection

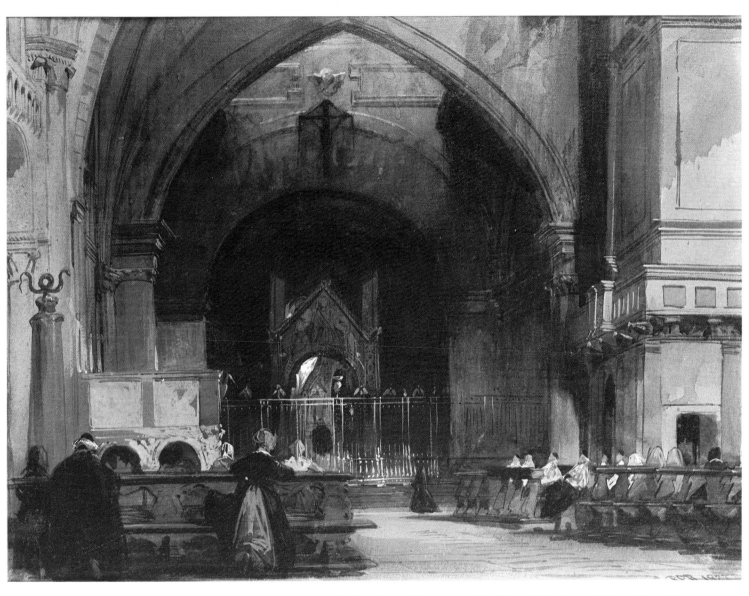

87 *Milan: Interior of S. Ambrogio*. 1827. Watercolour, body colour, with gum varnish, $8\frac{3}{4} \times 11\frac{1}{4}$ in. (22.1x28.6 cm.) Signed
lower right (cropped): *RPB 1827*. London, Wallace Collection

88 *Swiss Girl at Meyringen*. 1826. Pencil, 2¼ × 3 in. (5.7x7.6 cm.) Calne, Wiltshire, Bowood House

of a *Swiss Girl at Meyringen* (Plate 88) were drawn, like his studies in Normandy, more for his interest in costume, as the girl posed seated and standing, and for his obvious interest in her wide-brimmed hat.

When they reached Milan, having travelled through incessantly bad weather, San Ambrogio with its then unrestored Gothic interior inspired Bonington to a number of interior views. They were executed between 11 and 14 April, of which one later finished version (Plate 87), dated 1827, stands as a dramatic image of his abiding interest in Gothic architecture. The painting looks forward to the stagey interiors of David Roberts (1796–1864), but Bonington's detailed effects of light concentrate attention on the devotion of the worshippers. It is an example of his greater dramatization during 1827.

During the journey, according to Rivet, Bonington thought 'only of Venice', but made no effort to learn the language. They passed Lake Garda rapidly and Bonington was made ill-tempered by the bad weather. 'He is in a dismal mood. He ought always to have someone with him to make him laugh', thought Rivet. Bonington may have already been feeling the onset of his tuberculosis. Nevertheless, there are oil sketches of mountainous landscapes, and lake scenes which seem to show the overcast weather which Rivet described. One of *Landscape with Mountains* (Plate 91) is included here as an example of Bonington's sketching in oil on the spot, using one of the prepared Davy millboards which he had taken with him, and on which the majority of his Italian sketches are painted. Presumably they took up less room than canvas, did not need to be stretched, and had the smooth, hard surface that he liked to use. For their tonal subtlety this and other sketches take their due place in the *plein-air* tradition of oil sketching in Europe. This picture's rapid description in oil of the dark foreground, the distant hills, the rain-filled clouds, contrasted against the white of the villa, can be compared in immediacy and feeling for paint with Corot, and, like Corot's sketches, they are conceived in a French tradition of tonal values rather than the colouristic sketches of Constable.

The two travellers were in Verona on 18 April, where Bonington made many drawings in pencil, occasionally heightened with white, some of which he later worked up into finished compositions, which are also included here, to show what he made of his journey. A watercolour the *Corso Sant' Anastasia*, dated 1826 (Plate 89), was probably based on an initial pencil drawing, and looks like a worked-up sketch, full of the extremes of Italian light and dark, but with no real subject, other than a street scene, such as he had already drawn in Normandy. An oil sketch on the market in 1983 transferred the same scene with

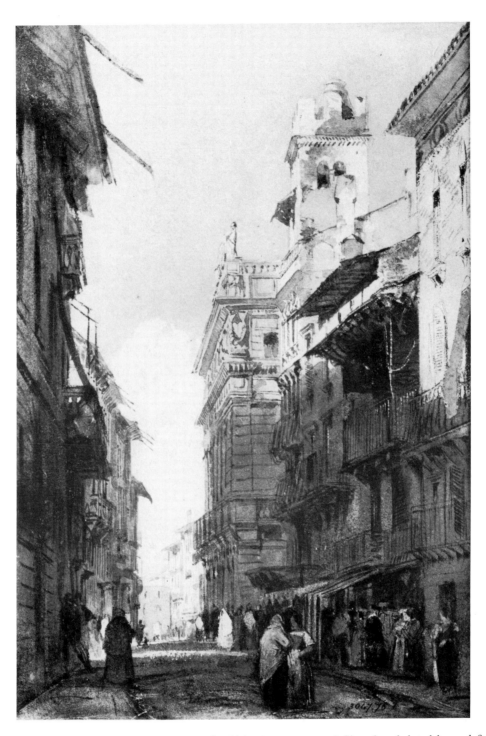

89 *Verona: Corso Sant'Anastasia.* 1826. Watercolour, 9¼ × 6¼ in. (23.5×15.9 cm.) Signed and dated lower left: *RPB 1826*.
London, Victoria and Albert Museum

the prominent buildings of the Torre del Gardello and Palazzo Maffei on the right, and
the entrance to Piazza delle Erbe on the left, into an everyday street market. What is probably
the finished oil on panel, *A Procession in the Corso Sant' Anastasia, Verona* (Plate 90), introduced
the subject of a religious procession, rather as he had at Dives (Plate 18, *c.*1822), or as he
was to paint San Ambrogio, Milan (Plate 87, 1827). In all three views in Verona, the archi-

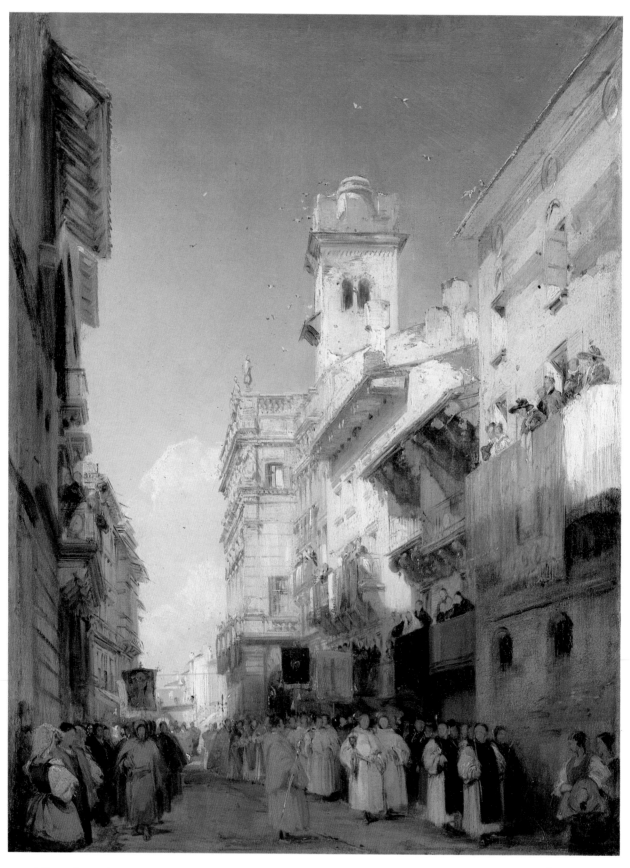

90 *A Procession in the Corso Sant' Anastasia, Verona. c.* 1826. Oil on panel, $23\frac{2}{3} \times 17\frac{1}{3}$ in. (59.5x44.0 cm.) New Haven, CT., Yale Center for British Art

91 *Landscape with Mountains.* 1826. Oil on millboard, 9⅘ × 13 in. (25.1x33.0 cm.) Edinburgh, National Gallery of Scotland

92 *The Colleoni Monument.* 1826. Pencil, 8¼ × 6 in. (22.5x15.2 cm.) Calne, Wiltshire, Bowood House

tectural details differ somewhat, and in the finished picture the perspective is bent around to include the procession. With regard to its bright colour, particularly the brilliant blue of its sky, (and none but Canaletto and Turner had so painted the light of Italy), the details of the fashionable spectators on the balconies picked out with delicate touches of green against the red of the hangings, and the luminosity of the shadows, all of which have been revealed by recent cleaning, this picture is typical of Bonington's finished works of Italian scenes which were in great demand after his trip to Italy. He was offering this, or something like it, to Dominic Colnaghi for approval in 1827. This example may, in fact, number among his very last works, *c.*1827–8. Patrick Noon has pointed out that it may have been done on commission, being left in Bonington's studio at his death. This may account for the suspicion that it is not quite finished, particularly in the foreground figures. In the event, in the sale following the artist's death, at Sotheby's, 29 June 1829, in the prominent position as the last item in the first day's sale, lot 110 was described as 'A HIGHLY FINISHED VIEW OF THE PALACE OF COUNT MAFFEI, AT VERONA, WITH RELIGIOUS PROCESSION, A SPLENDID SPECIMEN OF THE TALENTS OF THE ARTIST.' What must be the Yale picture was bought for the handsome sum of 70 guineas by one of the Directors of the British Institution, the Marquess of Stafford, in whose famous collection it remained until it was sold by Lord Ronald Sutherland Gower in 1911.

Bonington's arrival in Venice took place under cloudy skies, but he was able to draw countless details of the architecture and monuments in pencil, see the rich treasure of Venetian paintings in the churches and visit the Accademia where 'we can go close to the

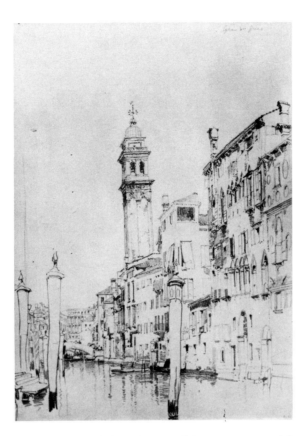

93 *Venice: the Rio dei Greci and the Greek Church.* 1826. Pencil, 15 × 10¾ in. (38.1×27.3 cm.) Inscribed by Bonington top right: *Eglise des Grecs, Venice.* Calne, Wiltshire, Bowood House

pictures, and even touch them', as Rivet remarked. They were also able to see a collection of historical costumes. A letter from Bonington's father brought news that he had sold every painting done since January, for which he had earned 7 to 8,000 francs. This probably included some of his larger seascapes in oil, as he had previously been earning about 200 francs per watercolour, that is about eight pounds in 1826 currency. Rivet advised him to buy a house when he got back. The weather and Bonington's temperament improved, and he began 'to complain less about the little he has done . . .'.

He made innumerable pencil sketches on the spot, some of which were later lithographed, and significantly he drew Titian's memorial in SS. Giovanno e Paolo. Rivet and he took dinner regularly at 5.30 p.m., then coffee afterwards in the Piazza San Marco. Sometimes they went to the theatre, where they saw Rossini's *La Semiramide*, which was 'being played indefinitely. Then we have an ice.' Just two of these drawings, many by their *mis-en-page* capable of being worked up later, will have to suffice as examples of his confident drawing style. *Venice: the Colleoni Monument* (Plate 92) is a bold individual study which he was later to use for a watercolour (Plate 94). As it is signed, and there are details in the original drawing which have been generalized into an overall silhouette, it too may have been done as one of his popular commissions on his return. A pencil drawing of *Venice: the Rio dei Greci and the Greek Church* (Plate 93), where his ability to describe detail and yet suggest atmosphere by what he left out, reveals that he was the equal, through his previous training, of any topographical draughtsman in Europe. There once existed a finished watercolour from this sharp study.

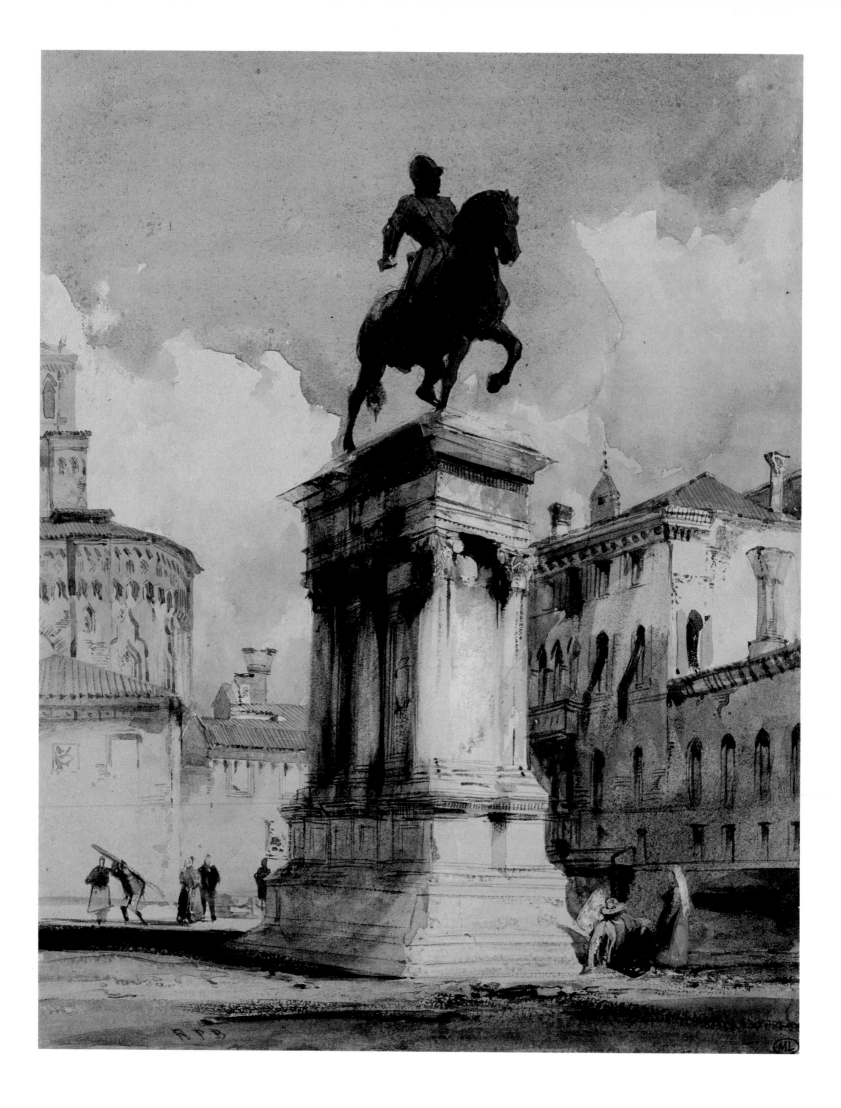

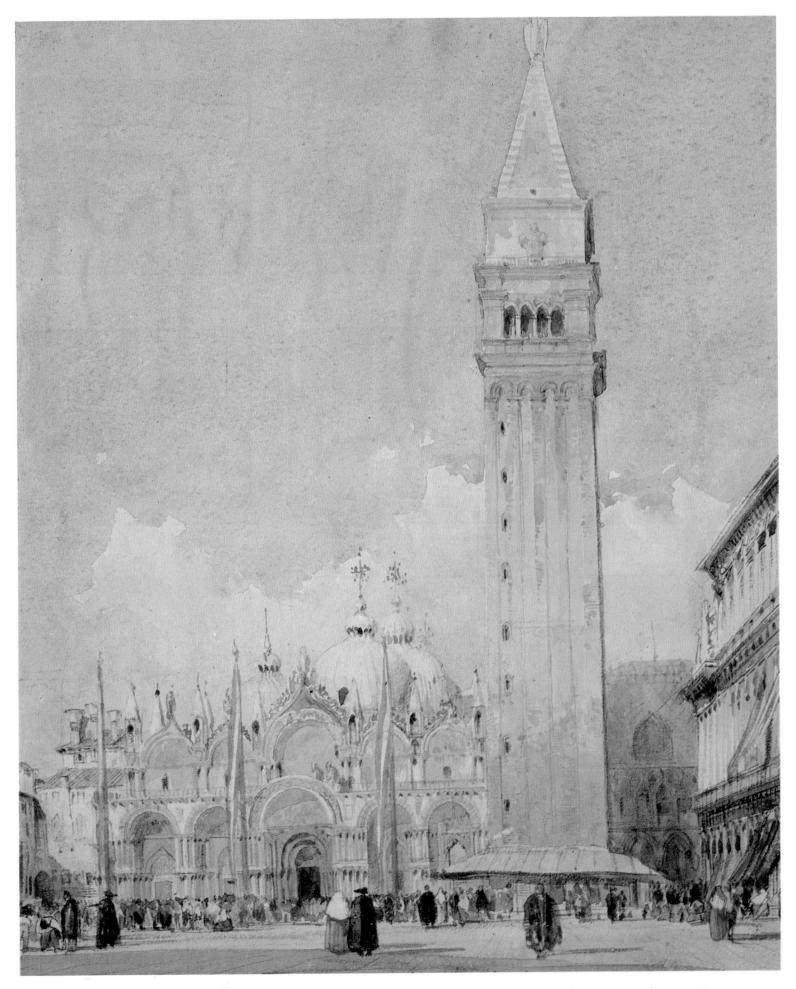

95 *Venice: the Piazza San Marco*. 1826. Watercolour, 10⅕ × 8⅕ in. (25.9x20.8 cm.) Signed and dated: *1826*, Cambridge, Fitzwilliam Museum

Opposite: 94 *Venice: the Colleoni Monument. c.* 1826–7. Watercolour, 9 × 6⅘ in. (22.9x17.5 cm.) Signed lower left: *RPB*. Paris, Musée du Louvre

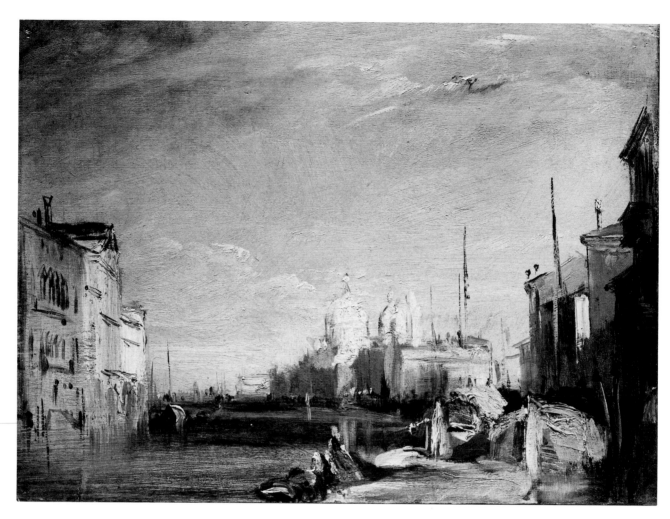

96 *Venice, the Grand Canal*. 1826. Oil on paper, laid on canvas, 8⅘ × 11⅘ in. (22.5x30.1 cm.) Edinburgh, National Gallery of Scotland

Bonington also found time to paint in oil, and his energy and facility during the month of his stay is astonishing. Only a few of the ravishing oil sketches he produced on his supply of millboards can be reproduced here. The *View on the Grand Canal* (Plate 1) may have been done from a gondola, as he had similarly once used cabs in Paris to draw from. It is a good example of his impressionistic touch for details of architecture not always accurate, but it equally well renders that particularly watery light of Venice. After rain in May, with the emerging sun, Venice would have sparkled, and Bonington was fully up to the task. A larger finished picture exists, which was once owned by Sir Robert Peel, where the principal buildings, including the Palazzo Bernardo, looking towards the Rialto were incorporated into the composition. The whole scene was also made more effective by the addition of moored boats and the dramatic use of chiaroscuro. It purports to be an evening scene. Other sketches produced motifs for finished pictures on his return to France, of which *Venice: the Grand Canal* (Plate 96) is an example. This was apparently painted from a boat near the Accademia Bridge, looking towards Santa Maria della Salute, whereas the Yale sketch was painted further up the Grand Canal looking the other way towards the Rialto. The Edinburgh sketch measures 22.5 x 30.2 cm., but the finished picture, measuring 102 x 134.6

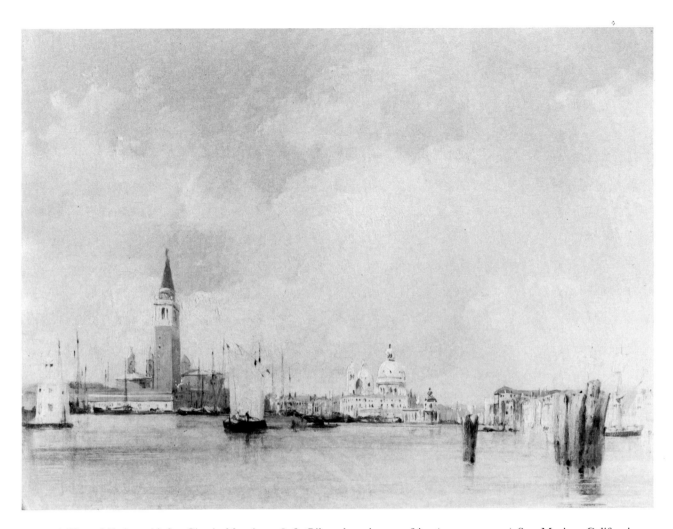

97 *A View of Venice, with San Giorgio Maggiore.* 1826. Oil on board, 12 × 16 in. (30.5x40.5 cm.) San Marino, California, Huntington Library and Art Gallery

cm., now in a private collection, was eventually bought by James Carpenter for 125 guineas (£131.25) for which a receipt exists, dated 23 February 1828. This was a respectable sum for a young artist. Constable was lucky to receive £100 for his 'six-foot' canvases. A rapid ink sketch of Bonington's painting is in a letter to John Barnett, which mentions other commissions, and it can be identified in a drawing by Thomas Shotter Boys of the interior of his studio in rue des Martyrs (Plate 100), which can be dated from before November 1827. Another sketch, which was in the artists's sale of 1829, showing another popular view of San Giorgio Maggiore and Sta. Maria della Salute, has recently been acquired by the Huntington Art Gallery, San Marino (Plate 97). Some oil sketches were based on an initial pencil drawing, of which one fine example is his *View of the Grand Canal with the Palazzo Bernardo, looking towards the Rialto* (Plate 101), which was recently on the market. The initial drawing (at Bowood) is taken slightly farther away from the Rialto, but in the sketch Bonington has compressed, or missed out, some of the buildings across the water. The Yale sketch (Plate 1) appears to incorporate the same Palazzo Bernardo, but it is very generalized, and there is no hint of the Rialto Bridge, which does however appear in the finished picture with the tell-tale campanile of San Bartolomeo, with its onion dome in the distance. The

98 *Bologna: the Leaning Towers. c.* 1826. Watercolour, body colour with some gum varnish, $9\frac{1}{3} \times 6\frac{2}{3}$ in. (23.4×16.9 cm.) London, Wallace Collection

99 *Paris: L'Institut Seen from the Quais.* 1828. Watercolour, with touches of gum, $9\frac{3}{5} \times 7\frac{4}{5}$ in. (24.5x20.0 cm.) London, British Museum

100 Thomas Shotter Boys (1803–74). *The Interior of Bonington's Studio*. 1827. Brown ink on tracing paper, 12½ × 16⅓ in. (31.7x41.5 cm.) London, British Museum

Palazzo Bernardo sketch (Plate 101) can be connected with an identical view which has been considered the finished, later version (Plate 85). This has been in the same collection since Bonington's posthumous sale, but it is smaller than the sparkling sketch, so perhaps on his return to France Bonington had a demand for such favourite views which he could hardly fulfill. This was certainly the case during 1827.

Samuel Prout later said that he had told Bonington where to stand to get the best views in Venice, and John Frederick Lewis (1805–1876), in a pencil drawing made later in the year (Cambridge, Fitzwilliam Museum), drew from exactly the same spot in a pencil style very close to Bonington's. Tourists with their cameras now stand on the only available projecting jetty, to take snapshots of the Rialto from an almost identical standpoint, but today there are very few painters jostling for space.

Bonington wanted to stay longer in Venice, even until July, but by mutual agreement with Rivet who wanted to see Florence and Bologna, they left on 19 May, after a stay of a little over a month. From the pencil drawings, which alone were done on the spot, and oil sketches, only some of which seem to have been, Bonington was to find a lucrative source of work until his final year. He produced watercolours and oils for this seemingly endless demand, some of which are included here to show what Venice meant in practical terms to a successful view painter. His obituary in *The Gentleman's Magazine* of 1828 suggested that he planned a series of large-scale Venetian views, but those that he managed to complete have only the simple addition of local colour, or the sort of devotional subjects that the watercolour of San Ambrogio, Milan, or his view of Verona included. There is little hint by the time of his death of his attempting history pictures in the same vein as Delacroix's *Execution of the Doge Marino Faliero*, or Turner's *Romeo and Juliet*, for example.

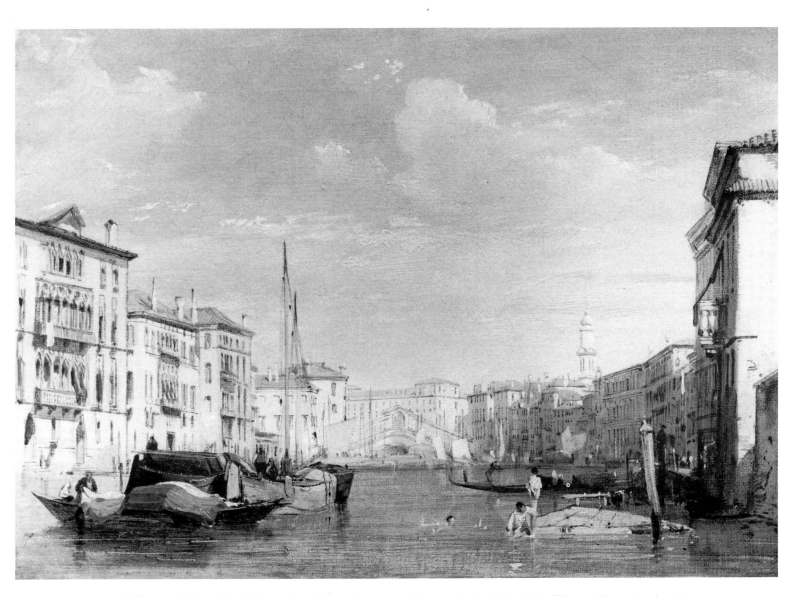

101 *A View on the Grand Canal, Venice, from Palazzo Bernardo, looking towards the Rialto.* 1826. Oil on millboard, 13⅘ × 18 in.
(35.2 × 45.4 cm.) Chicago, Richard L. Feigen

102 *Estuary with a Sailing Boat (Les Salinières by Trouville)*. *c.* 1826. Oil on board, 9 × 14 in. (22.8x35.5 cm.) Edinburgh,
National Gallery of Scotland

103 *A View of Lerici*. 1826. Oil on millboard, 14 × 18 in. (35.5x45.8 cm.) Chicago, Richard L. Feigen

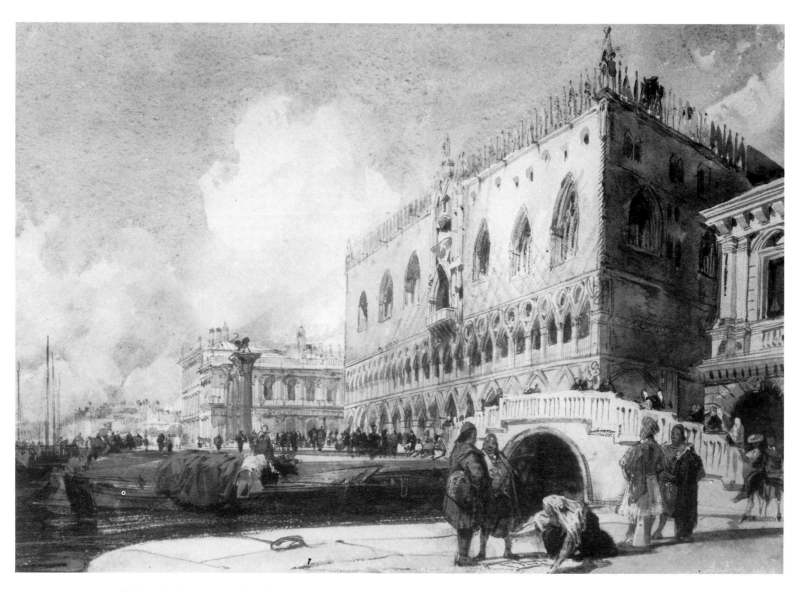

104 *Venice: the Doge's Palace from the Ponte della Paglia. c.* 1827. Watercolour and body colour with gum varnish, 8 × 10¾ in. (20.1x27.4 cm.) London, Wallace Collection

He worked from the initial pencil drawing, or oil sketch of the basic scene, towards a watercolour, and then the final picture was painted. This progression can be demonstrated in the watercolour of *Venice: the Doge's Palace from the Ponte della Paglia* (Plate 104) of *c.*1827, where he apparently 'skimped' on the architectural details that are obvious in his original pencil drawing (Bowood), a fault that can be found in his oil sketches. He has, however, included the Count of Palatiano in his palikar costume from his earlier studies. The finished picture which he exhibited at the Salon of 1827 (Plate 105) incorporated merchants from the Levant and even Switzerland, if the woman with the wide-brimmed hat is to be believed (Plate 88). A much larger picture of the same scene (Plate 106) which he exhibited at the British Institution of 1828, has introduced a religious procession with monks. They are reminiscences of Venice which Coutan in Paris, who owned the Louvre version, and Lord Northbrook, who owned the Tate picture, were pleased to acquire. The view of Bonington's studio (Plate 100) shows such large views being painted during 1827.

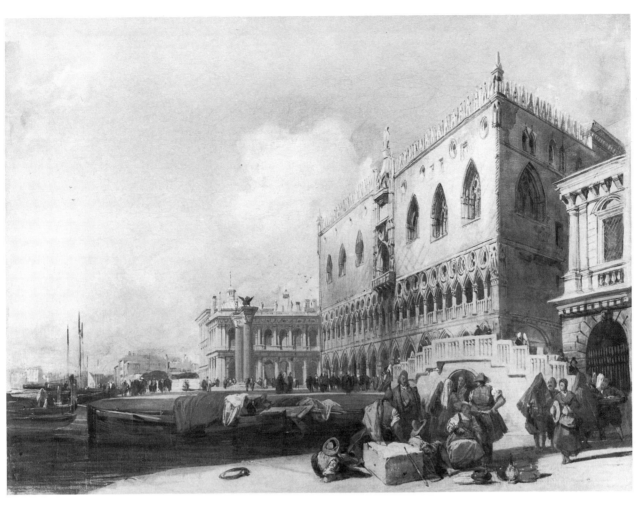

105 *Venice: the Doge's Palace from the Ponte della Paglia. c.* 1827. Oil on canvas, 16 × 21¼ in. (41.0x54.0 cm.) Paris, Musée du Louvre

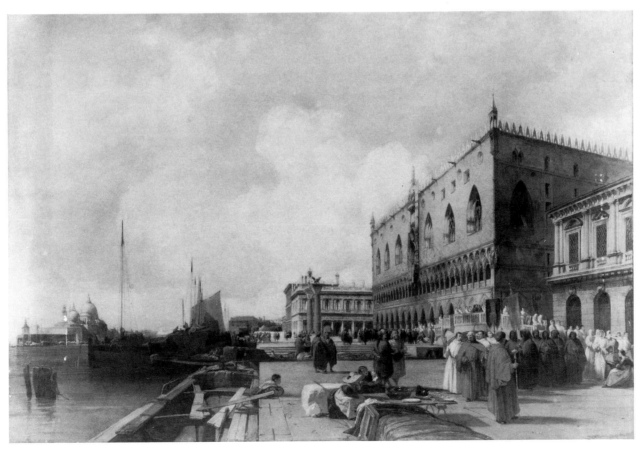

106 *Venice: Ducal Palace with a Religious Procession, c.* 1827–8. Oil on canvas, 114.3x162.6 cm. Signed lower right: *R P Bonington.* London, Tate Gallery

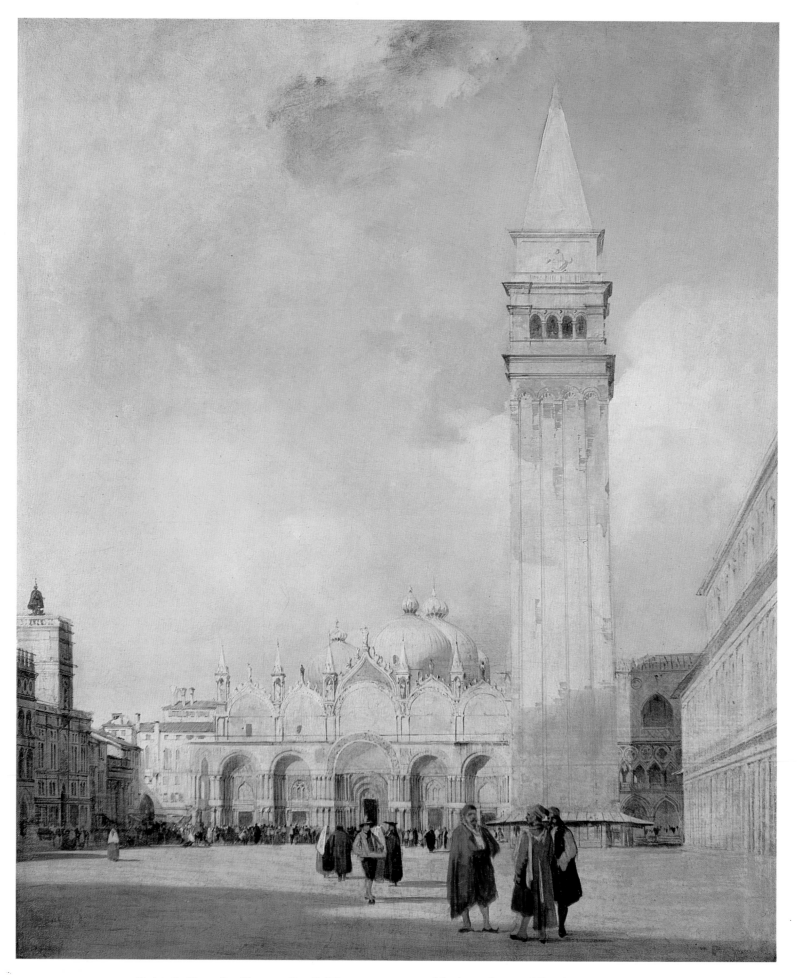

107 *Venice: the Piazza San Marco. c.* 1827–8. Oil on canvas, 39 × 31⅔ in. (99.4x80.3 cm.) London, Wallace Collection

108 *Venice, the Piazzetta. c.* 1826. Watercolour, 6⅘ × 8¾ in. (17.4x22.2 cm.) London, Wallace Collection

A similar sequence seems to have been followed from his brilliant, impressionistic watercolour *Piazza San Marco* (Plate 95), dated 1826, for which there does not appear to be a preliminary drawing, to the final, rather dull painting in the Wallace Collection (Plate 107). This was described as 'unfinished' at his sale in 1829, perhaps as one of the projected series, ordered but not paid for. Its size is an English 40 × 30 ins. canvas (101.6 × 76.2 cm.), which may give some hint of its destination. The watercolour of the Piazzetta (Plate 108), is based on a pencil drawing at Bowood, and another slightly different watercolour exists, but apparently no oil. Away from the scene he loses none of the sparkle of Venice in water-colour, whereas his finished pictures are rather laboured, which seems to confirm Delacroix's observation that he was not able to bring his initial brilliance to a finished conclusion on a large scale.

His brilliance on a small scale can be seen in his *View of Lerici* (Plate 103), one of the most atmospheric of his small oil sketches that he painted on Davy's millboard in Italy. Rivet and Bonington had set off from Venice to Padua, where they copied Titian's early frescoes, then to Ferrara, where Rivet hardly liked 'to admit that Raphael looks to me all

brick colour. I have been spoiled by the Venetian school.' They reached Bologna where some drawings were made, and by 24 May they reached Florence, where they remained, apart from an excursion to Pisa, for only a week. Bonington was, interestingly, attracted by the International Gothic style of Ghiberti, but not Michelangelo. They remained a little while at Lerici on the Gulf of Spezzia, where Byron had stayed and Shelley had been drowned four years before, and it was here that Bonington made a number of studies including this sketch. Its sparkling effects of light and water, with his delicate touches of red, make it the most attractive of his Italian views, and Rivet may have been the small figure sketching. It was bought at his posthumous sale by Sir Thomas Lawrence, the greatest of artist-connoisseurs. By 11 June Rivet and Bonington had reached Turin, and via Genoa, they returned to Paris on 20 June 1826. Significantly, they had not visited Rome, nor the Campagna, which every European artist hoped to do. Bonington had regretted leaving Venice, according to Rivet, 'he left it with a presentment that he would never see it again.'

On his return to Paris, he set about applying his new-found knowledge of Venetian art, light, and colouring to his landscapes and subject pictures, but he now had a new saleable subject of Italian views, of which Venice was foremost. The watercolour *Bologna: the Leaning Towers* (Plate 98) was probably painted after his return. It has the same impressionistic figures and bright blue sky of his watercolour *Piazza San Marco* (Plate 95), with the same inaccurate architecture – in this case he has greatly exaggerated the lean of the Torre Asinelli on the left, but it may also have been based on an initial pencil drawing. A rare pen and sepia ink drawing of studies and doodles (Plate 62), is mostly connected with his *Child at Prayer*, already mentioned with his small subject pictures of 1826 (Plate 63). This may give a date for the genesis of his small oil, as the sheet has a drawing of a gondola, with a hazy scribble of the Venetian skyline – probably a nostalgic memory. There are few rapid pen sketches by Bonington, except those drawn at the very end of his life, but as the studies are convincing as trials for the picture, rather than memories after it, the entire sheet must date from the latter half of 1826.

He did not neglect his old interests and friends when he returned to Paris. One new-found acquaintance was Thomas Shotter Boys (1803–1874), who sometime before 1826 had arrived in Paris, primarily to work as an engraver and lithographer. Boys' brother-in-law was W. J. Cooke, the engraver whom Bonington had met in London. Legend has it that Bonington encouraged Boys to turn from engraving to produce watercolour views of his own, which he did (Plate 109). He had certainly moved into Bonington's circle, as the letter of early 1826 reveals. During 1826 he was to paint – apparently in the company of Bonington – a view of *Les Salinières by Trouville* in watercolour, almost identical to Bonington's oil. An inscription on another watercolour by Bonington reveals that it was given to Boys in 1826, 'to show me the landscape of Chancre'. The oil sketch by Bonington (Plate 102) may, however, have been done in the studio, rather than side by side with Boys as has been suggested with a view to demonstrating his rapid fluid handling in this deceptively *plein-air* view of early spring.

They were still in contact in 1827 when Boys drew an interior of Bonington's studio (Plate 100), in the rue des Martyrs, which he was to leave at the end of 1827 for the rue St. Lazare. A rather bare interior is revealed, with hardly a hint, apart from a lute, of the studio props such as armour that Bonington possessed. It does show, however, the large views of Venice on which he was working. A view of the Doge's palace is on the easel, perhaps the Tate version (Plate 106), while *The View on the Grand Canal*, already mentioned, is that

109 Thomas Shotter Boys (1803–74). *Le Pont Royal, Paris. c.* 1830. Watercolour, $5\frac{2}{3} \times 9\frac{1}{2}$ in. (14.3x24.1 cm.) New Haven, Yale Center for British Art

leaning against another easel to its left. There are other pictures leaning against the wall to the right, which are also larger than his normal scale.

The style of Boys' own watercolours owes much to Bonington's example, and their mutual influence has been much discussed. They were about the same age, but Bonington's pre-eminence as a practising watercolourist and topographer must be acknowledged. Boys went on to produce scintillating views of Paris, for example *Le Pont Royal, Paris, c.*1830 (Plate 109). Although previously attributed to Bonington, this watercolour, when it is compared to one of Bonington's late works, *L'Institut Seen from the Quais* (Plate 99), shows marked inferiority of detail and atmospheric effect, even though the Bonington watercolour may well have been executed when he was ailing. Boys was to finish Bonington's only line etching *Bologna: the Leaning Towers* (Plate 98) after the latter's death, thus underlining his close but secondary role as a print maker. Boys was never better than with his series of Parisian and London townscapes of the 1830s, but that is all he ever did, and he was to fall on hard times. Bonington had already developed a varied technique to cope with a greater range of subject matter. The sadness of Bonington's final years was his inability to realize this potential.

110 *A Lady Dressing her Hair*. 1827. Pencil, watercolour, body colour, with gum varnish, 6 × 4 in. (15.2x10.2 cm.) Signed
lower right: *RPB 1827*. London, Wallace Collection

THE FINAL YEARS

Bonington was to turn again to his well-tried subjects during his remaining years, which finally brought him an international reputation. He was, after all, only 24, and did not know that he had only two years left to him. He had already made contact with the London trade for his engraved views, and he achieved in 1826 an immediate success with the aristocratic arbiters of taste in London. In Paris, he was already well known as one of the leading artists of the 'Anglo-Venetienne' school, and was linked with Delacroix and his circle in their attempt to create a new, romantic school of history painting. He was patronized by rich connoisseurs such as Coutan and Lewis Brown, who were avid for his works.

The most obvious result of his trip to Italy, apart from the tedious industry of providing views on demand, was the small cabinet pictures which he produced during the remainder of 1826, and the next two years, when he also exhibited them publicly. He had produced a further series of lithographs during 1826 for *Voyages pittoresques de l'Ecosse*, which he had never visited, and his prints were made after drawings by Pichot. His *Cahiers de Six Sujets*, which were from original designs, had found a ready market that he could develop. The design of *Amy Robsart and the Earl of Leicester* (Plate 111) had been published in reverse, and with some other differences, as the lithograph, *Le Silence Favorable*, in his *Cahiers*. Two later prints call it *The Gentle Reproof*. The male figure was based on a pencil drawing of Charles IX, by Clouet in the Louvre (Nottingham), and there was a watercolour version. The oil was simply called *Gentleman, Lady, and Dog* when it appeared in the Duke of Hamilton's sale; it is not clear when it came to be identified as the Earl of Leicester and his future wife, Amy Robsart, who both appear in Sir Walter Scott's *Kenilworth*, but it is a plausible identification. The oil must be a late variant in his sketchiest technique, which owes something to his Venetian experience for its painterly qualities, but with elegant overtones of Van Dyck.

The later cabinet pictures reveal the Venetian influence most strongly. There is a richness of colouring, which follows everyone's idea of Venice, that found expression in his work through a greater intensity of reds, blues, and a particular bright green. Even his landscape, *Les Salinières* (Plate 102), has it. To these bright colours, he added a luminosity in the shadows, which hints at the glazes of Venetian painters, always a source of envy to British artists, as Delacroix sharply observed in his Journals. With these sensuous elements, there is a feeling for the touch and sheen of fabrics, to which he was able to add Venetian details of architecture, sixteenth-century costume, and props, such as the lute in his studio. With the introduction of musical instruments, he not only echoes the Indian and Persian

miniatures he admired, but also anticipates the analogies between art and music which were made later in the nineteenth century with the Aesthetic movement. These elements of music, architecture, and costume were all combined to present a nostalgic view of the romance of Venice.

All of these tendencies can be seen in the subjects previously illustrated, particularly in *The Earl of Surrey and Fair Geraldine* (Plate 55), which had already incorporated the decorative world of Veronese that he had seen in the Louvre. He was still capable of this nostalgic view of Venice in his *Venetian Scene* (Plate 112) which, as it is signed, must have been meant as a finished watercolour. It is, as it were, a portion of Veronese's *Marriage Feast at Cana* (Louvre), but with figures that seem to originate in Titian's frescoes which he had seen at Padua. The page had appeared before with his knight (Plate 49), and an earlier version of 1826 had already set the scene. The principal woman's head is from Sebastiano del Piombo's *Visitation*, but smirking now at a lesser pleasure than a virgin birth.

But by his first-hand encounter with the expressiveness of Titian, and the drama of Tintoretto, he could now incorporate a rhetoric of gesture and pose, and a feeling for chiaroscuro in his intimate pictures, that would give them an intensity, not only of surface, but also of emotion. In these respects, his last subject pictures began to come to terms with the requirements of history painting on a larger scale, terms which Delacroix had already met.

A Lady Dressing her Hair (Plate 110) signed and dated 1827, is basically a watercolour but with so much gum and body colour that it almost qualifies as an oil sketch. It hints at an individualized moment in a seventeenth-century world with its heraldic green, mullioned windows, oak chair, and rich Dutch table carpet. This has been sensitively described by Ingamells as 'a particularly happy example of Bonington's historical genre . . . reminiscent of Keats' *The Eve of St. Agnes*:

> her vespers done
> Of all its wreathed pearls her hair she frees . . .'

She could equally well be dressing for an evening's assignation, with her elegant twisted pose and her bright green dress; the still life, and the bold slashes of paint across the chair enhance the sensuousness of the mood, thus making the enigmatic woman all the more tantalizing. The age of Victoria might have thought this indulgent gem smacked too much of the Regency period, and the lady might have been in danger of becoming a 'Fallen Woman', the subject of endless tracts from that day to this. Bonington, happily, did not make his position clear.

He did not at this stage attempt to show these intimate works at any exhibitions. He sent nothing to the British Institution of 1827, perhaps because of their exhibition of pictures from Carlton House, which therefore meant a much reduced, and later, winter exhibition when it finally opened. He did, however, submit an earlier work to the Royal Academy in April 1827, *A Scene on the French Coast*; it was thought to be by William Collins. His painting would have competed with Turner's *Now for the Painter . . .*, *Port Ruysdael*, and Constable's *Chain Pier, Brighton*, the latter remaining unsold, despite praise in *The Times*. The comparison of Bonington with Collins in the *Literary Gazette* would have especially rankled with Constable. Bonington had visited England in the spring of 1827 with a letter of introduction to Sir Thomas Lawrence from Mrs. Forster, the wife of the chaplain of the British Embassy in Paris, whom Lawrence knew from his stay there when painting Charles

111 *Amy Robsart and the Earl of Leicester*. 1826–7. Oil on canvas, 13¾ × 10⅔ in. (35.0x27.0 cm.) Oxford, Ashmolean Museum

X in 1825. Bonington seems to have been too shy to use it. He did, however, renew his contacts with the London art trade, with Dominic Colnaghi, W. B. Cooke, James Carpenter, and John Barnett, all of whom were to commission works, and later publish many prints after his designs. The following surviving letter give some idea of the work that was to ensue, as Bonington's health became steadily worse. The first was to Dominic Colnaghi, October 1827, from rue des Martyrs:

> Availing myself of the kind offer of Mr. Pickersgill, I have forwarded to you
> a small painting in the hope of completing the order you honor'd me with,
> when in England last. I must beg you to look with charitable eyes, at least
> till you may see it in a frame or varnished – the subject is a street in Verona,
> the building that advances is the Casa Mafei. May I request the favour of
> a few lines with your opinion; should it not meet with your approbation I
> beg you will by no means keep it from motives of delicacy. I would rather
> make a dozen trials and I hope to succeed at last. My friend Mr. Barnett
> wrote me you wished some drawings from Shakespeare with views, Venice
> etc. etc., but neither did he mention the size nor whether you wished the
> figures or background to be the principal. I have not yet commenced them,
> expecting to write to you soon.
> Anxious to hear from you on this subject as well as respecting my painting,
> I can sincerely hope that my endeavor may prove successful.
>
> > Allow me to remain
> > Your most obliged
> > R. P. Bonington

112 *A Venetian Scene. c.* 1827–8. Pencil, watercolour, body colour, with gum varnish, 7 × 9⅘ in. (18x24.9 cm.)
London, Wallace Collection

Opposite: 113 *Francis I and Margaret of Navarre. c.* 1827. Oil on canvas, 18 × 13⅔ in. (45.7x34.5 cm.) London, Wallace
Collection

In addition to unfulfilled commissions for Shakespearean illustrations, he may also have been referring, in his modest way, to the Yale picture (Plate 90) or the sketch. He also wrote to W.B. Cooke on 5 November about a commission for drawings of Père Lachaise, and Venetian drawings to be engraved. There was also a picture of Venice promised, and a request for Cooke to send a Venetian view 'of the two columns' to the British Institution by 18 January. This suggests that it was already in London, and the painting of the *View of the Piazzetta* (Tate Gallery) was duly sent in 1828 where it was bought by Robert Vernon, the important collector of British art. He had, at the same time, written to John Barnett, 21 October 1827, mentioning his Venetian views for Carpenter at the price of 125 guineas.

In France, the Salon of 1827 opened on 4 November, and he sent his view of *The Ducal Palace at Venice*, which was considered finer than Canaletto, and a view of *The Cathedral at Rouen*. In February 1828, a second supplement of the Salon opened, for which he substituted *Francis I and Margaret of Navarre* (Plate 113), *A View in Venice*, and probably a watercolour of *St. Omer*, at the same time as his *Piazzetta* view and a *Ducal Palace* were exhibited in London at the British Institution. He was also able to visit London again, where this time he did call on Sir Thomas Lawrence, apparently showing him a number of historical works, possibly including *Henri III receiving Don John of Austria* (Plate 117). He was also to publish a series of vignettes called *Contes du Gai Scavoir* which hark back to his early interest in medieval ballads, and to which his friend Henri Monnier also contributed.

Thus, in the midst of his Venetian industry, his other work was not neglected in spite of failing health. *Francis I and Margaret of Navarre* (Plate 113) is one of many variants of his famous composition, and probably not that exhibited at the rehung Salon of 1828, which had two dogs and a slightly different design. It is not clear which is the prime original of this late design, but the picture (Plate 113) shows very clearly how the influence of Venice has affected what is in fact a sixteenth-century French subject. Francis I (1494–1547), whose appearance here is based on Titian's portrait in the Louvre, is shown with his beloved sister, Marguerite d'Angoulème (1492–1549), who married Henry, King of Navarre. In 1724 the discovery was made of the inscription incised on the window at Chambord with a diamond, apparently in Francis' own hand:

Souvent femme varie
Mal habil qui s'y fie

The subject was painted by F. Richard in 1804, and Delacroix also worked on a design. They all incorporate Margaret of Navarre, and both Delacroix and Bonington owe much to Richard's design. This moment of contemplation, with the splendidly casual pose of Francis, became a famous image of the Romantic movement, as it seems to encapsulate its historicism, its vivacity, and its immediacy, happily realized by Bonington in this late work.

For the French market Bonington's smaller watercolours continued to find favour. *The Antiquary* (Plate 115) used a drawing which was probably based on an engraving after Tintoretto's *Doge Nicolo da Ponte* (Plate 114). His own experience of Tintoretto has enabled him to make the drawing much starker than his earlier copies, with bold strokes of chalk again influenced by his use of lithographic crayon. The head has been incorporated into a psychological rendering of the enthusiasm of a collector for his object. The woman bearing the refreshment seems less than enthusiastic and has stepped out of a Terborch. Their relationship, however, can be compared to *Don Quixote* (Plate 66), and Bonington may have

Left: 114 *Doge Nicolo da Ponte after Tintoretto. c.* 1823–5. Pencil, 6 × 5 in. (15.5x12.7 cm.) Calne, Wiltshire, Bowood House

Right: 115 *The Antiquary. c.* 1827. Watercolour and body colour with gum varnish, 8⅛ × 6⅓ in. (20.7x16 cm.) London, Wallace Collection

remembered the role of the spectators in Delacroix's version, which helps focus our attention on the central figure. It has all of Bonington's richness of texture which, for twentieth-century purists of watercolour, was 'a hybrid and meretricious result that is certainly near to oil painting'. Martin Hardie's extreme opinion gives a very limited range for watercolour and not one that was very strictly adhered to in the 1820s and 1830s following Bonington's resonant example.

A further development of the relationship of a similar central figure to another, is now called *Old Man and a Child* (Plate 116) dated 1827. The scene has no real subject other than the intensity of their relationship. In this late example of his 'fancy pictures', Bonington has finally achieved an emotional power comparable with Wilkie, to which he has also added the expressiveness he had found in Venetian art, here shown particularly in the tilt of the child's head and the confident set of the old man's pose. In addition, his richness of colouring, the blue hangings, the red sixteenth-century hat, and the touches of bright green on his shoes, also sing out as Venetian. The rapid white highlights on the child's dress project her into the foreground, which is an example of his increasing control of space to enhance

117 *Henri III receiving Don John of Austria. c.* 1828. Oil on canvas, $21\frac{1}{4} \times 25\frac{1}{3}$ in. (54.0x64.4 cm.) London, Wallace Collection

Opposite: 116 *Old Man and a Child.* 1827. Watercolour, body colour, with gum varnish, $7\frac{1}{2} \times 5\frac{1}{2}$ in. (19.2x14.2 cm.) Signed
lower right: *R. P. Bonington 1827*. London, Wallace Collection

his dramatic effects. It is, *pace* Martin Hardie, a masterpiece of Bonington's late poetical history painting. Connected as he was with other romantic history painters, such as Delacroix – and even Ingres' example was of some importance to him – Bonington's achievement was analogous to that of Watteau a century before. As the French Academy had had to invent a new category of subject picture to accommodate Watteau's *pièce de réception*, that of the *fête galante*, concerned not with heroism but passion, so Bonington developed a personal and individual form of romantic subject painting, which could be described as a sort of 'poetique venetienne,' dealing not with passion, but with recollection. Contemporary critics certainly recognized the connection of the new school with Venice, although they were not always complimentary.

To Lawrence, an admirer of history painting, Bonington showed the version of his *Henri III receiving Don John of Austria* (Plate 117), which he exhibited at the Royal Academy in 1828. It was his most ambitious and largest history painting so far, which seems to confirm Delacroix's idea that it was in this area that he wished to succeed. When the painting was exhibited at the Royal Academy it was accompanied by a quotation from A. Dumesnil, *Historie de Juan d'Autriche*, 1825, which described the scene. Henri III (1551–1589) was visited by Don John of Austria, en route to the Netherlands from Spain. Disguised as a servant, he gained entrance to the king's foppish court, where to his horror he found him surrounded by simpering retainers in the midst of a menagerie of chimpanzees and brightly coloured parrots, at the edge of which the king languidly dangled a fan. Delacroix may have lent Bonington a study of a head of Henri III after a portrait of *c*.1581, and indeed Delacroix's picture of *Henri IV and Gabrielle d'Estrees* has certain elements in common, but Bonington probably had little idea that this particular subject would not 'play', as they say, in London. It was praised by journalists, but hung low and was not sold. It was bought at his posthumous sale for 80 guineas. It is conceivable that Bonington was entirely unaware of the implications of his subject, although the elegant, twisted pose of the 'mignon' at the right gives some idea of the court, and the general francophobic attitude of his English collectors could have given some impetus towards its sale. It is clear, however, that to Bonington it was merely an excuse to dramatize an episode from French history, which gave him an opportunity to draw from his repertory of poses from the sixteenth and seventeenth centuries. The setting is almost as important as the two figures. The colours of the parakeets and the sheen and decoration of the costumes make this a very delicious contretemps. It was probably his last essay into dramatic subject matter.

This was to be his apogee, with almost simultaneous exhibits at the Salon, the British Institution, and the Royal Academy. He had also shown a coast scene and a Venetian view at the Academy, and there is no doubt that to him his future still was open. An *Odalisque aux Palmiers* in watercolour (Plate 120) is a mysterious variant of his oriental genre. A *Stormy Landscape with a Waggon descending a Hill*, also in watercolour (Plate 121), is a dramatic version of *c*.1827 of the Normandy landscapes, to which he still returned. In *Rouen: the Abbey of St. Armand* (Plate 128) he was still transcribing his Normandy topography into more dramatic architectural compositions, although admittedly with a looser hand. The oil of *Francis I and the Duchesse d'Etampes* (Plate 118) incorporated all his knowledge of sixteenth-century poses and elegant costume into a rich mélange. This would be suitable for connoisseurs of small intimate pictures, but by 1828 Bonington had finally realized that in England when people talked of art, they generally meant landscape, and his version of history may not have found favour as in Paris.

118 *Francis I and the Duchesse d'Etampes. c.* 1828. Oil on canvas, 13¾ × 10⅔ in. (35x27 cm.) Paris, Musée du Louvre

This may account for the dilemma he was in, compounded by his increasing weakness. The ideas and touch were still there, as were the commissions gained from London for vignette poetic illustrations, or pictures of Venice, but nothing too stern was rendered. *La Siesta* (Plate 119) signed and dated 1828, may be his last venture into 'poetiques venetiennes', and it was bought by Carpenter. It is surprisingly fuzzy, and obviously derivative of his *Le Repos* of 1826. He, himself, was in need of a rest. He had made the third effort of a visit to England to see Sir Thomas Lawrence, and to bring over his Academy exhibits. He wanted again to visit Normandy, accompanied by Huet, but he got no further than Mantes, and had to return. He had written the previous year to John Barnett, that 'What with pictures, and what with drawings, I shall not know which way to turn myself.' In July 1828 he wrote a letter to his friend, Godefroy, that gave a sad hint of his decline. He was taken for walks in the Bois de Boulogne. The large watercolour of L'Institut (Plate 99) may have been painted at this time, using sketches done from a cab.

Left: 119 *La Siesta*. 1828. Pencil, watercolour, body colour with gum varnish, $7\frac{2}{3} \times 5\frac{1}{8}$ in. (18.6x13 cm.) Signed lower left: *RPB 1828*. London, Wallace Collection

Right: 120 *Odalisque aux Palmiers*. 1827. Watercolour, body colour with gum varnish, $7\frac{1}{2} \times 5$ in. (19.0x13.0 cm.) Signed lower left: *RPB 1827*. Paris, Musée du Louvre

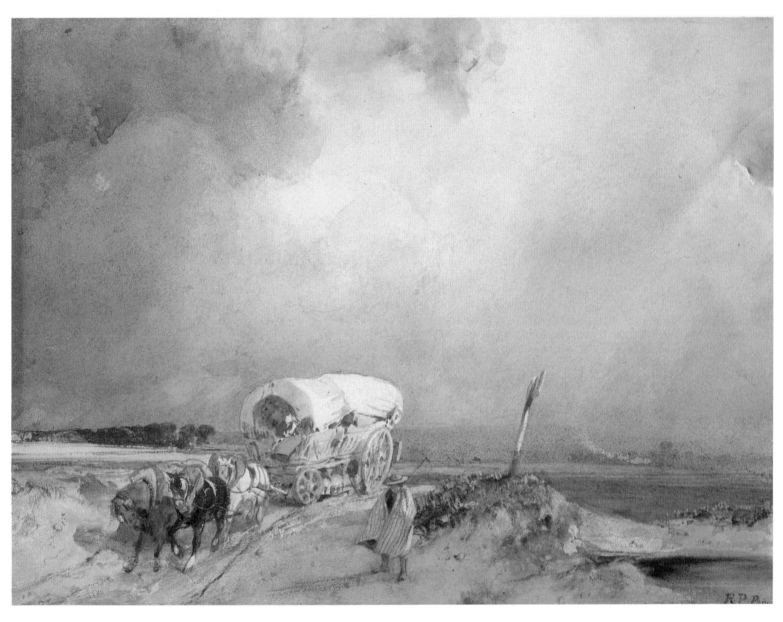

121 *Stormy Landscape with a Waggon descending a Hill. c.* 1827. Watercolour, $8\frac{3}{4} \times 10\frac{3}{4}$ in. (22.2x27.3 cm.) Inscribed or signed
lower right: *R P Bon*[*ington*]. Melbourne, National Gallery of Victoria

122 *Head and Shoulders of a Girl. c.* 1827–8. Pen and sepia ink, $6\frac{7}{8} \times 4\frac{1}{2}$ in. (17.5x11.4 cm.) Melbourne, National Gallery of Victoria

A number of drawings in sepia, walnut juice ink, and even watercolour, can be attributed to his final phase, on the basis of accounts of his last months. The sheet of drawings connected with the *Child at Prayer* (Plate 63) is an example of Bonington drawing in ink, as Delacroix had done in 1826. The *Studies for Shylock* (Endpapers) cannot easily have been drawn with a pen and ink at a theatre. It is true, however that Charles Kean was performing this role in Paris in 1828, and the drawing has several rapid gestures of an actor in performance. In style, however, it can be linked with the Edinburgh sheet (Plate 62) and it may represent the first glimmerings of ideas for the Shakespearian subjects that Colnaghi had apparently asked for by October 1827. In this case, the figures are 'the principals', as he put it to Colnaghi, but his knowledge of Venice would have been appropriate for the background to Shylock, the Merchant of Venice. The small figures at the bottom left are courtiers from a Venetian scene. Bonington did not start many Shakespearian sketches and only a few survive, for example, one in the Bibliothèque Nationale, which seems to represent *Romeo and Juliet*. His increasing concentration on dramatic scenes towards the end of his life could have given rise to many further compositions. Barnett had suggested *A Midsummer Night's Dream*, which Bonington said he was 'all anxiety to do!' 'Hamlet with Polonius', 'Henry IV with Prince Hal', 'Prince Hal courting his French wife', and so on, would have provided endless possibilities for Bonington's own style of figure compositions, had he been able to

123 *La Sylphide*. 1828. Pencil and sepia, $6\frac{1}{5} \times 4\frac{1}{2}$ in. (15.6x11.4 cm.) Signed and dated: RPB 1828. Calne, Wiltshire, Bowood House

proceed with the scheme. He had already painted *Anne Page and Slender* (Plate 54). The *Head and Shoulders of a Girl* (Plate 122) is a simple downcast pose done in pen and ink. It explores the potential for expression, perhaps for Juliet, but also for how he should draw with a pen.

His next visit to England was to be his last. With increasing desperation his parents decided to consult a quack doctor, John St. John Long, in London. He had a reputation for curing tuberculosis, but was himself to succumb to the disease. The family left for London in September, and Bonington dictated a letter to John Barnett that he could not travel without the help of his parents, to which his mother's postscript added that 'such is the State of our dear child that the great Power above can only save him . . . Our hearts are breaking.' In London, John Saddler, a pupil of W. J. Cooke, and his brother-in-law, Thomas Shotter Boys, saw Bonington trying out permanent brown ink made from walnut juice. Bonington had to be supported on two or three chairs. He expressed 'his intention when he was better he should try the material further . . .'

He had already drawn small vignettes in brown ink in the manner of Stothard, such as *La Sylphide* (Plate 123), which is totally in the style of sentimental illustrations for *The Keepsake*. The *Study of Two Female Figures* (Plate 126) may well have been another of these sentimental drawing experiments that was rescued from the wastepaper basket by Saddler in Bonington's final month in London.

During 1828 Bonington had not overlooked his initial love for watercolour landscapes. *A Coast Scene with Shipping* (Plate 124) is dated 1828, and with these last landscapes there is an expressiveness of space which parallels the dramatization of his subject pictures, but it is doubtful if any of the former were done on the spot. The *Coast Scene with Shipping* has a dry brushstroke, with a deliberate bold diagonal composition, but the view draws primarily on his memory of past scenes.

Even more impressive as a finished watercolour of 1828 is his *Sunset in the Pays de Caux* (Plate 125). This may well be based on an excursion with Newton Fielding in 1824, and there were initial pencil drawings in existence, but four years later when he signed this sheet, he had begun to come to terms with a much broader view of what landscape could be. By 1828 he had seen original Turners, and this surely is the explanation for the sun in the middle of the composition which overwhelms every other detail of the fisherfolk, however much they are picked out in red and blue. Finally, Bonington has achieved an understanding of Turner in an overall way that his earlier *Fish Market, Boulogne* (Plate 24) merely touched on. Had he been capable of continuing in this vein, Collins and Constable would have had just cause for alarm. This example, while his powers still held, was as far as he could go. *The Undercliff* (Plate 127), dated 1828, was apparently his last finished drawing, inscribed 'August 6th & 7th 1828 the last drawing made by our dear son about prior to his fatal dissolution. E. Bonington.' The scene of embarkation may have been portentous, and in this last image Bonington seems to have summoned up all the powers of his brushwork. He no longer bothers about the details of masts and figures but describes the whole scene in a few broad washes.

124 *A Coast Scene with Shipping*. 1828. Watercolour, $5\frac{3}{4} \times 7\frac{1}{4}$in. (14.6x18.4 cm.) Signed lower centre: *RPB 1828*. Aberdeen Art Gallery

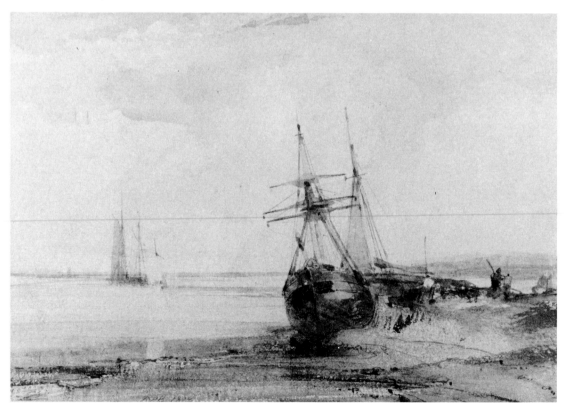

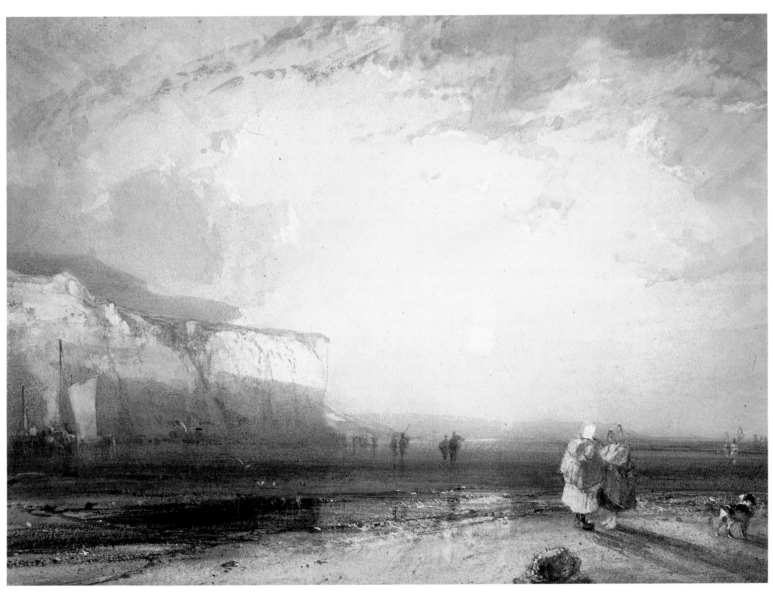

125 *Sunset in the Pays de Caux.* 1828. Watercolour, body colour, with gum varnish, $7\frac{4}{5} \times 10\frac{2}{5}$ in. (19.8x26.3 cm.) Signed
lower right: *RPB 1828*. London, Wallace Collection

126 *Study of Two Female Figures. c.* 1828. Pen and sepia ink, $3 \times 1\frac{1}{4}$ in. (7.9x3.2 cm.) Nottingham, Castle Museum and Art Gallery

He died 23 September 1828, in the house of John Barnett, 29 Tottenham Street, from which he had submitted his Academy exhibits of that year. He was buried at St. James's Chapel, Pentonville. Sir Thomas Lawrence, Henry Howard, G. F. Robson, Pugin, and the Rev. J. Judkin, Constable's friend, attended the ceremony. Lawrence wrote to Mrs. Forster in Paris:

> Except in the case of Mr. Harlow, I have never known in my own time the
> early death of talent so promising and so rapidly and obviously improving.
> If I may judge from the later direction of his studies, and from remembrance
> of a morning's conversation, his mind seemed expanding every way and
> ripening into full maturity of taste and elevated judgement, with that
> generous ambition which makes confinement to lesser departments in the art
> painfully irksome and annoying.

His parents circulated notices of death, there was a posthumous sale organized with professional perspicacity by his father in 1829, and then further sales from his father's (1834), and his mother's (1838) estate. Other important sales of his work took place in 1830 with the Coutan Sale in Paris and Sir Thomas Lawrence's sale in London. His reputation was further enhanced by the sales from the famous collection of John Lewis Brown in Paris in 1834 and 1837. When E. W. Cooke and Frederick Nash saw examples from the Brown collection in London in 1834, Cooke commented that they were 'Truly splendid and surprising works of art! Nothing in art so much affected me before!' In the same year it was remarked of Bonington that 'Fashion has made him an idol!'

Propositions have been forwarded that Bonington's artistic output was part of a group style, but the Wallace Collection alone has enough examples in watercolour and oil to show how influential he was on a whole group of French artists who were his younger con-

temporaries in France. Many were also pupils of Baron Gros, such as J. L. H. Bellangé (1800–66), or Leon Cogniet (1794–1880) whose *Rebecca and Sir Brian de Bois Guilbert*, taken from Scott's *Ivanhoe*, was painted in 1828. Bonington's intimate style of history painting was taken up by other French artists, such as Joseph Nicholas Robert-Fleury (1797–1891), with his *Cardinal Richelieu* of 1831 and 1834, or Camille-Joseph-Etienne Roqueplan (1803–55), with his watercolour of *Meg Merilees*, 1834, now at the Whitworth Art Gallery, Manchester. Paul Delaroche (1797–1856) was to become famous as a history painter with an independent style, but his *Death of the Duc de Guise* of 1832 in watercolour, and his *The Alchemist* certainly owe much to Bonington's example. Even Alexandre-Gabriel Decamps (1803–60), who was to specialize in Middle-Eastern subjects, occasionally paid homage to the pioneering oriental subjects of Delacroix and Bonington; Decamps' *Janissary*, exhibited at the Salon of 1827, and *Bookworm*, painted as late as 1846 – both reveal a debt to Bonington's style.

In landscape painting, Bonington's influence was even more widespread. The list of French artists, major and minor, who were touched in some way by Bonington's example, ranges from Roqueplan, Isabey and Huet through to Corot and other members of the Barbizon group such as Diaz, Rousseau, Daubigny, and Dupré. English artists were also affected. The reaction of Constable and Turner, and the delight taken by leading patrons of art in his work has already been mentioned, but younger English artists were also impressed. William Wyld, James Holland, Thomas Shotter Boys, W. J. Müller and David Roberts are the English artists most obviously influenced by Bonington, and their work has sometimes been confused with his; William Callow, David Cox, Clarkson Stanfield, Thales Fielding and Samuel Prout should also be included, although they rarely attained Bonington's delicacy of touch or sparkle. This roll-call of honour would seem to contradict attempts to suppress Bonington anonymously in a group of artists.

Apart from the giants of Romanticism such as Géricault, Delacroix, Turner, and Constable, there is no other artist of Bonington's generation who could claim to be his equal in the facility and imaginative powers of his landscape and subject paintings. It is perhaps a failing of modern perception that does not hear the echoes in his art of the masters of the past, or realize that his particular brand of eclecticism was an integral part of the Romantic movement. During his short life he strove to be equal to the task of fulfilling his many commissions, and his industry and facility were never in doubt. At the very end of his life he stood on the threshold of an individual, non-judgemental style of history painting, a style that was particularly to be developed in the Victorian age when the popular anecdotal aspects of his art were seized upon. There is every indication that his painting was about to achieve a larger vision, and he seems to have come closer to a real understanding of Turner than many of that artist's other followers such as J. B. Pyne ar Holland. There was no other contemporary who came near to such an achievement. We must, however, content ourselves with the considerable evidence of Bonington's growing vision, rather than speculate too grandly. The fare is rich even so.

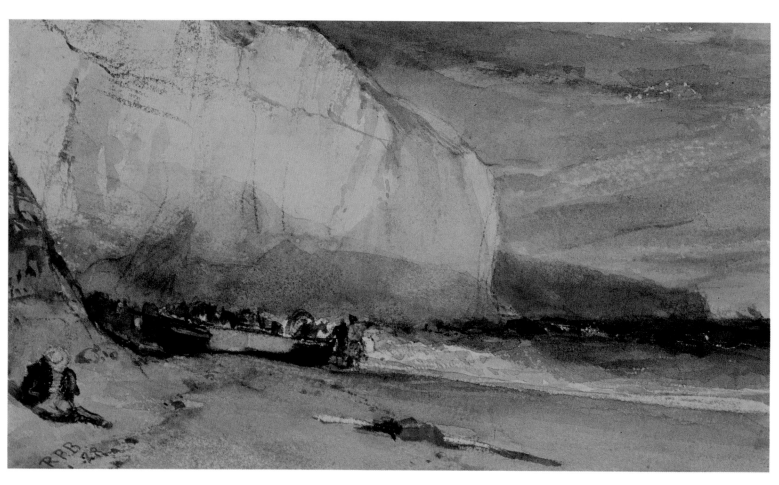

127 *The Undercliff.* 1828. Watercolour, $5\frac{1}{5} \times 8\frac{1}{2}$ in. (13.0×21.5 cm.) Signed lower left: *RPB 28*. Nottingham, Castle Museum and Art Gallery

ACKNOWLEDGEMENTS

Because this is the sort of book without footnotes, acknowledgement to many authors is here made generally. To A. Dubuisson and C. E. Hughes all writers on Bonington are indebted for their important pioneering work. Everyone working on Bonington is grateful for Marion Spencer's exhibition in 1965 at Nottingham which provided the largest display of his work, and I also benefited from conversations with her, as well as with the late Edward Croft Murray and Dr. Lee Johnson, during the course of the exhibition. More recently, John Ingamells and my colleague, Patrick Noon, above all, have helped me most unselfishly with advice, and shared the results of their researches. The work of Sir Roy Strong, Professor Francis Haskell, and Marcia Pointon has also been useful, and I have received much help from Evelyn Joll at Agnew's, David Moore-Gwyn at Sotheby's, Simon Dickinson at Christie's, and Anthony Spink of Spinks Ltd., as well as Robert Wark, Richard Feigen, David Scrase, and Duncan Robinson who must be thanked particularly for many kindnesses. The staff of the Paul Mellon Centre for British Studies, especially Brian Allen, Evelyn Newby, and Douglas Smith have, as always, been most kind, as have the staff in the Photo Archive at the Yale Center for British Art. Finally, Joy Pepe has been very patient and assiduous in coping with the manuscript.

Photographic Acknowledgements

The National Trust, Fairhaven Collection, Anglesey Abbey 76; The Trustees, The Cecil Higgins Art Gallery, Bedford 19; Bequest of Josiah Bradlee 68; Reproduced by kind permission of Lord Shelburne 28, 29, 88, 92, 93, 114, 123; Bequest – Greville L. Winthrop Half-title; Ferens Art Gallery: Hully City Museums and Art Galleries 81; Photographs Courtesy of Thos Agnew & Sons, Ltd 15, 101; Reproduced by Courtesy of the Trustees of the British Museum 16, 21, 36, 37, 38, 43, 50, 53, 61, 99, 100; Reproduced by kind permission of the Leger Galleries 45; Reproduced by Courtesy of Sotheby's 77; Reproduced by Courtesy of the Trustees of the Victoria and Albert Museum 17, 46, 89; Reproduced by permission of the National Gallery of Victoria, Felton Bequest 60, 121, 122; Yale Center for British Art, Paul Mellon Collection 1, 2, 3, 7, 9, 24, 32, 35, 40, 41, 49, 74, 78, 79, 82, 90, 109, Endpapers; The Metropolitan Museum of Art, Gift of Francis Neilson, 1945 84; Cliché des Musées Nationaux, Paris 44, 57, 65, 94, 105, 118, 120; Gift of Mrs Lincoln Davis in memory of her son, George Cole Scott, on behalf of the family 8; The Toledo Museum of Art, Gift of Edward Drummond Libbey 26; By kind permission of the Marquess of Tavistock, and the Trustees of the Bedford Estates 5.

SELECT BIBLIOGRAPHY

Books

CURTIS, A., *L'Oeuvre gravé et lithographie de R. P. Bonington*, Paris, 1939
DUBUISSON, A. and HUGHES, C. E., *Richard Parkes Bonington*, London, 1824
GOBIN, M., *R. P. Bonington*, Paris, 1955
INGAMELLS, J., *Richard Parkes Bonington*, London, Wallace Collection, 1979
 — *The Wallace Collection Catalogue of Pictures, British, German, Italian, Spanish*, London, Wallace Collection, 1985
 — *The Wallace Collection Catalogue of Pictures, French School*, London, 1986
JOHNSON, L., *The Paintings of Eugene Delacroix: a critical catalogue*, 4 vols., Oxford, 1981–86
LEMAÎTRE, H., *Le Paysage a l'aquarelle 1760–1851*, Paris, 1955
NOON, P., '*Richard Parkes Bonington: Fish Market, Boulogne*', in *In Honour of Paul Mellon*, Washington, D.C. 1986
POINTON, M., *The Bonington Circle, English Watercolour and Anglo-French Landscape 1790–1855*, Brighton, 1985
 — *Bonington, Francia and Wyld*, London, Victoria and Albert Museum, 1985
RACE, S., *Notes on the Bonington's*, Nottingham, 1950
REED, A., and SMITH, S., *Louis Francia*, exhibition catalogue, Anthony Reed Gallery, Nottingham, 1965
SHIRLEY, A. S., *Bonington*, London, 1940
SPENCER, M., *R. P. Bonington*, exhibition catalogue, Nottingham, 1965
WHITLEY, W. T., *Art in England 1821–37*, Cambridge, 1930
WILTON, A., *British Watercolours 1750–1850*, Oxford 1977

Articles

CORMACK, M., 'The Bonington Exhibition', *Master Drawings*, III, 3, 1965, pp. 286–90
HUGHES, C. E., Notes on Bonington's Parents', *Walpole Society*, III, 1914, pp. 99–112
JOHNSON, L., '*Bonington at Nottingham*', *Burlington Magazine*, CVII, June, 1965, pp. 318–20.
LONDON, B. S., 'The Salon of 1824', *Connoisseur*, LXVIII, February, 1924, pp. 66–76
MANTZ, P., 'Bonington', *Gazette des Beaux-Arts*, XIV, 1876, pp. 288–306
NOON, P., 'Bonington and Boys: some unpublished documents at Yale', *Burlington Magazine*, CXXIII, 938, May 1981, pp. 294–300
OPPE, A. P., book review, *Burlington Magazine*, LXXIX, September, 1941, pp. 99–101
SPENCER, M., 'The Bonington Pictures in the Collection of the Fourth Marquess of Hartford', *Apollo*, LXXI, June, 1965, pp. 470–75

INDEX

128 *Rouen: The Abbey of St. Armand. c.* 1827. Watercolour, $7\frac{2}{3} \times 5$ in. (19.5x12.7 cm.) Private Collection

129 *River Scene in Picardy. c.* 1823–4. Oil on canvas, 17 × 22 in. (43.2×55.9 cm.) National Trust, Knightshayes Court